ANATOMY
FOR
ARTISTS

ANATOMY
FOR
ARTISTS

SIRIUS

SIRIUS

This edition published in 2024 by Sirius Publishing, a division of
Arcturus Publishing Limited,
26/27 Bickels Yard, 151–153 Bermondsey Street,
London SE1 3HA

ISBN: 978-1-3988-4325-7
AD011592UK

Printed in China

CONTENTS

INTRODUCTION

Anatomy books are essential for figure artists, but many are published for medical purposes and tend to give too much information. For example the inner organs of the body are interesting to know about, but not relevant for drawing. What is important for the artist or art student is to learn the structure of the human form, based on the skeleton and the musculature. Having a good understanding of what is going on under the skin will help to inform your drawings of the human figure, giving them depth, subtlety and realism.

This comprehensive anatomy book has all the information necessary for an artist, using drawings and diagrams presented in an easy-to-follow format, alongside practice pages for you to make your own drawings.

In the first chapter I deal with the full figure, followed by a chapter on the anatomy of each major part of the body: the head, the torso, the arms and hands, and the legs and feet. Each section shows the skeleton from different viewpoints; then the muscles on top of the bone structure; and finally, the surface form of the body. In addition, some parts of the body are shown in more detail, to demonstrate how the joints and muscles work in movement.

In the final chapter we'll explore practices and techniques for drawing the whole human figure, including step-by-step exercises, quick life class poses and how to capture the body in movement.

We'll also consider how you can place your figure on the paper to create a successful composition.

In the technical introduction immediately after this, you will find an explanation of descriptive terms as used in medical circles, followed by a detailed list of Latin terminology. This is worth reading, because understanding anatomical terms will help you follow the annotations in the book. It may take a little time to remember all the names you need, but after regular use of these terms, you usually remember enough to describe what you are looking at.

I have omitted any description of the brain, heart, lungs and other viscera because these items are housed within the cranium, the ribcage and the pelvis, and it is the bony parts that dictate the surface shape for figure-drawing purposes. I have also left out details of the male genitalia, because the differences in size and shape are too variable.

Of course, not all human bodies are perfectly formed and proportions do differ from person to person. Throughout the book I have used well-proportioned, fairly athletic figures. This means that you become acquainted with the shapes of the muscles at their best, although you will probably draw many people who do not have well-toned bodies like these.

Throughout history, artists have looked at our bodies and shown their beauty, force and distortions. I have used the best possible references

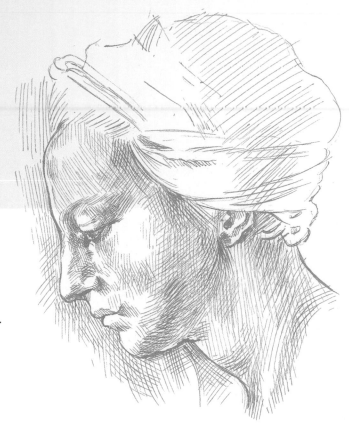

to draw the pictures in this book, including my own life studies, but have not drawn from dissected corpses, as Michelangelo or Leonardo da Vinci did. Artists have contributed a lot to the study of anatomy, both for artistic and medical purposes. In drawing, the practising artist wants to capture the form of this complex bodily machinery, but first he or she needs to know how it works.

PRACTICE PAGES

When it comes to learning any discipline, there is no substitute for practice. Throughout this book you will find practice pages and I encourage you to make full use of these. Many of the practice pages are placed directly opposite diagrams and include outlines for you to use as a guide. On other pages you can make your own drawings and notes, based on the examples provided. Where possible, annotate your drawings with the names of the bones and muscles as you learn them. Some of the anatomical terms are quite complex, but you will find that they become familiar with repetition and, if you practise regularly, you will soon be able to identify certain features on the surface of the body.

TECHNICAL INTRODUCTION

This section is intended to give you some initial detail about the human anatomy before starting to draw. I have described the properties of bones, muscles, tendons, cartilage, skin, fat and joints, as well as showing diagrams of the different types of joints and muscles. There is also an introduction to anatomical terminology: you will find this useful as certain terms are used throughout the book.

BONES

The skeleton is the solid framework of the body, partly supporting and partly protective. The shape of the skeleton can vary widely. It will affect the build of a person and determine whether they have masses of muscle and fat or not.

Bones are living tissue supplied by blood and nerves. They can become weaker and thinner with lack of use and malnutrition, or heavier and stronger when having to support more weight. They are soft and pliable in the embryo, and only become what we would consider hard and bone-like by the twenty-fifth year of life.

Humans have 206 bones, but a few fuse together with age and it is possible to be born with some bones missing or even having extra ones. We each have a skull, ribcage, pelvis and vertebral column, as well as arm, hand, leg and foot bones. Most bones are symmetrical. The bones of the limbs are cylindrical, thickening towards the ends. The projecting part of a bone is referred to as a ***process*** or an ***eminence***.

Highly mobile areas of the body, such as the wrists, consist of numerous small bones. Other bones, like the scapula (shoulder blade) can move in all directions, controlled by the muscles around it.

The bones of the cranium (skull) differ from all others. They grow from separate plates into one fused vault to house the brain. The mandible (jawbone) is the only movable bone in the head.

The long bones of the arms and legs act like levers, while the flat bones of the skull, the cage-like bones of the ribs and the basin shape of the pelvis protect the more vulnerable organs such as the brain, heart, lungs, liver and the abdominal viscera.

MUSCLES

The combination of bones, muscles and tendons allows both strong, broad movements and delicate, precise ones. Muscles perform our actions by contracting or relaxing. There are long muscles on the limbs and broader muscles on the trunk. The more fixed end of the muscle is called the ***head*** or ***origin***, and the other end – usually farthest from the spine – is the ***insertion***. The thick muscles are powerful, like the biceps; and the ring-shaped muscles (sphincters) surround the openings of the body, such as the eye, mouth and anus. Certain muscles grow together and have two, three or four heads and insertions. Combined muscles also have parts originating in different places.

The fleshy part of a muscle is called the ***meat***, and the fibrous part the ***tendon*** or ***aponeurosis***.

Striated (voluntary) muscles operate under our conscious control. The 640 voluntary muscles account for up to 50 per cent of the body's weight and form the red flesh. Organized in groups and arranged in several layers, these muscles give the body its familiar form. The drawings on the facing page show the various different types of striated muscles, with the tendons at each end. Note the distinctive shape of the sphincter muscle in the bottom row, on the far right.

Smooth (involuntary) muscles are confined to the walls of hollow organs, such as intestines and blood vessels. They function beyond our conscious control.

Cardiac (heart) muscles are both striated and involuntary, with a cell structure that ensures synchronic contraction.

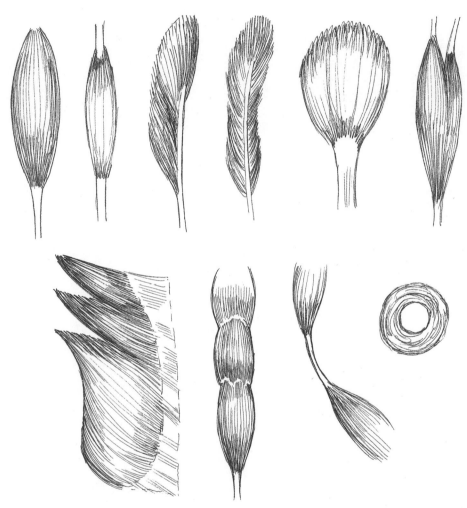

TENDONS

The tendons are fibrous structures that attach the ends of the muscles to the bones at protruding points called *tubercles* and *tuberosities*. Some muscles are divided by intervening tendons (see illustration above: bottom row, second from right). Tendons may be round and cord-like, or flat and band-like, consisting of strong tensile fibres arranged lengthwise. They are inextensible, allowing the muscles to pull hard against them. Many are longer than the muscles that they serve, such as in the forearm.

APONEUROSES

These are broad, flat, sheet-like tendons, a continuation of broad, flat muscles that either attach to the bone or continue into the *fascia*.

TENDINOUS ARCHES

Fibrous bands connected with the fasciae of muscles.

FASCIAE

Fibrous laminae of various thicknesses, occurring in all parts of the body, enveloping all muscles, blood vessels, nerves, joints, organs and glands. They prevent friction between moving muscles.

LIGAMENTS

Fibrous, elastic bands situated at joints where articulated bones connect, or stretched between two immobile bones.

CARTILAGE

Cartilage is connective tissue composed of collagen (a protein). Fibrous cartilage forms the symphysis pubis (the joint between the pubic bones) and invertebral discs. Elastic cartilage gives shape to the outer flap of the ear. Hyaline cartilage – the most common form – covers the articular surface of bones (the ends near the joints); forms the rings of the trachea (windpipe), also the bronchi (airways) of the lungs; and gives shape to the lower ribcage and nose.

SKIN

A tough, self-replenishing membrane about 2 mm thick, which defines the boundary between the internal and the external environments. Human skin is thickest on the upper back, soles of the feet and palms of the hand; it is thinnest on the eyelids. Not only the body's largest sense organ, the skin also protects the body from abrasions, fluid loss and the penetration of harmful substances. And it regulates body temperature, through perspiration and the cooling effect of surface veins.

EPIDERMIS

The skin's top layer with the dermis beneath, a thicker layer of loose connective tissue. Beneath this is the hyperdermis, which is a fine layer of white connective fatty tissue, also called the **superficial fascia**.

FAT

Fat is the body's energy reserve. Its layers soften the contours of the skeletal-muscular frame. Fat is primarily stored around the buttocks, navel, hips, inner and outer thighs, front and back of knees, beneath the nipples, on the back of the arms, in the cheeks and below the jaw.

JOINTS

Joints form the connections between bones. In fibrous joints, such as sutures in the skull, there is no appreciable movement. There is limited movement in the cartilaginous joints. The most mobile are the synovial joints such as the knees, where the bones are not fixed.

The principal movements of the joints are **flexion**, which means bending to a more acute angle; **extension**, straightening; **adduction**, which means moving towards the body's midline; **abduction**, moving away from the midline; and **medial** and **lateral rotation** (turning towards and away from the midline).

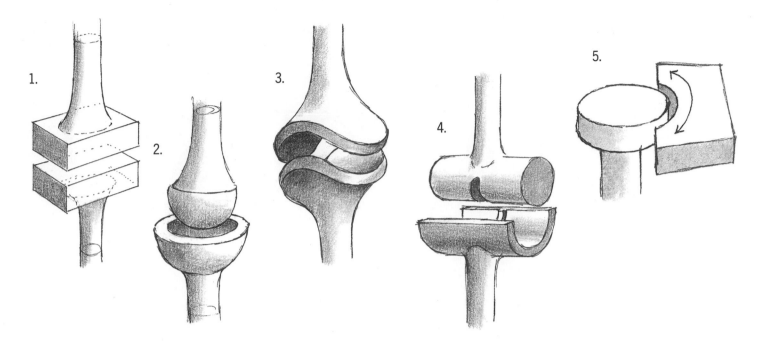

1. PLANE JOINT

Formed by flat or slightly curved surfaces, with little movement, such as the instep.

2. BALL AND SOCKET JOINT

The spherical edge of one bone moves in a spherical excavation of another, like the hip joint.

3. SADDLE OR BIAXIAL JOINT

Allows limited movement in two directions at right angles to each other, like the thumb.

4. HINGE JOINT

Bending and straightening movement is possible on one plane only, such as in the knee, the elbow and the finger.

5. PIVOT JOINT

One bone moves around another on its own axis, such as the radius and the ulna.

UNDERSTANDING ANATOMICAL TERMINOLOGY

To those who have no knowledge of Latin, the Latin names of the muscles and bones may be rather off putting and hard to grasp. However, once you understand that, for example, an extensor is a muscle involved in the process of extension, that *brevis* is Latin for 'short' and that *pollicis* means 'of the thumb', the position, attachment and function of the extensor *pollicis brevis* muscle become much easier to remember.

But even English anatomical vocabulary may not be familiar to everyone who sets out to draw the human body. For this reason, the main technical terms used in this book, both English and Latin, are explained overleaf.

Some technical terms in English

deep far from the body surface
superficial near to the body surface
inferior lower
superior upper
anterior relating to the front surface or part
posterior relating to the back surface or part
lateral farther from the inner line of the body
medial of or closer to the median line down the centre of the body
distal farther from the point of attachment to the trunk
proximal nearer to the point of attachment to the trunk
prone (of the arm or hand) with the palm facing down
supine (of the arm or hand) with the palm facing up
radial on the thumb side of the arm or hand
ulnar on the little finger side of the arm or hand
fibular on the little toe side of leg or foot
tibial on the big toe side of leg or foot
alveolar of the gums or tooth ridge
costal of the ribs
dorsal of the back; of the back of the hand or top of the foot
frontal of the forehead
hypothenar of the mound of muscle on the little-finger side of the palm
lumbar of the loins
mental of the chin
nuchal of the nape of the neck
occipital of the back of the head
orbital of the area around the eye
palatine of the roof of the mouth
palmar of the palm of the hand
plantar of the sole of the foot
supraorbital of the area above the eye

temporal of the temple
thenar of the ball of the thumb
thoracic of the chest

BONES

calcaneus the heel bone
carpus the wrist
clavicle the collarbone
coccyx the four fused vertebrae below the sacrum
condyle a knob at the end of a bone
costae the ribs
epicondyle a knob on or above a condyle
femur the thigh bone
fibula one of the lower leg bones
humerus the upper arm bone
ilium one of the hip bones
ischium one of the hip bones
malleolus a hammer-shaped prominence of a bone (e.g. in the ankle)
mandible the lower jawbone
maxilla the upper jawbone
metacarpus the bones of the palm of the hand
metatarsus the bones of the front part of the foot, except the toes
olecranon the elbow bone
patella the kneecap
phalanges the finger and toe bones
process a projecting part (also **eminence**)
pubis the pubic bone, part of the hip bone
radius one of the arm bones
sacrum five fused vertebrae near the end of the spine
scapula the shoulder blade
sternum the breastbone
tarsus the ankle, instep and heel bones
tibia one of the lower leg bones
ulna one of the arm bones
vertebra one of the bones of the spine

zygomatic bone the cheekbone

Many bones are named from their shapes: **pisiform** (pea-shaped), **cuneiform** (wedge-shaped), **scaphoid** (boat-shaped), etc.

MUSCLES

As outlined on page 10, among the movements of the joints are **flexion** (bending to a narrower angle), **extension** (straightening), **abduction** (movement away from the midline of the body) and **adduction** (movement towards the midline). The muscles involved in such movements are **flexors, extensors, abductors** and **adductors.** There are also **rotators.**

Other muscles named from their functions are **levators** and **depressors**, which respectively raise and lower some part of the body. A **tensor** tightens a part of the body and a **dilator** dilates it. The **corrugator** is the muscle that wrinkles the forehead above the nose (think of 'corrugated iron'!).

Muscles come in various sizes and the relative size is often indicated by a Latin adjective:

longus	long
brevis	short
magnus	large
major	larger
maximus	largest
medius	middle
minor	smaller
minimus	smallest

Similarly with regard to position:

interossei	between bones
lateralis	lateral, of or towards the side
medialis	medial, of or towards the middle
orbicularis	round an opening
profundus	deep (opposite to **superficialis**)

(For **anterior**, **posterior**, **inferior** and **superior**, see the English terms opposite.)

Latin forms that indicate 'of the ...'

abdominis	of the abdomen
anguli oris	of the corner of the mouth
auricularis	of the ear
brachii	of the arm (also **brachialis**)
capitis	of the head
carpi	of the wrist
cervicis	of the neck
digiti	of a finger or toe (**digiti minimi** of the little finger or toe; **digitorum** of the fingers or toes)
dorsi	of the back
fasciae	of a fascia (see below)
femoris	of the femur
frontalis	of the forehead
hallucis	of the big toe
indicis	of the forefinger
labii	of the lip
lumborum	of the loins
mentalis	of the chin
naris	of the nostril
nasalis	of the nose (also **nasi**)
nuchae	of the nape of the neck
oculi	of the eye
oris	of the mouth
palmaris	of the palm
patellae	of the kneecap
plantae	of the sole of the foot
pectoralis	of the chest or breast
pollicis	of the thumb
radialis	of the radius
scapulae	of the shoulder blade
thoracis	of the chest
tibialis	of the tibia
ulnaris	of the ulna

Other parts of the body

fascia	a sheet of connective tissue (pl **fasciae**)
fossa	a pit or hollow (pl **fossae**)

DRAWING MATERIALS

Before you start drawing, consider your choice of materials. There are many possibilities and good specialist art shops will be able to supply you with all sorts of materials and advice. Here are some of the basics to start with.

Pencils, graphite and charcoal

Good pencils are an absolute necessity, and you will need several grades of blackness or softness. You will find a B (soft) pencil to be your basic drawing instrument, and I would suggest a 2B, 4B, and a 6B for all your normal drawing requirements. Then a propelling or clutch pencil will be useful for any fine drawing that you do, especially for anatomical diagrams, because the lead maintains a consistently thin line. A 0.5mm or 0.3mm does very well.

Another useful medium is a graphite stick, which is a thick length of graphite that can be sharpened to a point. The edge of the point can also be used for making thicker, more textured, marks.

An historic drawing medium is, of course, charcoal, which is basically a length of carbonized willow twig. This will give you marvellous smoky texture, as well as dark heavy lines and thin gray ones.

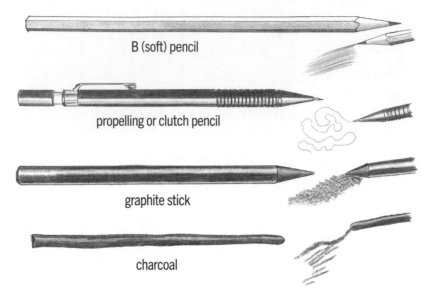

B (soft) pencil

propelling or clutch pencil

graphite stick

charcoal

Now for an instrument called a 'stump', which is just paper rolled up into a solid stump and sharpened at both ends. Use this to blend tones in a drawing – it produces very gradual changes of tone quite easily.

stump

Brushes

If you wish to work in brush and wash, you will need a couple of brushes of different thicknesses; I find that Nos 2 and 8 are the most useful. The best brushes are sable hair, but some nylon brushes are quite adequate. Use your brushes with a liquid watercolour as shown opposite.

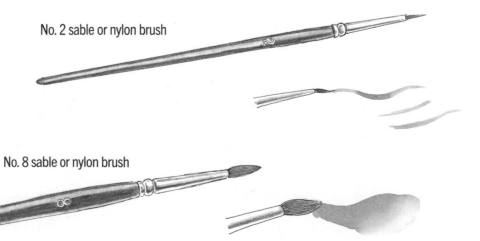

No. 2 sable or nylon brush

No. 8 sable or nylon brush

Pen and ink

Next, take a look at the various pens available for ink drawing, a satisfying medium for many artists. There is the ordinary 'dip and push' pen, which requires liquid ink and can produce lines both of great delicacy and boldness just by varying the pressure on the nib. With this you will need a bottle of Indian ink, perhaps waterproof, or a bottle of liquid watercolour.

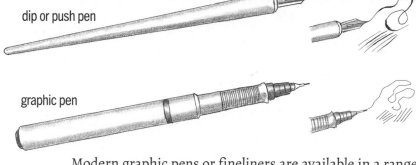

dip or push pen

graphic pen

Modern graphic pens or fineliners are available in a range of thicknesses and produce a consistent fine line. They are less messy than the dip pen, but not as versatile.

liquid concentrated watercolour

Indian ink

Felt tips and markers

There are also felt tips, which are thicker than the graphic pens, and permanent markers that produce very thick lines in indelible colours.

felt tip

permanent marker

Erasers

When using pencil you will almost certainly want to get rid of some of the lines you have drawn. There are many types of eraser, but a good solid one (of rubber or plastic) and a kneadable eraser (known as a 'putty rubber') are both worth having. The putty rubber is a very efficient tool, useful for very black drawings; used with a dabbing motion, it lifts and removes marks leaving no residue on the paper.

craft knife

scalpel

Sharpeners

Don't forget you will need some way of sharpening your pencils frequently, so investing in a good pencil-sharpener, either manual or electric, is well worth it. Many artists prefer keeping their pencils sharp with a craft knife or a scalpel. Of the two, a craft knife is safer, although a scalpel is sharper.

soft rubber eraser

putty or kneadable eraser

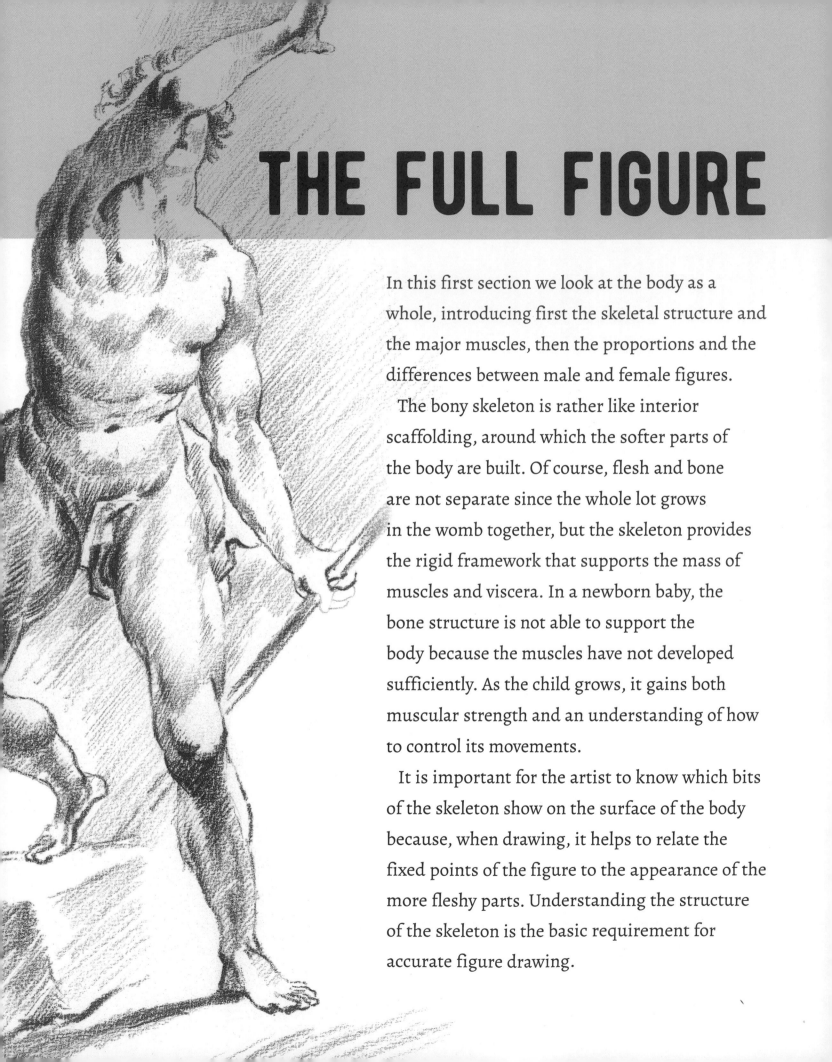

THE FULL FIGURE

In this first section we look at the body as a whole, introducing first the skeletal structure and the major muscles, then the proportions and the differences between male and female figures.

The bony skeleton is rather like interior scaffolding, around which the softer parts of the body are built. Of course, flesh and bone are not separate since the whole lot grows in the womb together, but the skeleton provides the rigid framework that supports the mass of muscles and viscera. In a newborn baby, the bone structure is not able to support the body because the muscles have not developed sufficiently. As the child grows, it gains both muscular strength and an understanding of how to control its movements.

It is important for the artist to know which bits of the skeleton show on the surface of the body because, when drawing, it helps to relate the fixed points of the figure to the appearance of the more fleshy parts. Understanding the structure of the skeleton is the basic requirement for accurate figure drawing.

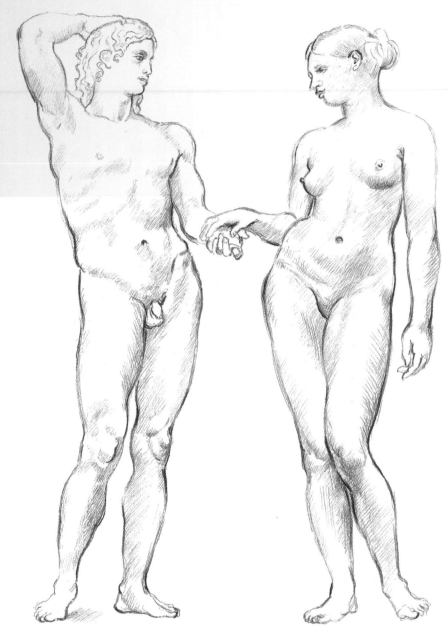

When you draw the human body, you cannot see exactly where the muscles start and end. However, if you know something about the configuration, you'll find it makes it easier to indicate the main shape of any muscle more accurately in your drawing.

Practise drawing the diagrams of the skeleton and muscles from different angles, using the outlines provided. This is never time wasted as it both hones your drawing skills and helps to familiarize you with the complex structure of the human body.

Bear in mind that a person who is an athlete will have a muscle structure that is much easier to see on the surface than someone who has led a more sedentary life. In general, women have a thicker layer of fatty tissue than men, and sometimes a muscle that is obvious on a man will be more subtle and softer looking on a woman. Then of course, either male or female may have a more fatty development of their surface area overall, which will make it harder to see how the muscles overlap one another.

We may always see the human body from the outside, but knowledge of what lies beneath the skin helps to produce more significant and convincing drawings. Study the examples drawn by master artists to see how they portrayed the subtleties of the nude figure.

THE SKELETON
Front view

First we look at three simple views of the skeleton: the front, the back and the side view (also called the anterior, the posterior and the lateral views). I have kept the number of bones named here to a minimum, since we will be going into greater detail when looking at the parts of the body in close-up.

TORSO

Clavicle (collarbone)

Coracoid process

Scapula
(shoulder blade)

Manubrium

Sternum (breastbone)

Costae (12 pairs of ribs)

5 lumbar vertebrae

Anterior superior iliac spine
Ilium

Symphysis pubis

Pubis (pubic bone)

LEG AND FOOT
(lower limb)

Head of femur

Lesser trochanter

Greater trochanter

Patella (kneecap)

Fibula

Tibia (shin bone)

Tarsus
Metatarsus
Phalanges (14 toe bones)

SKULL

Frontal bone

Zygomatic bone (cheekbone)

Maxilla

Mandible (jawbone)

7 cervical vertebrae

ARM AND HAND
(upper limb)

Humerus

Radius

Ulna

Carpus (wrist bones)

Metacarpus

Phalanges
(14 finger bones)

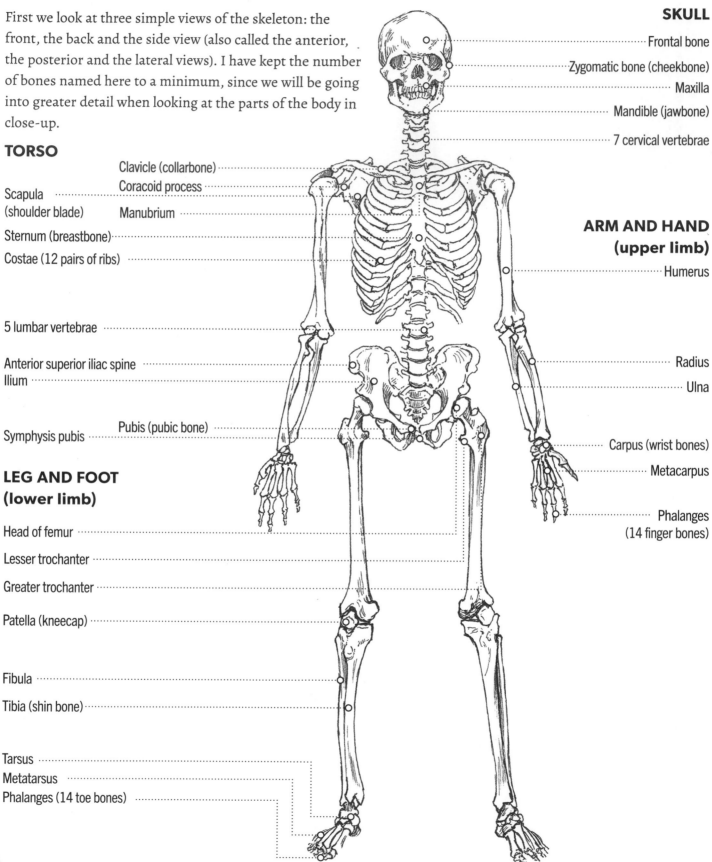

THE SKELETON
Back view

SKULL

Parietal bone ·····································

Occipital bone ·····································

7 cervical vertebrae ·····································

**ARM AND HAND
(upper limb)**

Humerus ·····································

Radius ·····································

Ulna ·····································

Carpus (wrist bones) ·····································

Metacarpus ·····································

Phalanges (14 finger bones) ·····································

TORSO

Scapula (shoulder blade)

12 thoracic or dorsal vertebrae

Costae (12 pairs of ribs)

Iliac crest

Posterior superior iliac spine

Sacrum

Coccyx

Ischium

**LEG AND FOOT
(lower limb)**

Femur

Fibula

Tibia

Calcaneus (heel bone)

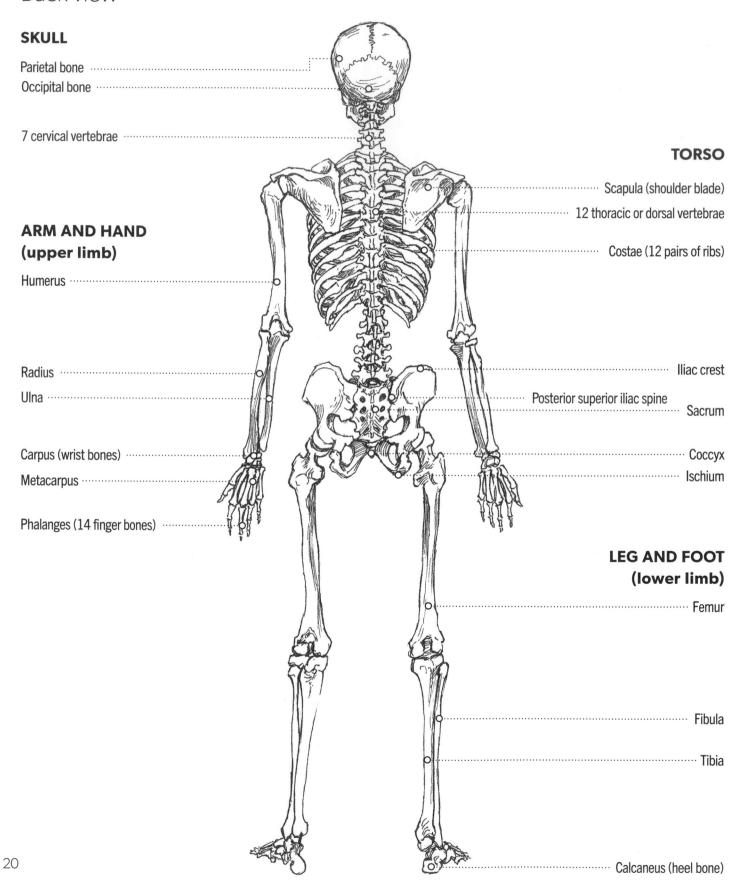

THE SKELETON
Side view

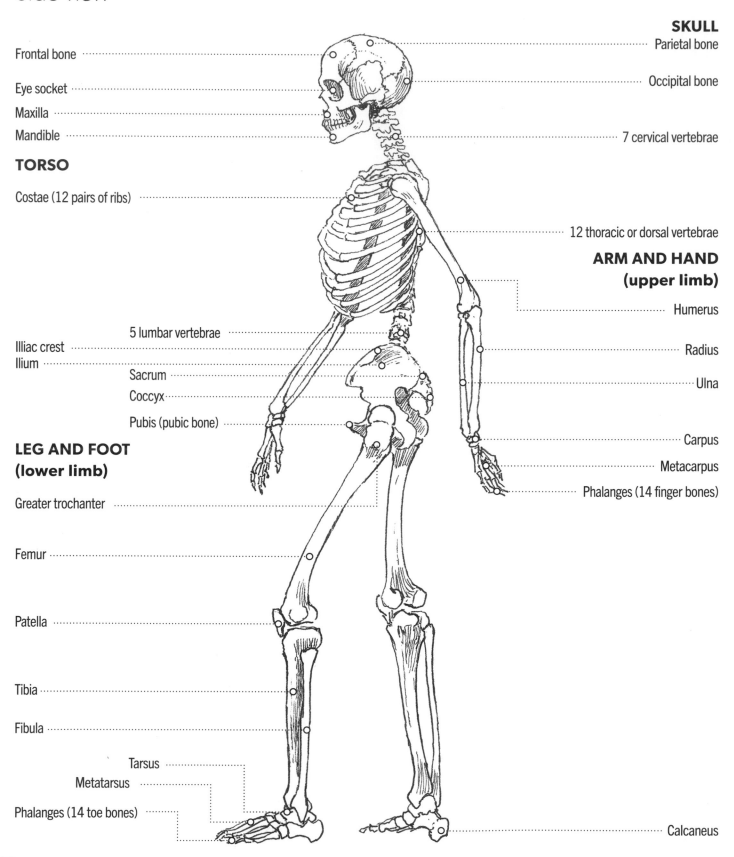

SKULL

Frontal bone

Parietal bone

Eye socket

Occipital bone

Maxilla

Mandible

7 cervical vertebrae

TORSO

Costae (12 pairs of ribs)

12 thoracic or dorsal vertebrae

**ARM AND HAND
(upper limb)**

Humerus

5 lumbar vertebrae

Illiac crest

Ilium

Radius

Sacrum

Ulna

Coccyx

Pubis (pubic bone)

Carpus

**LEG AND FOOT
(lower limb)**

Metacarpus

Phalanges (14 finger bones)

Greater trochanter

Femur

Patella

Tibia

Fibula

Tarsus

Metatarsus

Phalanges (14 toe bones)

Calcaneus

THE MUSCLES
Front view

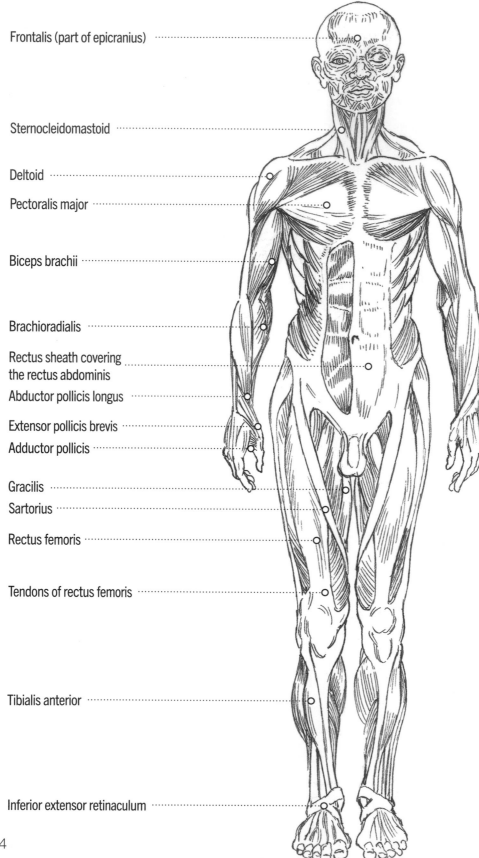

Frontalis (part of epicranius)

Sternocleidomastoid

Deltoid

Pectoralis major

Biceps brachii

Brachioradialis

Rectus sheath covering
the rectus abdominis

Abductor pollicis longus

Extensor pollicis brevis

Adductor pollicis

Gracilis

Sartorius

Rectus femoris

Tendons of rectus femoris

Tibialis anterior

Inferior extensor retinaculum

We show here the musculature
of the whole body, so as to give
some idea of the complexity
of the sheaths of muscles over
the bone structure. Later in the
book, we shall also be looking
at some of the deeper muscles
in the body, but here only the
more superficial muscles are
on show.

The drawings that follow
are based on a male body.
Of course there are slight
differences between the male
and female musculature, but
not much in the underlying
structure. The main differences
are in the chest area and the
pubic area. There are also
slight proportional differences
and we will look at these later
in the chapter.

THE MUSCLES
Back view

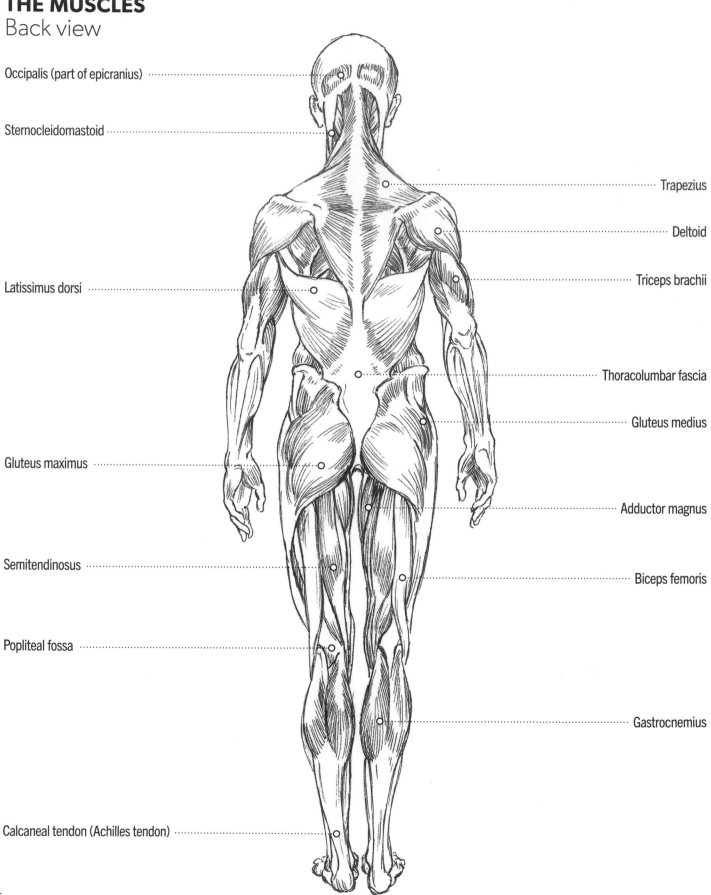

Occipalis (part of epicranius)

Sternocleidomastoid

Latissimus dorsi

Gluteus maximus

Semitendinosus

Popliteal fossa

Calcaneal tendon (Achilles tendon)

Trapezius

Deltoid

Triceps brachii

Thoracolumbar fascia

Gluteus medius

Adductor magnus

Biceps femoris

Gastrocnemius

THE MUSCLES
Side view

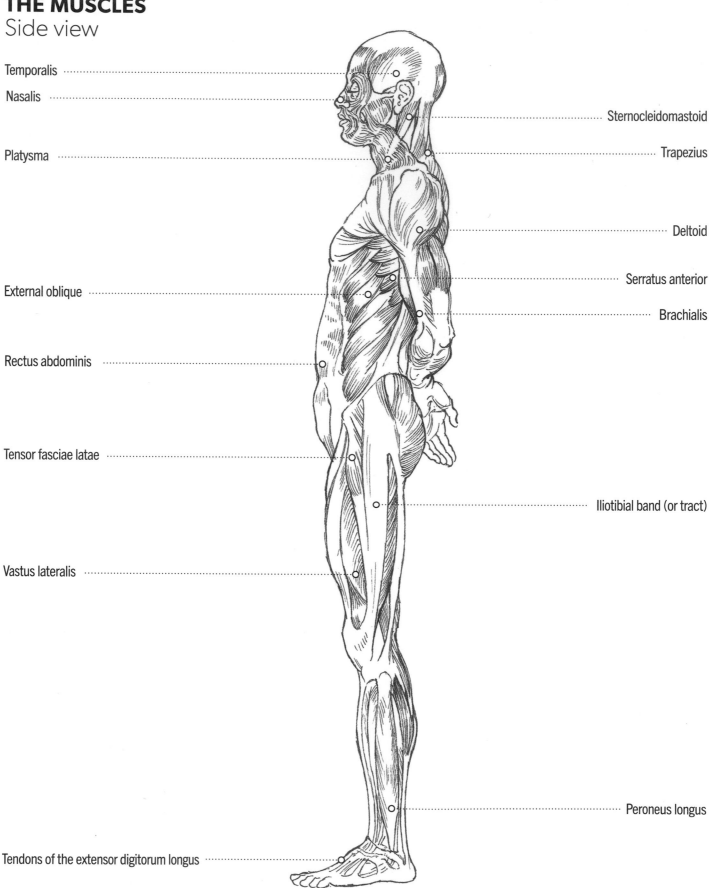

Temporalis

Nasalis

Platysma

External oblique

Rectus abdominis

Tensor fasciae latae

Vastus lateralis

Tendons of the extensor digitorum longus

Sternocleidomastoid

Trapezius

Deltoid

Serratus anterior

Brachialis

Iliotibial band (or tract)

Peroneus longus

THE SURFACE OF THE BODY
Front view – male

When you come to examine the surface of the human body, all the bones and muscles we have looked at are rather disguised by the layers of fat and skin that cover them. For the artist this becomes a sort of detective story, through the process of working out which bulges and hollows represent which features underneath the skin.

To make this easier, I have shown drawings of the body from the front and back, which are in a way as diagrammatic as the skeleton and the muscular figures in the previous pages. Because, on the surface, the male and female shapes become more differentiated, I have drawn both sexes. Later in the chapter you will find diagrams of the proportions of figures, including children (see pages 40–1), to help you to draw the figure correctly.

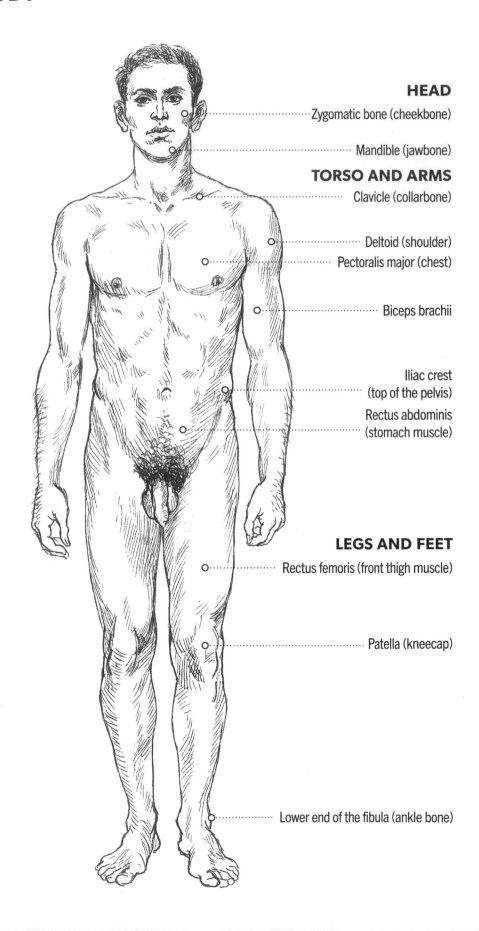

HEAD
Zygomatic bone (cheekbone)

Mandible (jawbone)
TORSO AND ARMS
Clavicle (collarbone)

Deltoid (shoulder)
Pectoralis major (chest)

Biceps brachii

Iliac crest
(top of the pelvis)
Rectus abdominis
(stomach muscle)

LEGS AND FEET
Rectus femoris (front thigh muscle)

Patella (kneecap)

Lower end of the fibula (ankle bone)

Front view – female

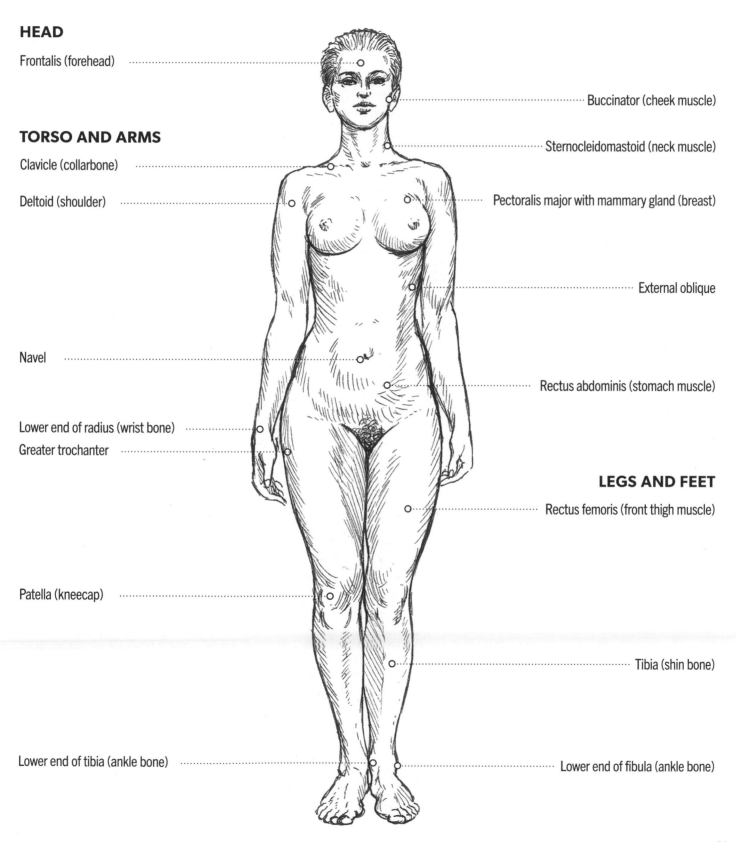

HEAD

Frontalis (forehead)

TORSO AND ARMS

Clavicle (collarbone)

Deltoid (shoulder)

Navel

Lower end of radius (wrist bone)

Greater trochanter

Patella (kneecap)

Lower end of tibia (ankle bone)

Buccinator (cheek muscle)

Sternocleidomastoid (neck muscle)

Pectoralis major with mammary gland (breast)

External oblique

Rectus abdominis (stomach muscle)

LEGS AND FEET

Rectus femoris (front thigh muscle)

Tibia (shin bone)

Lower end of fibula (ankle bone)

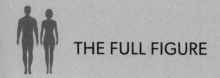

Back view – male

In these back views, I have again highlighted the most prominent muscles and parts of the bone structure visible on the surface of the body. The difference between the male and female shapes is clear, in that the male shoulders are wider than any other part of the body, while the female hips and shoulders are of a similar width.

All these body shapes are based on an athletic form, because this shows more clearly the main features of muscle and bone.

Sternocleidomastoid (neck muscle)
Trapezius (top of shoulder)
Acromion

Deltoid (shoulder)
Scapula (shoulder blade)
Teres major
Triceps brachii

Spinal groove

Latissimus dorsi (lower back)
Iliac crest (top edge of pelvis)

Styloid process of radius

Gluteus maximus (buttock)

Biceps femoris (back of thigh)
Iliotibial band

Popliteal fossa (ham)

Gastrocnemius (calf muscle)

Soleus (outer calf)

Medial malleolus of tibia

Tendo calcaneus (Achilles tendon)

Back view – female

Spine of scapula

Deltoid (shoulder)

Triceps brachii (upper arm)

Posterior superior iliac spine

Gluteus maximus (buttock)

Semitendinosus (inner thigh)

Gastrocnemius (calf muscle)

Calcaneus

Trapezius (upper shoulder)

Scapula (shoulder blade)

Latissimus dorsi (middle back)

Sacrum

Styloid process of ulna

Biceps femoris (back of thigh)

Lateral malleolus of fibula

DIFFERENCES BETWEEN THE MALE AND FEMALE SKELETON

There are differences in structure between the male and female skeleton and between some of the surface muscles. Here, I have illustrated those differences that can be identified fairly easily when drawing a figure. Of course, bear in mind that body shape varies widely. Some female figures are nearer to the masculine shape and vice versa.

Generally speaking, the bones of a female skeleton are smaller and more slender than those of a male skeleton. Also the surface of the bone is usually rougher in the male and smoother in the female.

Then, taking the other more obvious differences, the female ribcage is more conical in shape and the breastbone is shorter than the male; this gives an appearance to female shoulders of sloping more than the male. In the male skeleton, the thorax is longer and larger, and the breastbone longer; this makes the shoulders look more square and the neck shorter.

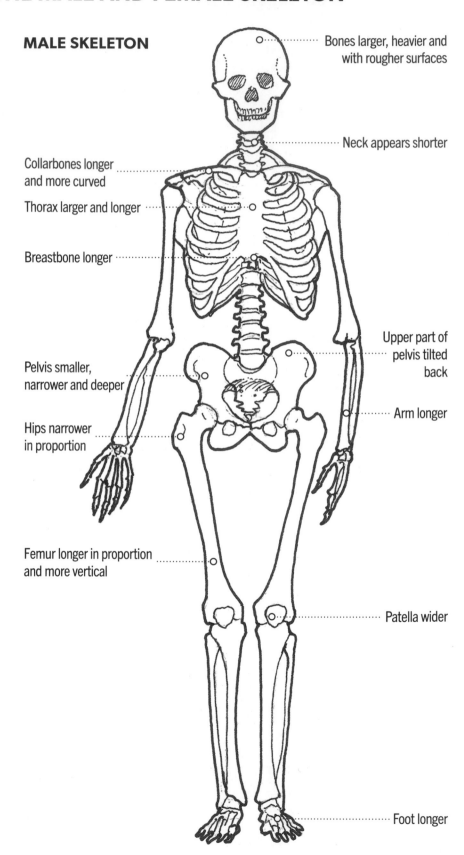

MALE SKELETON

Bones larger, heavier and with rougher surfaces

Neck appears shorter

Collarbones longer and more curved

Thorax larger and longer

Breastbone longer

Upper part of pelvis tilted back

Pelvis smaller, narrower and deeper

Arm longer

Hips narrower in proportion

Femur longer in proportion and more vertical

Patella wider

Foot longer

FEMALE SKELETON

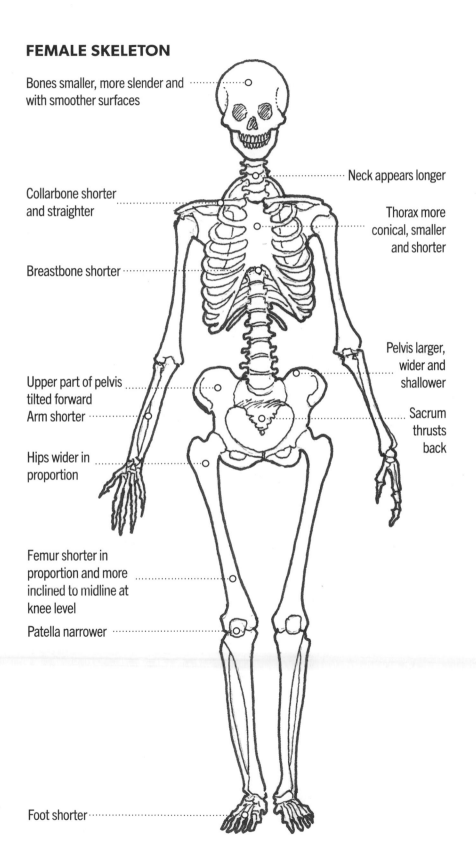

Bones smaller, more slender and with smoother surfaces

Collarbone shorter and straighter

Breastbone shorter

Upper part of pelvis tilted forward

Arm shorter

Hips wider in proportion

Femur shorter in proportion and more inclined to midline at knee level

Patella narrower

Foot shorter

Neck appears longer

Thorax more conical, smaller and shorter

Pelvis larger, wider and shallower

Sacrum thrusts back

Another clear difference between the two sexes is in the disposition of the pelvis. In the female it is broader and shallower than in the male structure. The pubic arch is wider and the sacrum thrusts backwards while the upper part of the pelvis is tilted forwards to accommodate pregnancy and provide the birth canal. In conjunction with this, the female thigh bone (the femur) is generally shorter and inclined more towards the midline at knee level than the male thigh. The effect of this is to make the hips of the female look wider in relation to their height.

Other differences are that the patella, or knee bone, is narrower in the female, and the feet shorter. This is all in proportion to the height of the full figure. Just as the leg is slightly shorter in the female skeleton, so also is the arm in relation to the rest of the skeleton. This all becomes more obvious when you see the skeleton covered with muscles and fat and skin, while in the skeleton itself it is not quite so noticeable. In some cases it is quite difficult to tell the difference between a male and a female skeleton.

DIFFERENCES BETWEEN THE MALE AND FEMALE SKULL

MALE SKULL
Larger and heavier than the female
Contours rougher

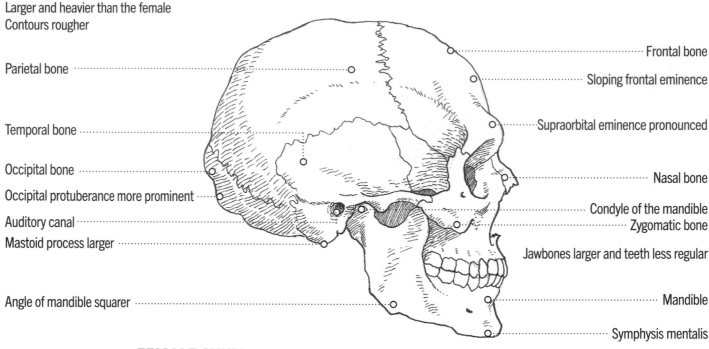

Parietal bone

Temporal bone

Occipital bone

Occipital protuberance more prominent

Auditory canal

Mastoid process larger

Angle of mandible squarer

Frontal bone

Sloping frontal eminence

Supraorbital eminence pronounced

Nasal bone

Condyle of the mandible

Zygomatic bone

Jawbones larger and teeth less regular

Mandible

Symphysis mentalis

FEMALE SKULL

Smaller, lighter and smoother than the male skull

Contours rounder and smoother

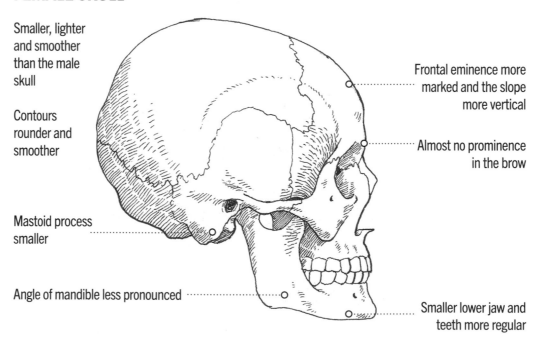

Frontal eminence more marked and the slope more vertical

Almost no prominence in the brow

Mastoid process smaller

Angle of mandible less pronounced

Smaller lower jaw and teeth more regular

INFANT SKULL

The main difference between the infant skull and the adult one is the smaller size of the face compared with the cranium.

The upper and lower jaws are much smaller due to not having any teeth. As teeth appear, the jaw grows.

FAT DISTRIBUTION OVER THE BODY SURFACE OF AN AVERAGE YOUNG WOMAN

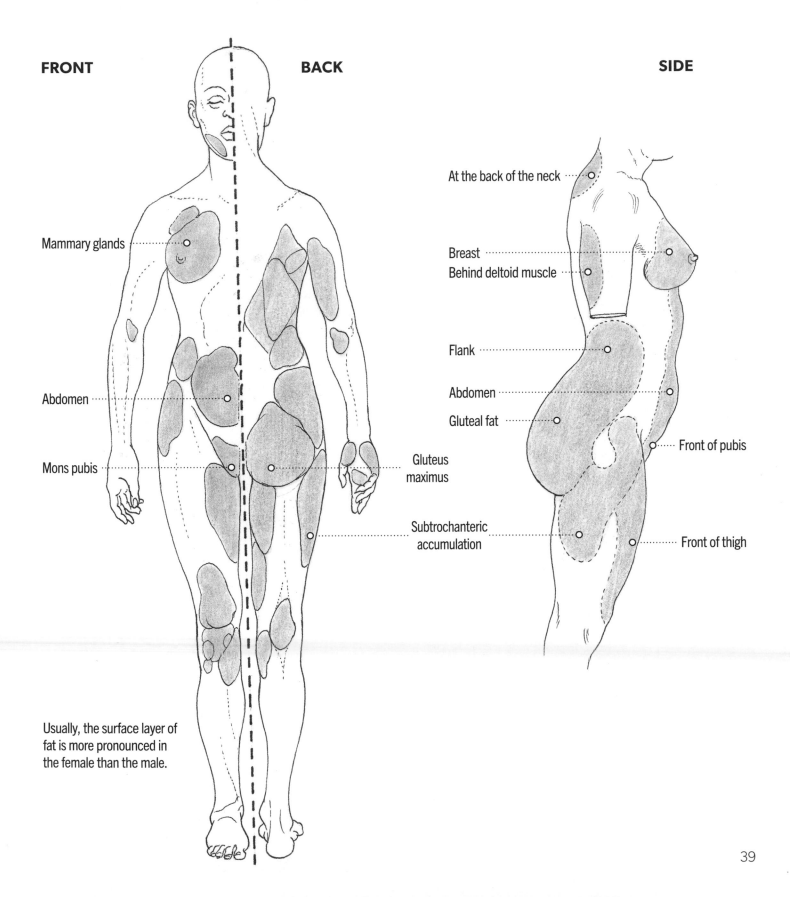

FRONT

BACK

SIDE

Mammary glands

Abdomen

Mons pubis

Gluteus
maximus

Subtrochanteric
accumulation

At the back of the neck

Breast
Behind deltoid muscle

Flank

Abdomen

Gluteal fat

Front of pubis

Front of thigh

Usually, the surface layer of
fat is more pronounced in
the female than the male.

PROPORTIONS OF THE FIGURE
Male and female

Before we look at drawings of the whole body, let's pause to study the proportions of the human figure. These are not the precise proportions of every individual but represent an average.

Viewed from the front, the height of the average adult – male or female – is approximately seven-and-a-half to eight times the length of their own head, measured from top to bottom. Notice how the halfway mark of the human figure is the lower end of the torso and the top of the legs. The second unit down is the level of the nipples on the chest, and the navel is three units down.

Note how the figures shown here are the same height; in reality the female is probably shorter than the male but the proportion of head to height remains the same.

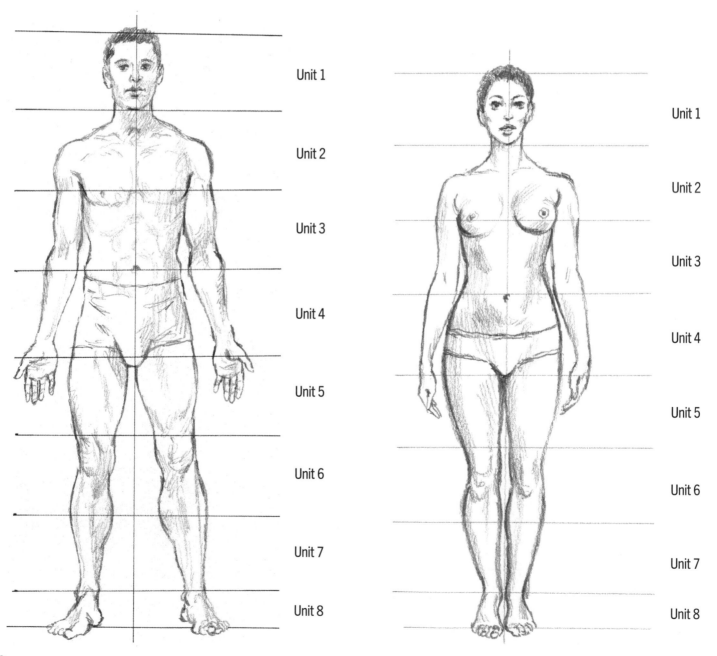

Unit 1

Unit 2

Unit 3

Unit 4

Unit 5

Unit 6

Unit 7

Unit 8

Unit 1

Unit 2

Unit 3

Unit 4

Unit 5

Unit 6

Unit 7

Unit 8

Children

The proportions of children's bodies change very rapidly and because children grow at very different speeds what is true of one child at a certain age may not always be so true of another. Consequently, the drawings here can only give an average guide to children's changes in proportion as they get older.

The thickness of children's limbs varies enormously but often the most obvious difference between a child, an adolescent and an adult is that the limbs and body become more slender as part of the growing process. In some types of figure there is a tendency towards puppy fat which makes a youngster look softer and rounder.

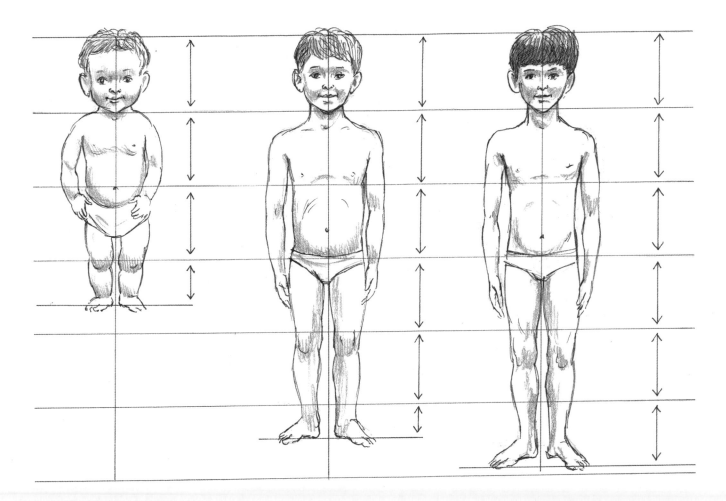

At the beginning of life the head is much larger in proportion to the rest of the body than it will be later. On the left I have drawn a child of about 18 months old, giving the sort of proportion you might find in a child of average growth. The height is only three and a half times the length of the head, which means that the proportions of the arms and legs are much smaller in comparison to those of an adult.

At the age of about six or seven, a child's height is a little over five times the length of the head, though again this is a bit variable. At about 12 years, the proportion is about six times the head size. Notice how in the younger children the halfway point in the height of the body is much closer to the navel, but this gradually lowers until it reaches the adult proportion at the pubic edge of the pelvis where the legs divide.

FORESHORTENING

The proportions you learnt on pages 40–1 will not of course apply when you look at the figure from different angles, since what is nearest to you appears to be proportionately larger than what is further away. You can see this clearly from the two drawings on this page. With foreshortening, the actual relative sizes of parts of the body are meaningless.

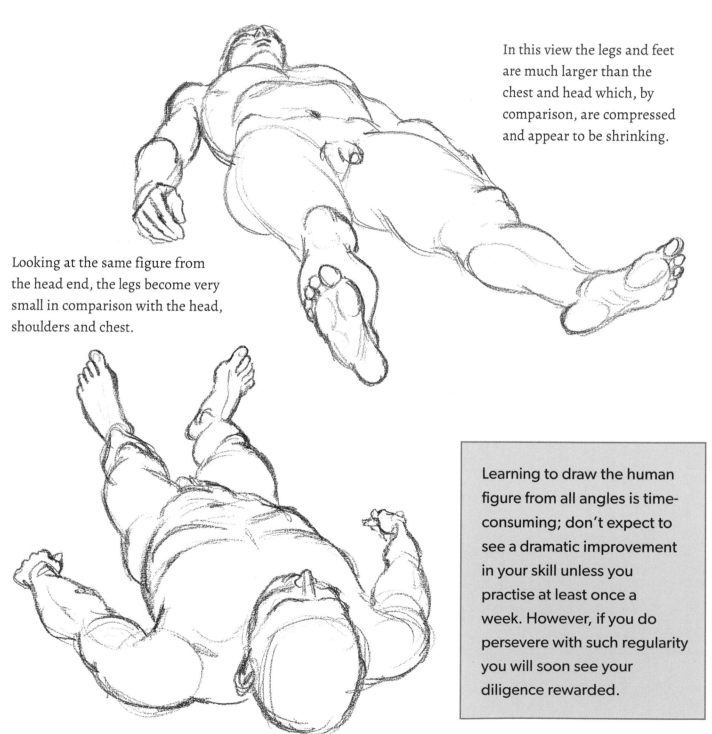

In this view the legs and feet are much larger than the chest and head which, by comparison, are compressed and appear to be shrinking.

Looking at the same figure from the head end, the legs become very small in comparison with the head, shoulders and chest.

Learning to draw the human figure from all angles is time-consuming; don't expect to see a dramatic improvement in your skill unless you practise at least once a week. However, if you do persevere with such regularity you will soon see your diligence rewarded.

The foreshortened skeleton

To underline the effect of perspective, let us look at the skeleton seen from either end as well. Here we have the pelvis and ribcage and the skull seen from the feet end of the figure and is obvious how the curve of the ribcage becomes such a dominant feature of this view. Notice how large the pelvic bone looks in relation to the ribcage and how tiny the skull appears.

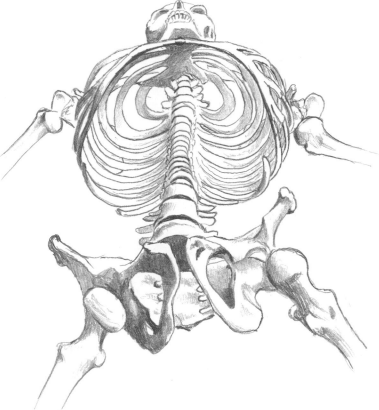

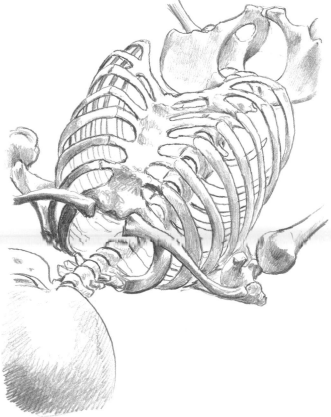

In this drawing I have drawn the skeleton from the head end: the skull is so large it is mostly out of the picture and the ribcage is a massive curving latticework. In both of these drawings I have left out the legs and arms in order to show the structure of the torso more clearly. Once again the width is proportionately larger than the length of the ribcage.

THE FIGURE DRAWN BY MASTER ARTISTS
After Camille Corot (1796–1875)

Studying the work of master artists is a valuable lesson in drawing anatomy, as in other artistic disciplines. Over the following pages we'll look at some examples of figure drawings, annotated to show the location of anatomical features and muscles.

Corot's drawing is interesting to the student of anatomy, because despite primarily showing smooth, flowing forms, it is still possible to see the main shapes of the muscles and bone structure underneath.

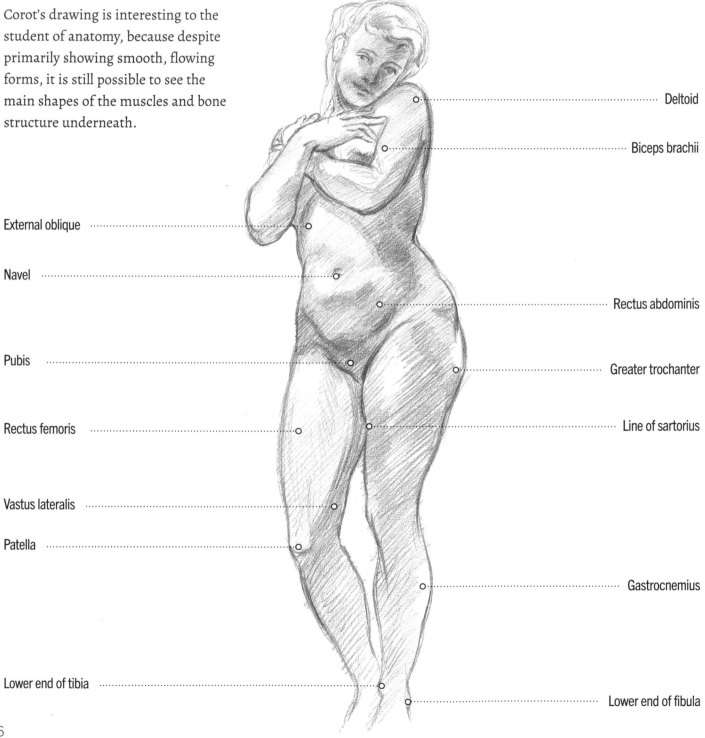

Deltoid

Biceps brachii

External oblique

Navel

Rectus abdominis

Pubis

Greater trochanter

Rectus femoris

Line of sartorius

Vastus lateralis

Patella

Gastrocnemius

Lower end of tibia

Lower end of fibula

After an unknown German master, 18th century

In this 18th-century drawing the musculature is made more obvious by the strong, oblique lighting that throws into relief the edges of the muscles and bones on the surface.

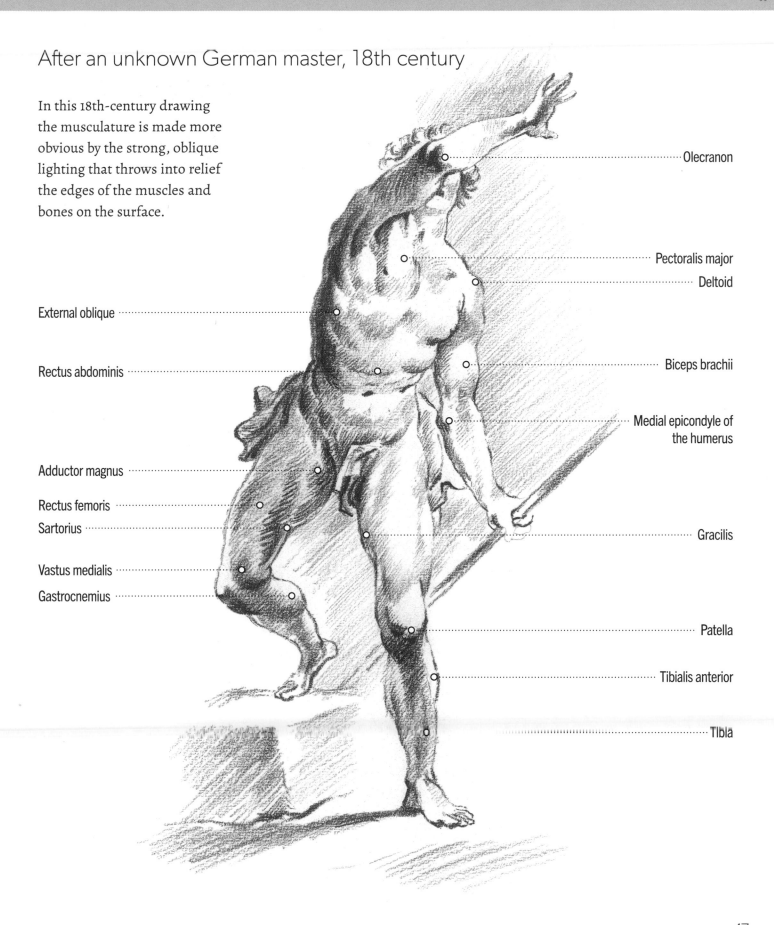

Olecranon

Pectoralis major

Deltoid

External oblique

Rectus abdominis

Biceps brachii

Medial epicondyle of the humerus

Adductor magnus

Rectus femoris

Sartorius

Gracilis

Vastus medialis

Gastrocnemius

Patella

Tibialis anterior

Tibia

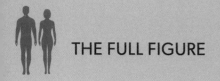

After Luca Signorelli (1445–1523)

Signorelli's figure drawing always shows the large muscles very clearly. This study of the back view of a male figure shows how well he understood the muscularity of the human form.

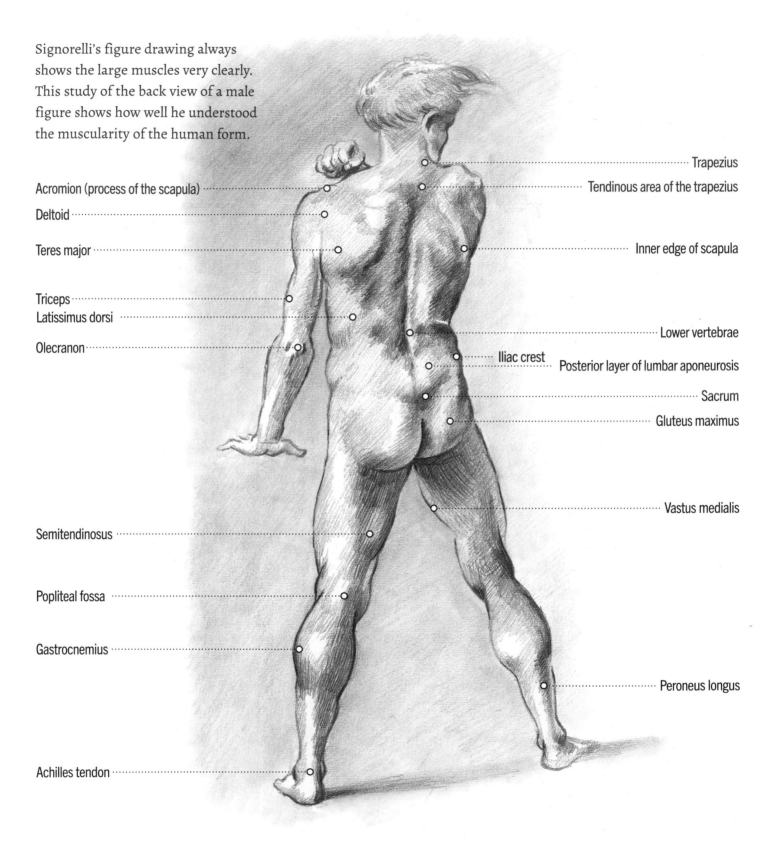

Acromion (process of the scapula)

Deltoid

Teres major

Triceps
Latissimus dorsi

Olecranon

Semitendinosus

Popliteal fossa

Gastrocnemius

Achilles tendon

Trapezius

Tendinous area of the trapezius

Inner edge of scapula

Lower vertebrae

Iliac crest
Posterior layer of lumbar aponeurosis

Sacrum

Gluteus maximus

Vastus medialis

Peroneus longus

After Noel-Nicholas Coypel (1692–1734)

Noel-Nicholas Coypel's study of the back of a nymph under a strong, oblique light makes each curve of the body stand out clearly. Note particularly the details of the upper back.

Extensor digitorum communis

Biceps brachii

Deltoid

Spine of scapula

Trapezius

Inner border of scapula

Infraspinatus

Line of the spine

Teres major

Latissimus dorsi

Gluteus maximus

Semitendinosus

Biceps femoris

Gastrocnemius

Soleus

External malleolus of fibula

Internal malleolus of tibia

49

THE HEAD

In the following sections we will explore each part of the body in greater detail, starting with the head and neck. As in the opening chapter, we begin by looking at the bone structure and then go on to study the musculature. The skull, or cranium, is made up of several bones, although by the time an individual reaches puberty many of them have fused together in a process called ossification; in doing so they provide a solid case for the delicate instruments inside. The joins of these bones are called sutures. At birth, the bones have not yet knitted together because they must be flexible during the birth process; and since the brain will grow quite a bit before adulthood, the sutures in a child's skull do not fuse completely for a number of years. The mandible (jawbone) grows dramatically as the child matures, and an adult jaw is noticeably larger in proportion to the rest of the skull than that of a small child.

When it comes to drawing the head, the main thing is to start with its overall shape. We are all used to concentrating on the features of the face – particularly the eyes and mouth – because this is where we read people's moods. This means we tend to disregard the rest of the head, its overall structure and aspect, which is crucial to achieving an accurate depiction. We'll look at the proportions of the head and study its shape from various angles.

Although the muscles of the head are not very large in comparison with the rest of the body, they are significant because so many of them work to change our facial expressions. The face is the part of the body that we respond to most and, as artists, the chief feature by which we capture the likeness of a person. We'll be looking at the muscles involved in expressing a whole range of emotions, from anger to contentment.

Finally we'll study each of the facial features in detail – eyes, mouths, noses and ears – examining their structure and particularities.

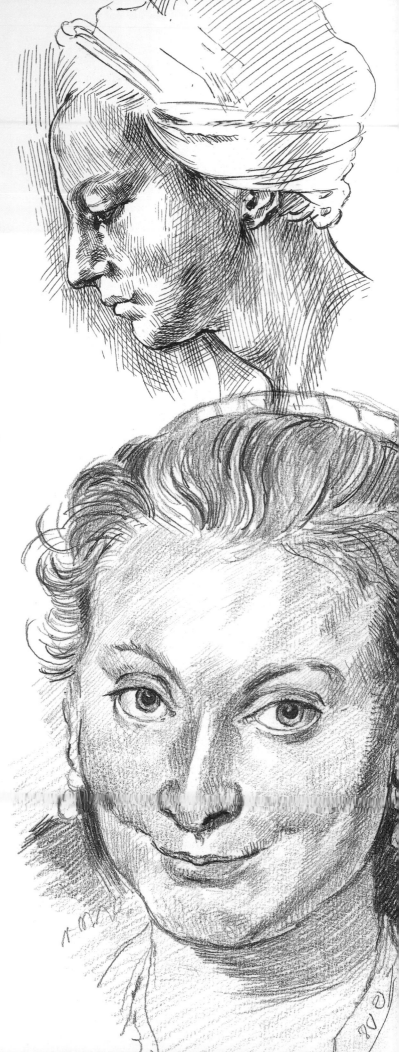

THE SKULL
Front view

The upper part of the skull contains the brain and the organs of sight and hearing. The front and rear parts consist of the thickest bone, where impacts are most likely; the sides of the head are much thinner. There are various openings in the case of the skull such as the nose and ear holes; and the eye sockets, which contain smaller apertures for the passage of the optic nerves to the brain. Underneath we find the nasal cavities; also the foramen magnum, through which the spinal column passes and connections are maintained between the brain and the rest of the body.

The lower part of the skull is the mandible, which houses the lower teeth and is hinged at the sides of the upper skull just below the ears. The first (milk) teeth fall out during childhood and are replaced by much larger adult teeth, which fill out the growing jaw.

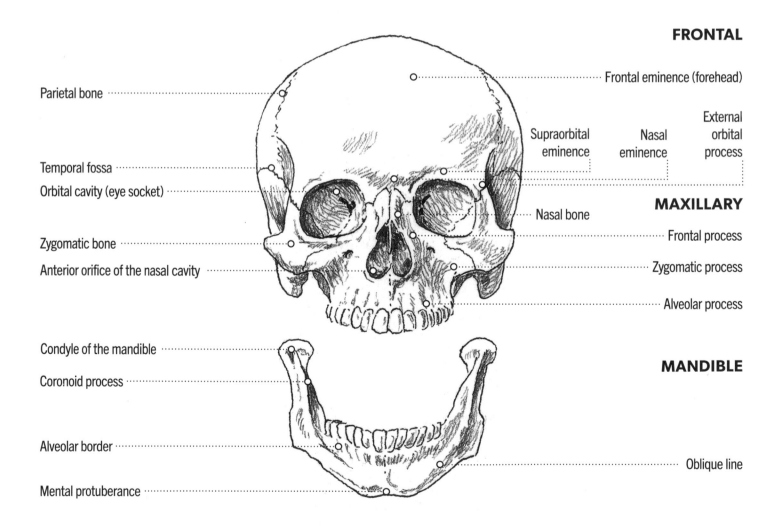

FRONTAL

Frontal eminence (forehead)

Parietal bone

External orbital process

Supraorbital eminence

Nasal eminence

Temporal fossa

Orbital cavity (eye socket)

MAXILLARY

Nasal bone

Frontal process

Zygomatic bone

Anterior orifice of the nasal cavity

Zygomatic process

Alveolar process

Condyle of the mandible

MANDIBLE

Coronoid process

Alveolar border

Oblique line

Mental protuberance

THE SKULL
Side view

PARIETAL

Parietal eminence

Temporal line

Occipital bone

TEMPORAL

Auditory hiatus

Zygomatic arch

Styloid process

Mastoid process

FRONTAL

Frontal eminence

Temporal line

Nasal eminence

Great wing of sphenoid bone

Nasal bone

Zygomatic bone

Maxillary bone

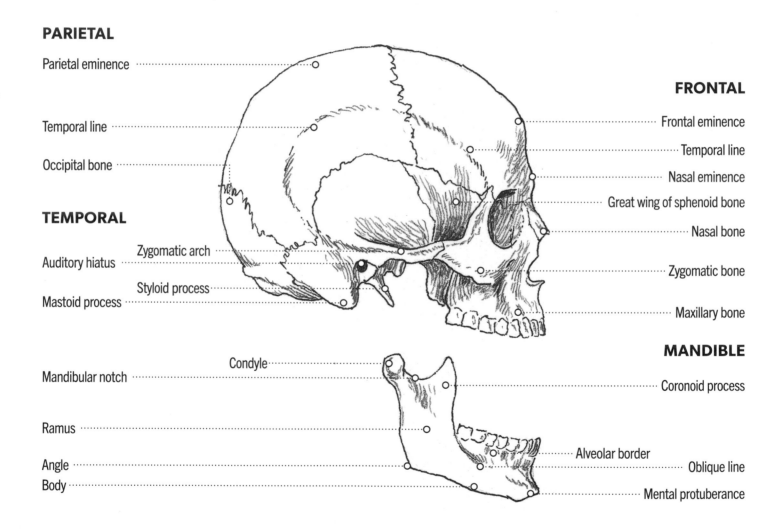

MANDIBLE

Condyle

Mandibular notch

Ramus

Angle

Body

Coronoid process

Alveolar border

Oblique line

Mental protuberance

THE SKULL
Top and back views

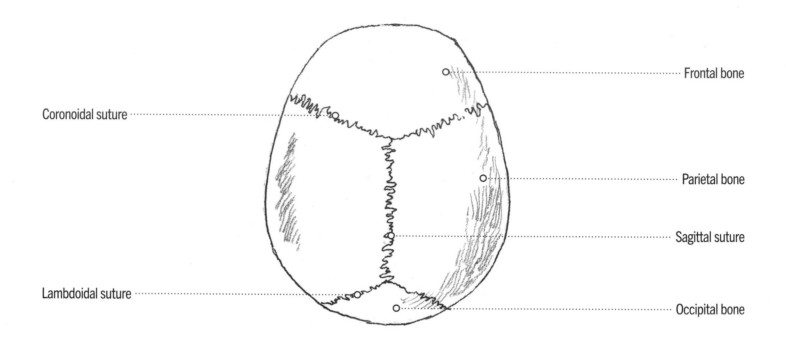

Coronoidal suture

Lambdoidal suture

Frontal bone

Parietal bone

Sagittal suture

Occipital bone

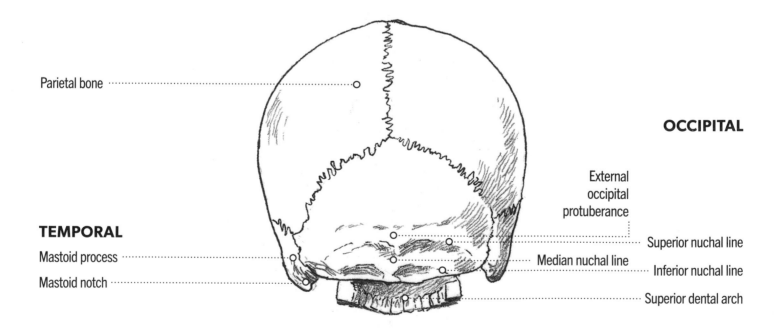

Parietal bone

OCCIPITAL

TEMPORAL

Mastoid process

Mastoid notch

External occipital protuberance

Superior nuchal line

Median nuchal line

Inferior nuchal line

Superior dental arch

HEAD MUSCLES
Front view

These are the muscles that enable us to eat and drink, and of course they surround our organs of sight, sound, smell and taste. Although they don't have the physical power of the larger muscles of the limbs and trunk, they do play an important part in our lives.

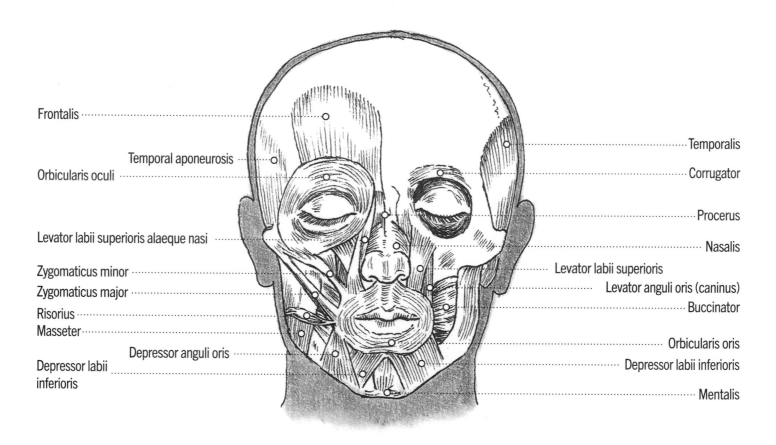

Frontalis

Temporal aponeurosis

Orbicularis oculi

Levator labii superioris alaeque nasi

Zygomaticus minor

Zygomaticus major

Risorius

Masseter

Depressor anguli oris

Depressor labii inferioris

Temporalis

Corrugator

Procerus

Nasalis

Levator labii superioris

Levator anguli oris (caninus)

Buccinator

Orbicularis oris

Depressor labii inferioris

Mentalis

HEAD MUSCLES
Side views

DEEP LAYER

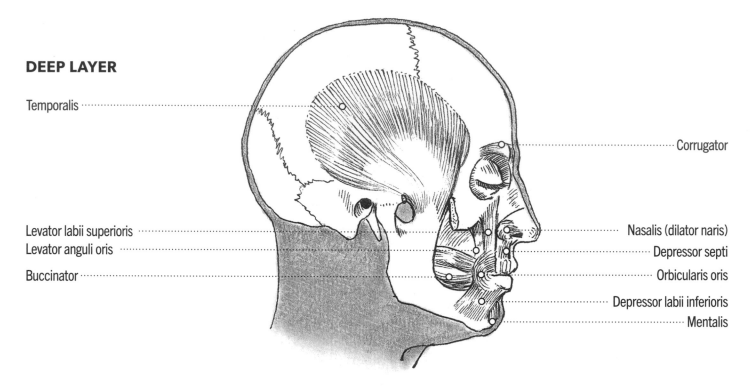

Temporalis

Corrugator

Levator labii superioris
Levator anguli oris

Buccinator

Nasalis (dilator naris)
Depressor septi
Orbicularis oris
Depressor labii inferioris
Mentalis

SUPERFICIAL LAYER

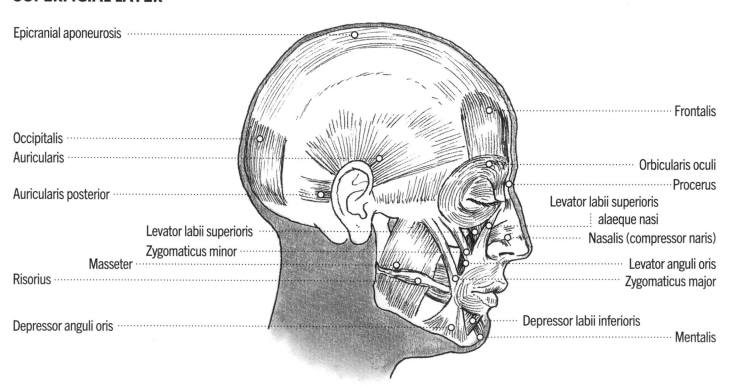

Epicranial aponeurosis

Frontalis

Occipitalis
Auricularis

Orbicularis oculi
Procerus

Auricularis posterior

Levator labii superioris
alaeque nasi
Nasalis (compressor naris)

Levator labii superioris
Zygomaticus minor
Masseter
Risorius

Levator anguli oris
Zygomaticus major

Depressor anguli oris

Depressor labii inferioris
Mentalis

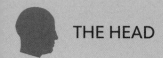

NECK MUSCLES
Front and side views

I have included the muscles of the neck with the head because, in most respects, their effect can be closely aligned with the head structure.

Sternocleidomastoid

Omohyoid
Sternohyoid
Trapezius
Scalenus posterior

Omohyoid
(continues under
clavicle)

Scalenus posterior
Thyrohyoid
Scalenus anterior
Scalenus posterior
Sternothyroid

Semispinalis capitis

Sternocleidomastoid

Splenius capitis

Levator scapulae

Scalenus posterior

Scalenus anterior

Trapezius

Digastricus
Stylohyoid
Mylohyoid
Digastricus
Thyrohyoid
Sternohyoid
Omohyoid

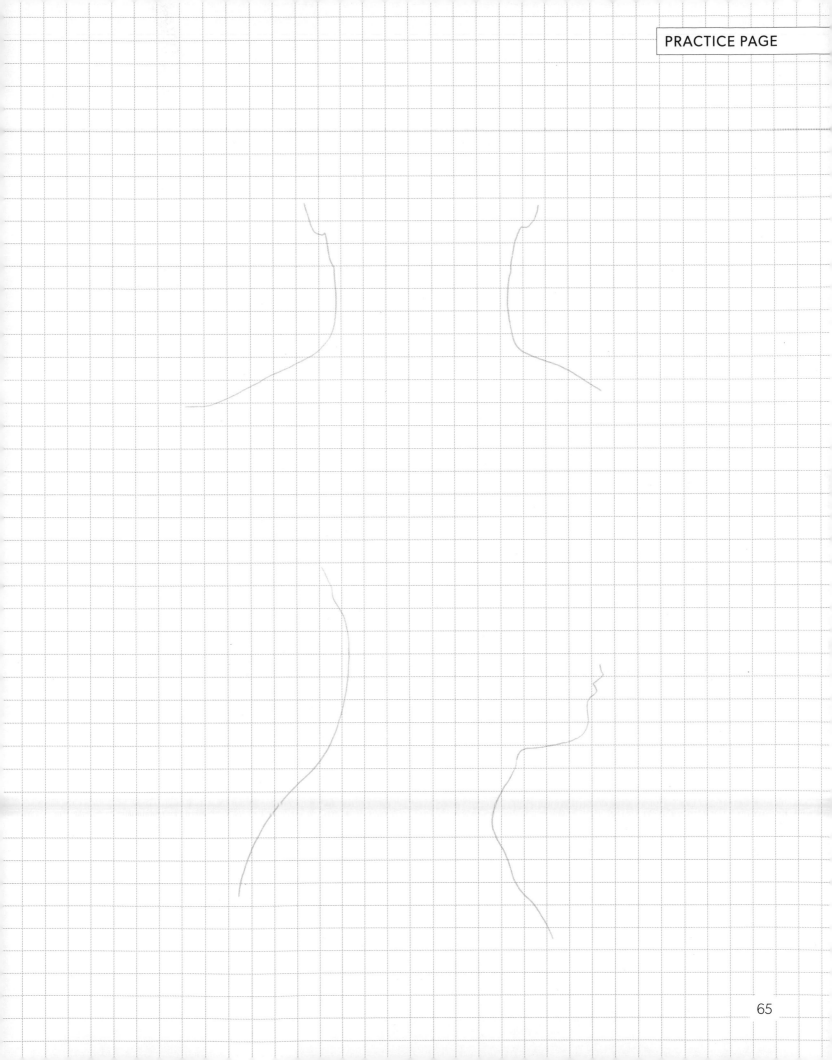

PROPORTIONS OF THE HEAD
Adult heads

The head proportions shown here are broadly true of adult humans of any race or culture. If this is the first time you have studied these measurements you may find some of them a little surprising; for example the eyes are not situated in the top half of the face, but exactly halfway down the head.

Profile view

This view of the head can be seen proportionately as a square which encompasses the whole head. When this square is divided across the diagonal, it can be seen immediately that the mass of the hair area is in the top part of the diagonal and takes up almost all the space, except for the ears.

When the square is divided in half horizontally you can see that the eyes are halfway down the length of the head. Where the horizontal halfway line meets the diagonal halfway line is the centre of the square. The ears are just behind this central point.

A line level with the eyebrow also marks the top edge of the ear. The bottom edge of the ear is level with the end of the nose, which is halfway between the eyebrow and the chin. The bottom edge of the lower lip is about halfway between the end of the nose and the chin.

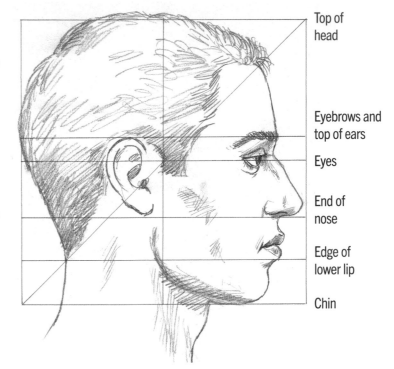

Top of head

Eyebrows and top of ears

Eyes

End of nose

Edge of lower lip

Chin

Front view

From the front, the widest part of the head is just above the ears.

As in the side view, the eyes are halfway down the length of the head and the end of the nose is halfway between the eyebrows and the chin; the bottom edge of the lip is about halfway between the end of the nose and the chin.

The space between the eyes is the same as the length of one eye. The width of the mouth is such that the corners appear to be the same distance apart as the pupils of the eyes, when looking straight ahead.

While these measurements aren't exact, they are fairly accurate and will hold good for most people's heads.

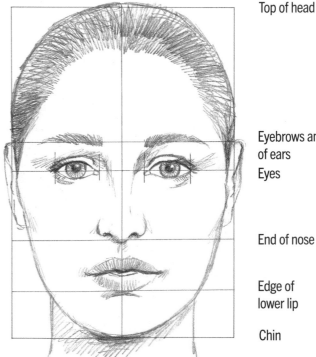

Top of head

Eyebrows and top of ears

Eyes

End of nose

Edge of lower lip

Chin

Children's heads

There are significant proportional differences between the heads of children and adults which the artist has to bear in mind; I have the listed the main ones below. The features, too, change with growth. In adults the eyes are closer together and are set halfway down the head. Nose, cheekbones, and jaw become more clearly defined and more angular as we mature.

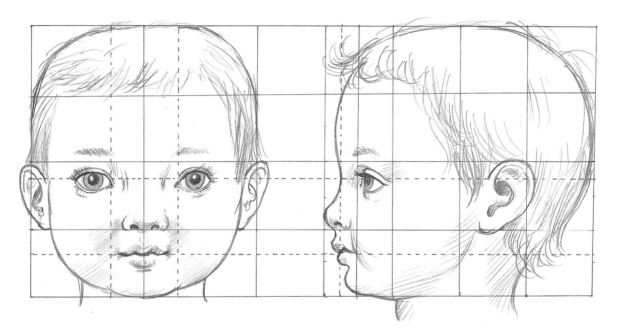

THE HEAD: MAJOR DIFFERENCES

- As we saw on page 41, in relation to its body, a child's head is much larger; this will be evident even if you can only see the head and shoulders. A child's head is much smaller than an adult's, but the proportion of head to body is such that the head appears larger.

- The cranium or upper part of the child's skull is much larger in proportion to the rest of the face. This gradually alters as the child grows and reaches adult proportions.

- The child's eyes appear much larger in the head than an adult's, whereas the mouth and nose often appear smaller. The eyes also appear to be wider apart.

- The jawbones and teeth are much smaller in proportion to the rest of the head, again because they are still not fully developed.

- The rule with the adult – that places the eyes halfway down the head – does not work with a child, where the eyes appear much lower down.

- With very young children, the forehead is high and wide, the ears and eyes very large, the nose small and upturned, the cheeks full and round, and the mouth and jaw very small. Also there are no lines to speak of on the face.

- The hair is finer, even if luxuriant, and so tends to show the head shape much more clearly.

THE HEAD FROM DIFFERENT ANGLES

The head is often observed turning from full face towards a profile view. Looking at the full face (1), both eyes are the same shape, the mouth is fully displayed, and the nose is indicated chiefly by the nostrils. As shown in our diagram, when the head turns, the features remain the same distance apart and stay in the same relationship horizontally.

However, as the head rotates away to a three-quarter view (2), we begin to see the shape of the nose becoming more evident, while the far side of the mouth compresses into a shorter line, and the eye farthest from our view appears smaller than the nearer one.

Continuing towards the profile or side view (3), the nose becomes more and more prominent, while one eye disappears completely. Only half of the mouth can now be seen and – given the perspective – this is quite short in length. Notice how the shape of the head also changes from a rather narrow shape – longer than it is broad – to quite a square one, where width and length are almost the same. We can also see the shape of the ear, which at full face was hardly noticeable.

1. 2. 3.

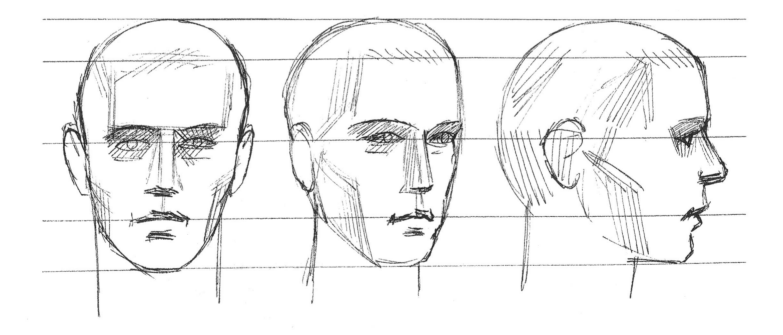

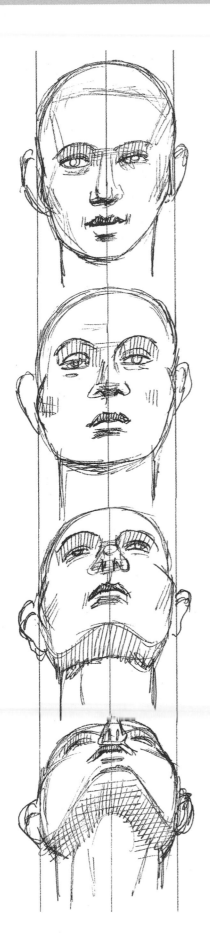

Next, we shall look at the head in another sequence that opens with the full face, but this time the head will be lifted backwards with the chin tilting up, until very little of the face is seen from below.

Note at the beginning that the front view goes from the top of the head to the tip of the chin, and the facial features are all clearly visible.

Now, as we tilt the head backwards, we see less of the forehead and start to reveal the underside of the jaw and the nose. The end of the nose now seems to be about halfway down the head instead of three-quarters, as it was in the first diagram. The eyes appear narrower and the top of the head is invisible.

One more tilt of the head shows an even larger area underneath the jaw, and the mouth seems to curve downwards. The underside of the nose, with both nostrils very clearly visible, starts to look as though it is positioned between the eyes, which are even more narrowed now. The forehead is reduced to a small crescent shape and the cheekbones stand out more sharply. The ears, meanwhile, are descending to a position level with the chin, and the neck is very prominent.

One further tilt lifts the chin so high that we can now see its complete shape; and the nose, mouth and eyebrows are all so close together that they can hardly be seen. This angle of the head is unfamiliar to us, and is only usually seen when someone is lying down and we are looking up towards their head.

Note how the head looks vastly different from this angle, appearing as a much shorter, compacted shape.

These examples show variations on viewing the head from slightly unusual angles, and you can see how they all suggest different expressions of the body's movement. Although the models for these drawings were not trying to express any particular feelings, the very fact of the movement of the head lends a certain element of drama to the drawings. This is because we don't usually move our heads without meaning something, and the inclination of the head one way or another looks as though something is meant by the action.

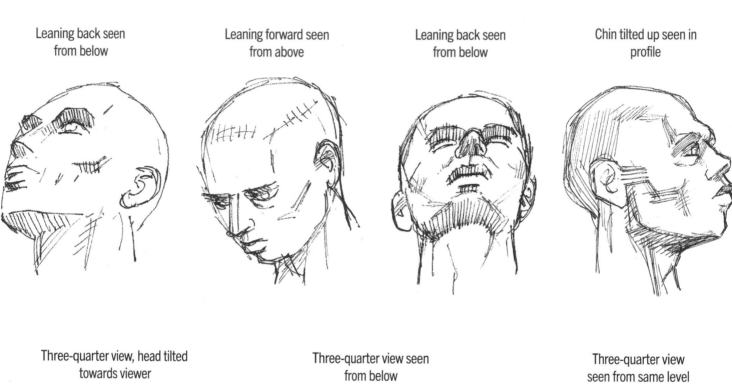

Leaning back seen from below

Leaning forward seen from above

Leaning back seen from below

Chin tilted up seen in profile

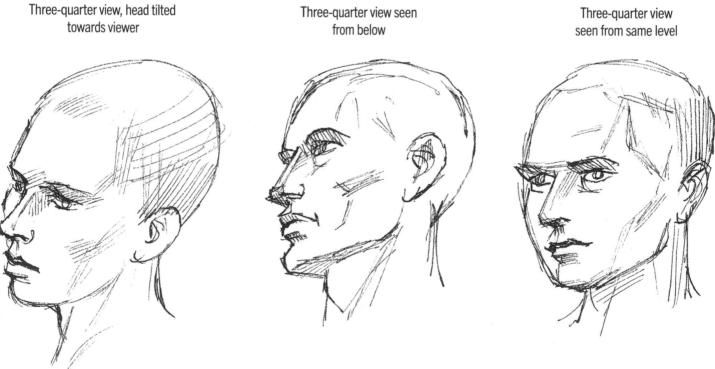

Three-quarter view, head tilted towards viewer

Three-quarter view seen from below

Three-quarter view seen from same level

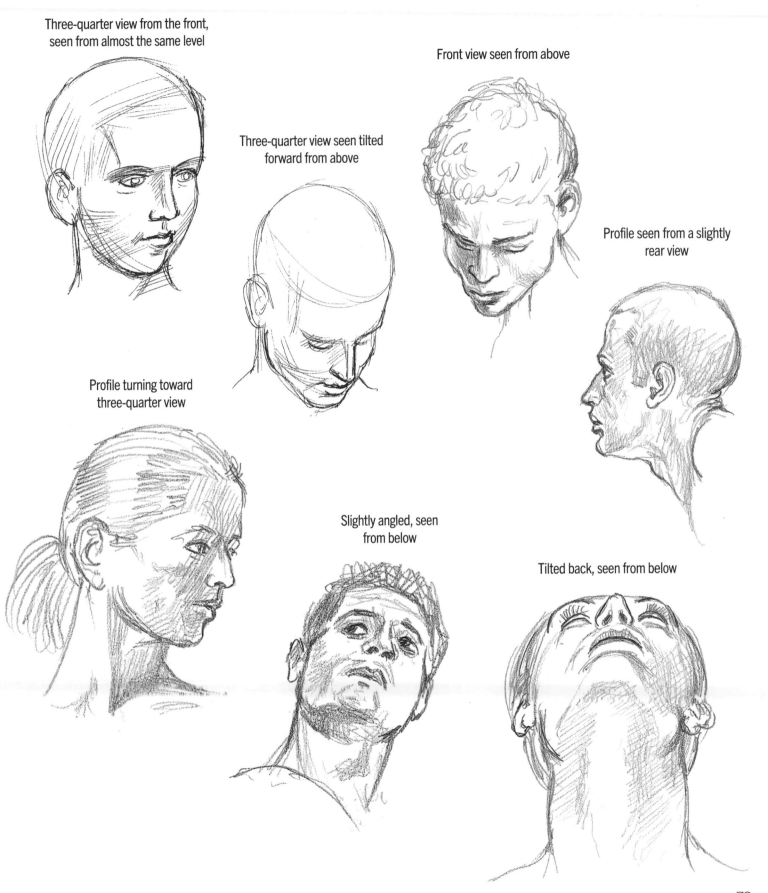

Three-quarter view from the front, seen from almost the same level

Three-quarter view seen tilted forward from above

Front view seen from above

Profile seen from a slightly rear view

Profile turning toward three-quarter view

Slightly angled, seen from below

Tilted back, seen from below

73

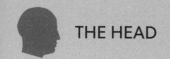

FACIAL EXPRESSIONS

Now we move on to another great challenge of drawing the head: capturing facial expressions. Here are a series of expressions showing the dominant muscles. Study them and make your own versions on the practice page.

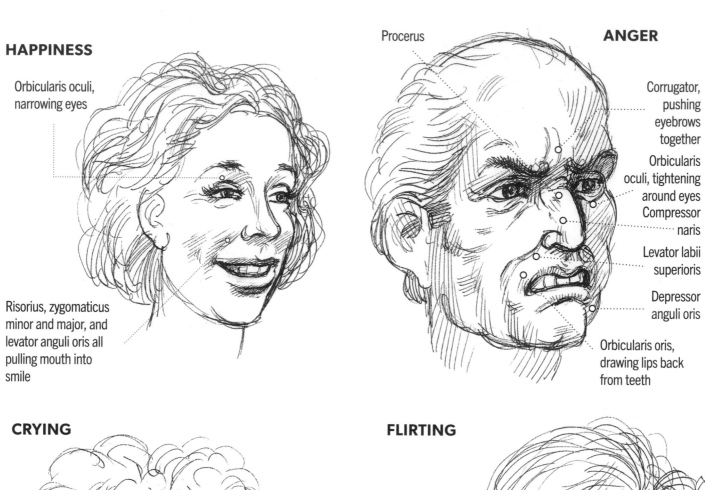

HAPPINESS

Orbicularis oculi, narrowing eyes

Risorius, zygomaticus minor and major, and levator anguli oris all pulling mouth into smile

Procerus

ANGER

Corrugator, pushing eyebrows together

Orbicularis oculi, tightening around eyes

Compressor naris

Levator labii superioris

Depressor anguli oris

Orbicularis oris, drawing lips back from teeth

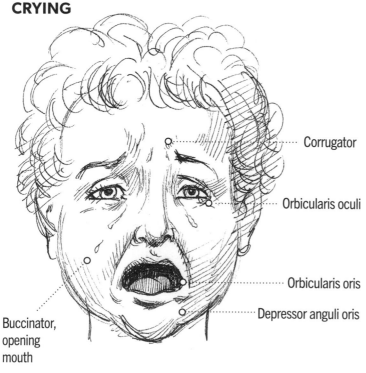

CRYING

Corrugator

Orbicularis oculi

Orbicularis oris

Depressor anguli oris

Buccinator, opening mouth

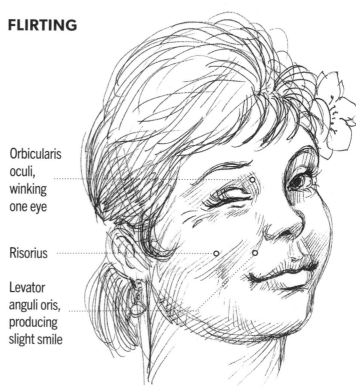

FLIRTING

Orbicularis oculi, winking one eye

Risorius

Levator anguli oris, producing slight smile

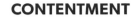

CONTENTMENT

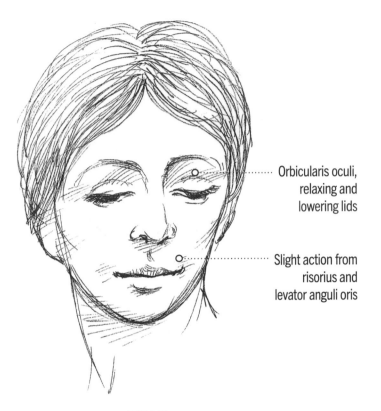

Orbicularis oculi, relaxing and lowering lids

Slight action from risorius and levator anguli oris

WORRY OR REMORSE

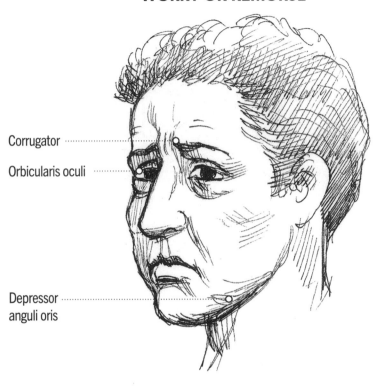

Corrugator

Orbicularis oculi

Depressor anguli oris

FEAR

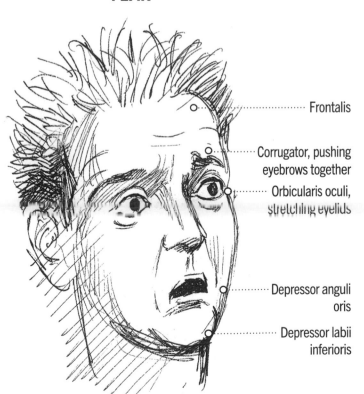

Frontalis

Corrugator, pushing eyebrows together

Orbicularis oculi, stretching eyelids

Depressor anguli oris

Depressor labii inferioris

SHOCK OR SURPRISE

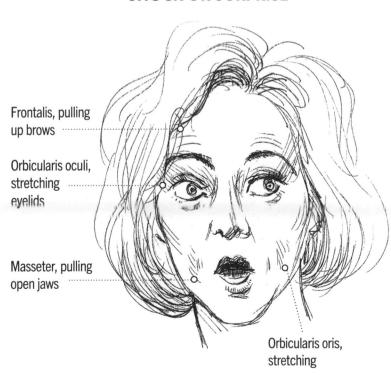

Frontalis, pulling up brows

Orbicularis oculi, stretching eyelids

Masseter, pulling open jaws

Orbicularis oris, stretching

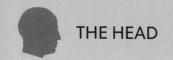

These examples on this page show less obvious expressions, where the major facial muscles are still visible.

Levator labii superioris

Orbicularis oris

Corrugator

Frontalis

Orbicularis oculi

Orbicularis oris

Depressor anguli oris

Orbicularis oculi

Levator anguli oris

Frontalis

Orbicularis oculi

Zygomatic bone

Orbicularis oris

Mentalis

Risorius

FEATURES OF THE FACE
Eyes

Here we show the individual features of the face: the eye, the mouth, the nose and the ear, giving some information about the normal formation of these features. We can see the basic structure of these features and their most obvious shape, but bear in mind that the features of individuals do vary quite dramatically sometimes.

First note that the normal position of the eye, when open and looking straight ahead, has part of the iris hidden under the upper eyelid, and the lower edge of the iris just touching the lower lid.

FRONT VIEW

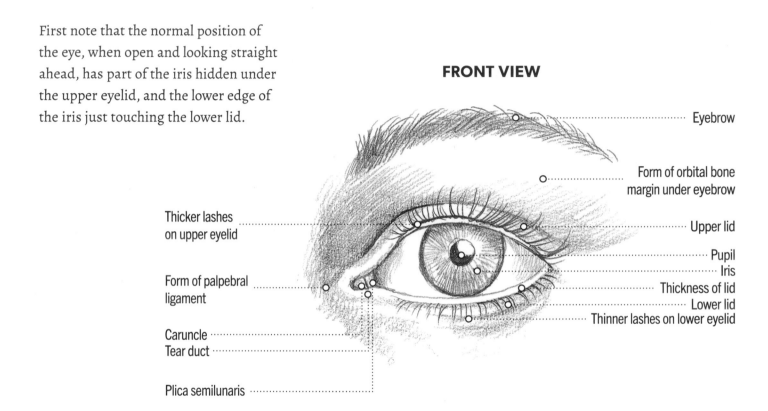

Eyebrow

Form of orbital bone margin under eyebrow

Upper lid

Pupil

Iris

Thickness of lid

Lower lid

Thinner lashes on lower eyelid

Thicker lashes on upper eyelid

Form of palpebral ligament

Caruncle

Tear duct

Plica semilunaris

SIDE VIEW

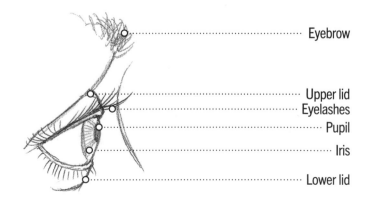

Eyebrow

Upper lid

Eyelashes

Pupil

Iris

Lower lid

Note the tendency of the eye's inner corner (medial canthus) to be slightly lower than the outer corner (lateral canthus), to help tear drainage.

Various eye shapes

Narrow eyes

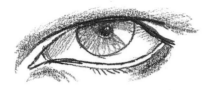

Round eyes

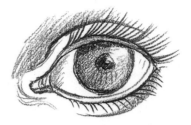

Heavy-lidded eyes

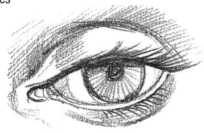

Eyes with uncreased lids

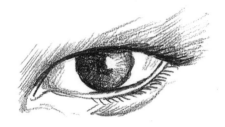

PRACTICE AREA

Mouths

FRONT VIEW

Normal structure of lips

Wing .. Wedge shape

.. Wing

Lobe .. Lobe

.. Centre groove

VARIOUS MOUTH SHAPES

FRONT VIEWS **SIDE VIEWS**

Full lips

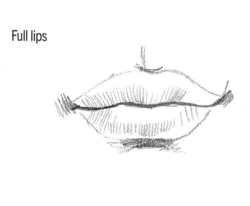

Full lips

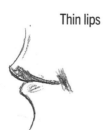

Angled: lower lip behind upper lip

Thin lips

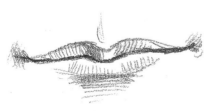

Thin lips

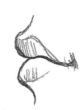

Lower and upper lips protrude the same amount (pouting)

Average 'Cupid's bow' lips

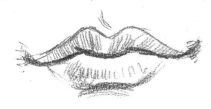

Average lips

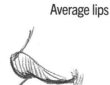

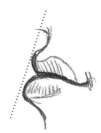

Angled: lower lip projecting beyond upper lip

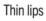

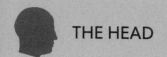

Noses

SIDE VIEWS

Long nose Short straight nose Aquiline nose Hook nose Broken nose Retroussé or snub nose

FRONT VIEWS

Normal, strong nose

Retroussé or snub nose

Aquiline nose

Ears

Helix

Triangular fossa

Morphological apex

Leg of helix

Tragus

Anti-helix

Meatus

Concha

Anti-tragus

Lobe

Rounded ear

Ear without lobe

Rounded ear

Ear from front

Ear from back

As previously stated, there are enormous variations in the shapes of these features, and these pictures show only a few. However, their basic structure is the same and the artist needs to grasp this generalized information before exploring the detailed differences.

THE TORSO

The torso and head are the two sections of the human body that most artists are interested in drawing, chiefly because of their subtlety and the challenge of rendering them convincingly. Of the two, the torso is less familiar, because we don't usually see it unclothed. The torso is capable of bending, stretching and twisting in all directions, thanks to the marvellous design and coordination of the spinal vertebrae, ribcage and pelvis. Although they are flexible, these structures are also very stable, owing to the fact that they have to contain and protect most of the major organs of the body.

The torso also contains most of the body's largest broad or flat muscles, which help to cover and support the ribcage, vertebrae and pelvis. At the front, the pectorals and the rectus abdominis cover most of the surface area and are easily recognizable in an athletic figure. The shoulder and upper back muscles are very much involved with the movement of the arms and so it is sometimes

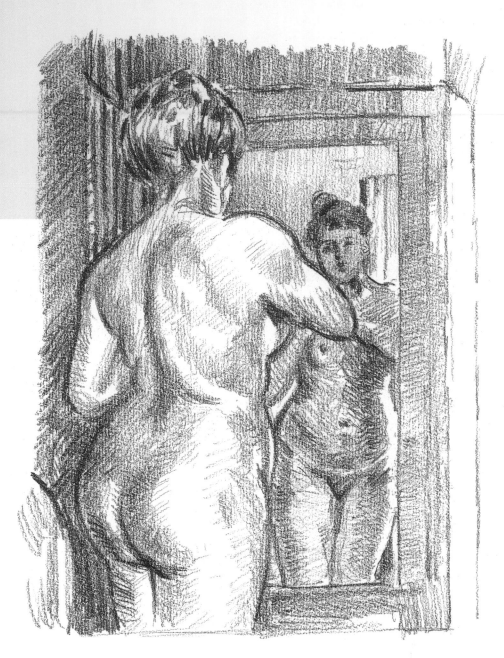

difficult to decide where the torso muscles finish and those of the arm begin. This is equally true of the musculature surrounding the pelvis and the upper legs. The long valley of the vertebral column, down the centre of the back, is formed by the number of large muscles fanning out from the vertebrae and allows us to feel the bony structure underneath the surface of the skin.

Look out for the differences between the male and female torso: whereas the muscles are very pronounced on an athletic male figure, the female shape is smoother and large muscles like the pectoralis major are not so visible under the mammary glands.

SKELETON OF THE HEAD AND TORSO
Front view

The thorax is the area of the trunk between the neck and the abdomen, including the sternum or breast bone, the 12 ribs or costae and the 12 thoracic vertebrae. These make up the thoracic cage (the ribcage) which protects the heart, lungs and viscera.

Below the thorax, the abdomen is made up of the lumbar vertebrae or column and the pelvic bones.

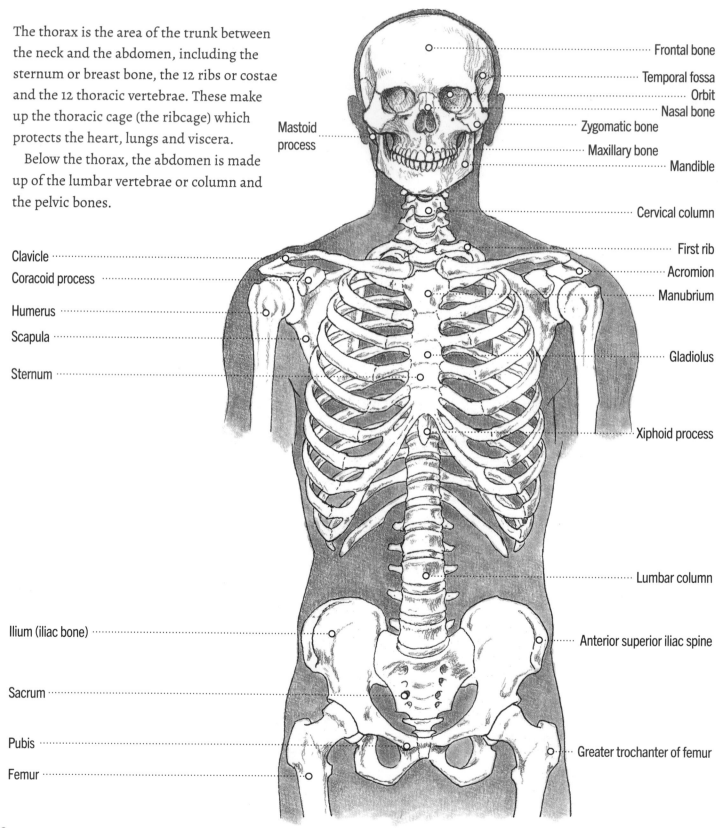

Frontal bone

Temporal fossa

Orbit

Nasal bone

Zygomatic bone

Maxillary bone

Mandible

Mastoid process

Cervical column

Clavicle

Coracoid process

First rib

Acromion

Manubrium

Humerus

Scapula

Sternum

Gladiolus

Xiphoid process

Lumbar column

Ilium (iliac bone)

Anterior superior iliac spine

Sacrum

Pubis

Greater trochanter of femur

Femur

SKELETON OF THE HEAD AND TORSO
Back view

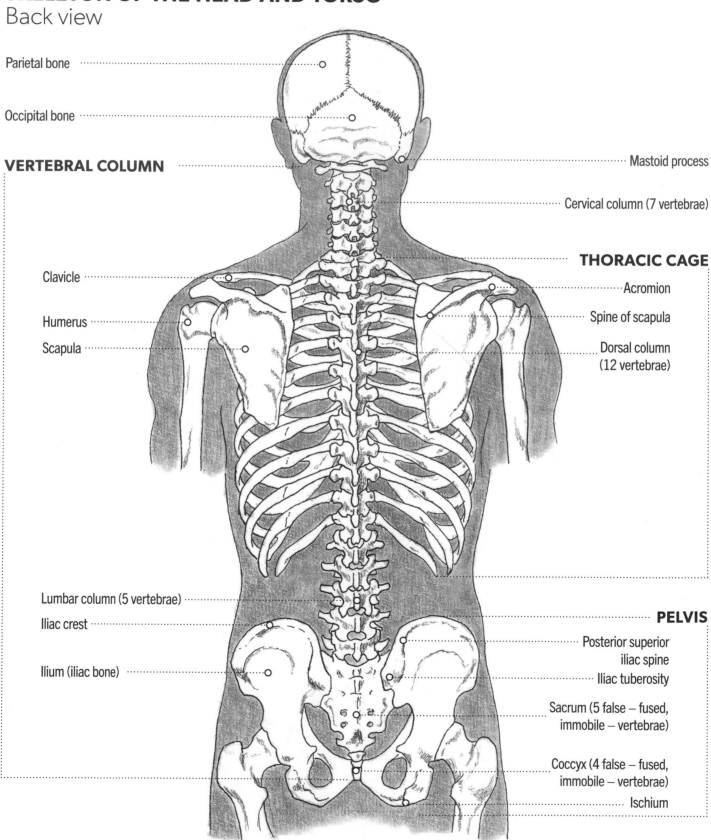

Parietal bone

Occipital bone

VERTEBRAL COLUMN

Clavicle

Humerus

Scapula

Lumbar column (5 vertebrae)

Iliac crest

Ilium (iliac bone)

Mastoid process

Cervical column (7 vertebrae)

THORACIC CAGE

Acromion

Spine of scapula

Dorsal column
(12 vertebrae)

PELVIS

Posterior superior
iliac spine

Iliac tuberosity

Sacrum (5 false – fused,
immobile – vertebrae)

Coccyx (4 false – fused,
immobile – vertebrae)

Ischium

SKELETON OF THE HEAD AND TORSO
Side view

Parietal bone

Occipital bone

Mastoid process

Cervical column

Superior angle of scapula Acromion

Humerus

Scapula

Inferior angle of scapula

Lumbar column

Sacrum

Coccyx

Femur

Frontal bone

Zygomatic bone

Maxillary bone

Mandible

Clavicle

Angle of the sternum

Thoracic cage (ribcage)

HIP BONE

Ilium

Pubis

Ischium

THE VERTEBRAL COLUMN
Side view

We examine the vertebral column by itself here, because it is such an important part of the whole skeleton that it needs to be seen separately, without the distractions of the ribs and the pelvis. Note the curved form, and the way the parts are larger at the lower end and smaller at the higher end – a brilliant piece of natural architecture.

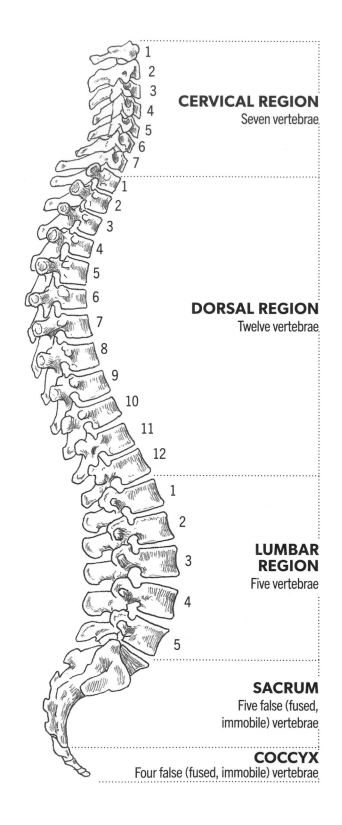

CERVICAL REGION
Seven vertebrae.

DORSAL REGION
Twelve vertebrae.

LUMBAR REGION
Five vertebrae

SACRUM
Five false (fused, immobile) vertebrae

COCCYX
Four false (fused, immobile) vertebrae

SKELETON OF THE PELVIS

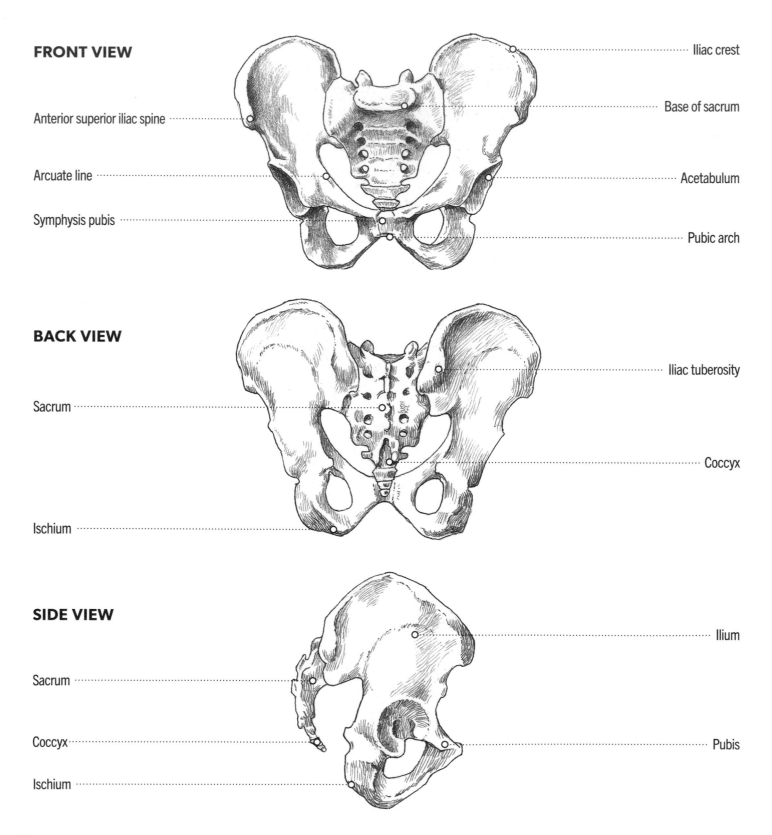

FRONT VIEW

Anterior superior iliac spine

Arcuate line

Symphysis pubis

Iliac crest

Base of sacrum

Acetabulum

Pubic arch

BACK VIEW

Sacrum

Ischium

Iliac tuberosity

Coccyx

SIDE VIEW

Sacrum

Coccyx

Ischium

Ilium

Pubis

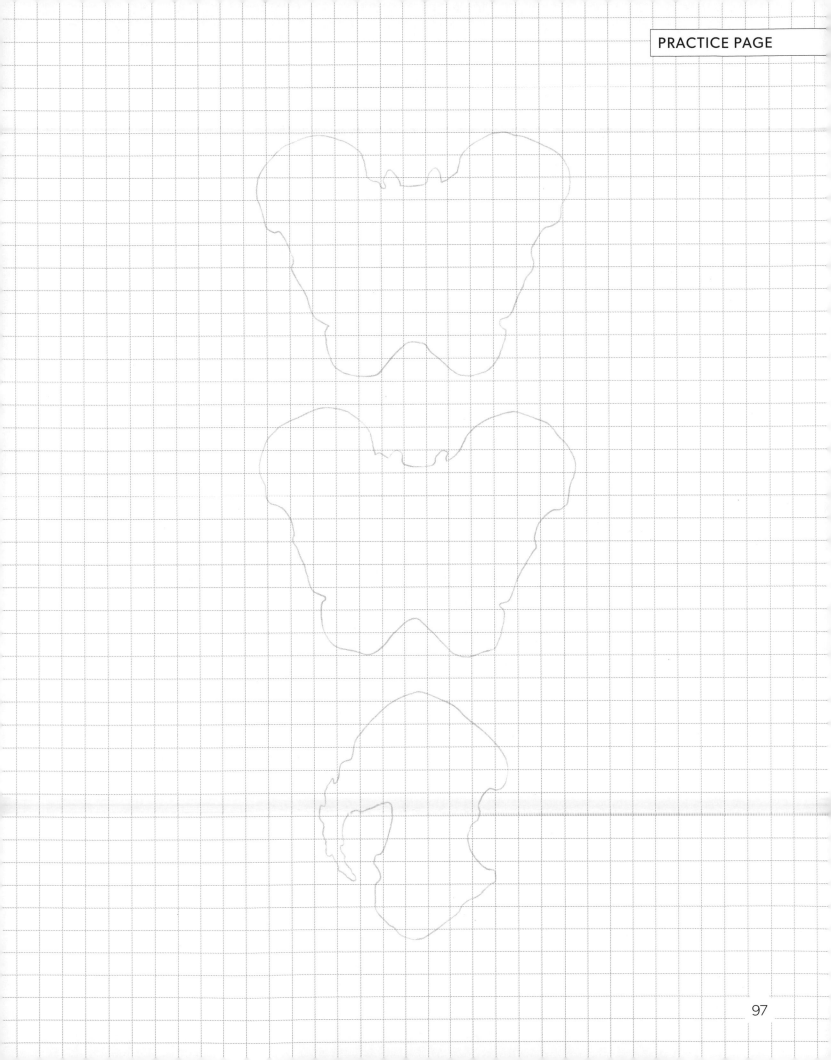

MUSCLES OF THE TRUNK AND NECK
Front view

The muscles of the trunk are in the main quite large and fairly flat in shape. They are layered over the ribcage and pelvis and cover the big joints of the hips and shoulders. There are deeper layers of muscle in the back that sometimes help shape the more superficial muscles.

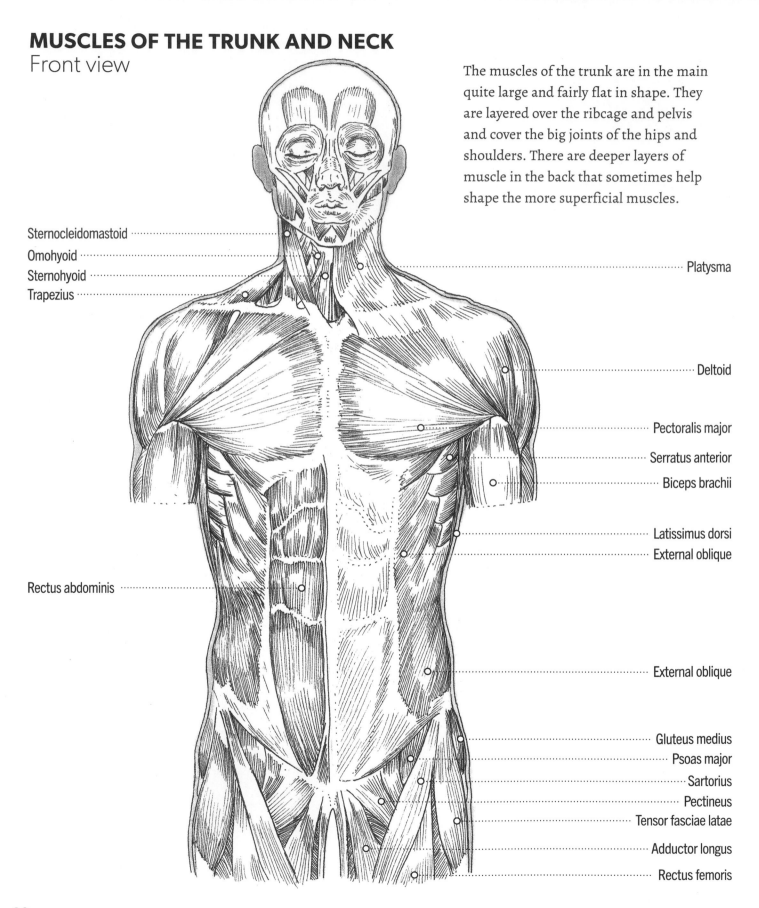

Sternocleidomastoid

Omohyoid

Sternohyoid

Trapezius

Rectus abdominis

Platysma

Deltoid

Pectoralis major

Serratus anterior

Biceps brachii

Latissimus dorsi

External oblique

External oblique

Gluteus medius

Psoas major

Sartorius

Pectineus

Tensor fasciae latae

Adductor longus

Rectus femoris

MUSCLES OF THE TRUNK AND NECK
Back view

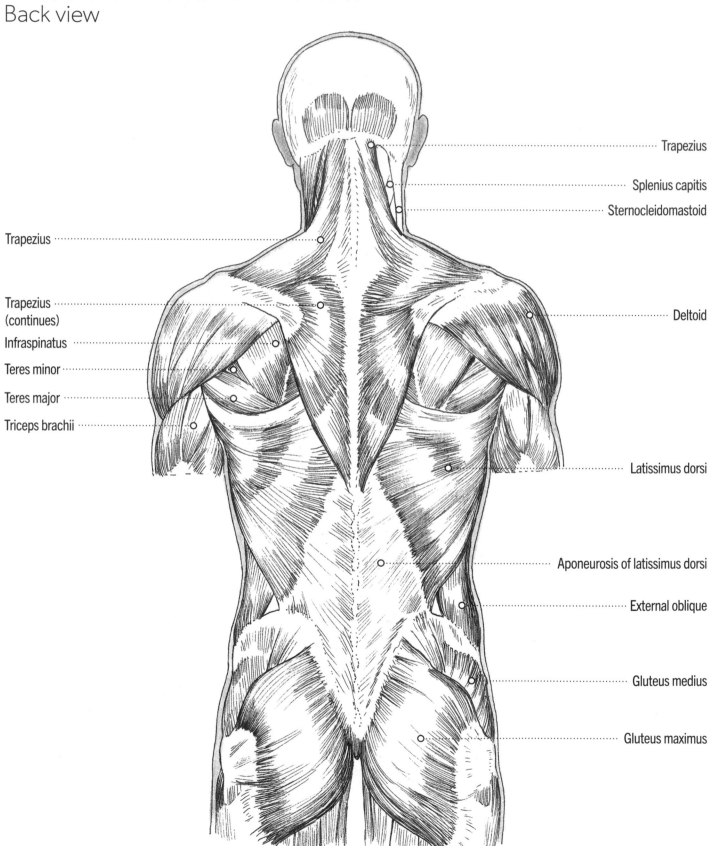

Trapezius

Splenius capitis

Sternocleidomastoid

Trapezius

Deltoid

Trapezius
(continues)

Infraspinatus

Teres minor

Teres major

Triceps brachii

Latissimus dorsi

Aponeurosis of latissimus dorsi

External oblique

Gluteus medius

Gluteus maximus

MUSCLES OF THE TRUNK AND NECK
Side view

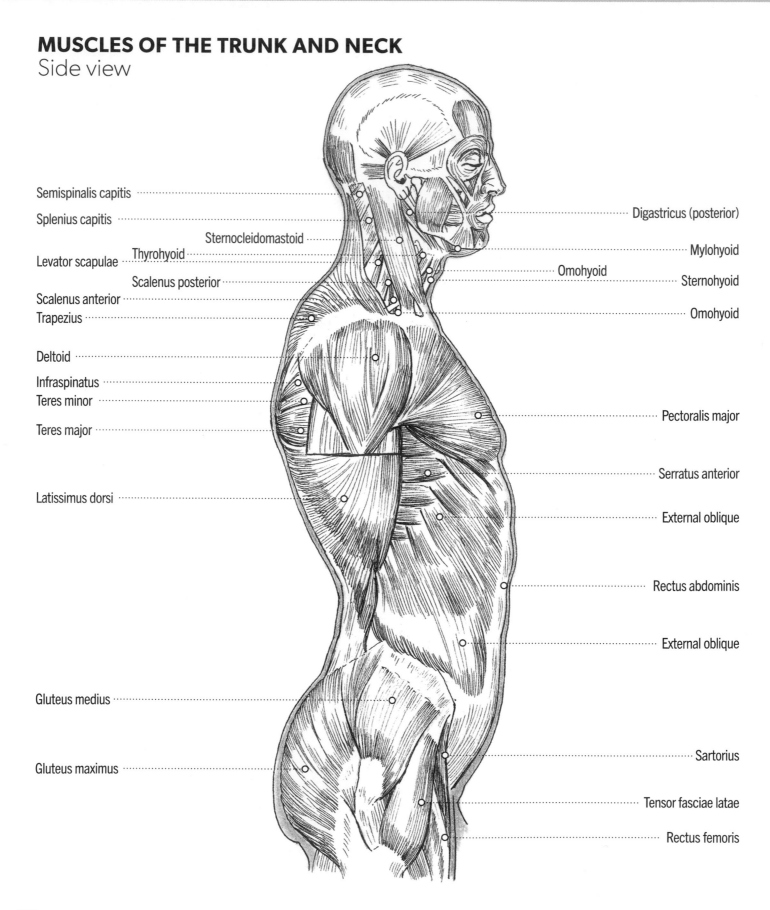

Semispinalis capitis

Splenius capitis

Sternocleidomastoid

Thyrohyoid

Levator scapulae

Scalenus posterior

Scalenus anterior

Trapezius

Deltoid

Infraspinatus

Teres minor

Teres major

Latissimus dorsi

Gluteus medius

Gluteus maximus

Digastricus (posterior)

Mylohyoid

Omohyoid

Sternohyoid

Omohyoid

Pectoralis major

Serratus anterior

External oblique

Rectus abdominis

External oblique

Sartorius

Tensor fasciae latae

Rectus femoris

VIEWS OF THE TORSO BY MASTER ARTISTS
After Michelangelo Buonarroti (1475–1564)

In characteristic fashion, Michelangelo draws the torso of a male figure with all the muscles clearly shown through his pen strokes. His first love was sculpture, and his drawings always have a sense of growing out from the paper, like a three-dimensional, carved form. Here you can see quite a few of the bony protuberances of the skeleton, as well as the clearly defined muscles of the front of the torso. Michelangelo does not leave out anything that might help inform the viewer about the shape and dimensional effects of the body.

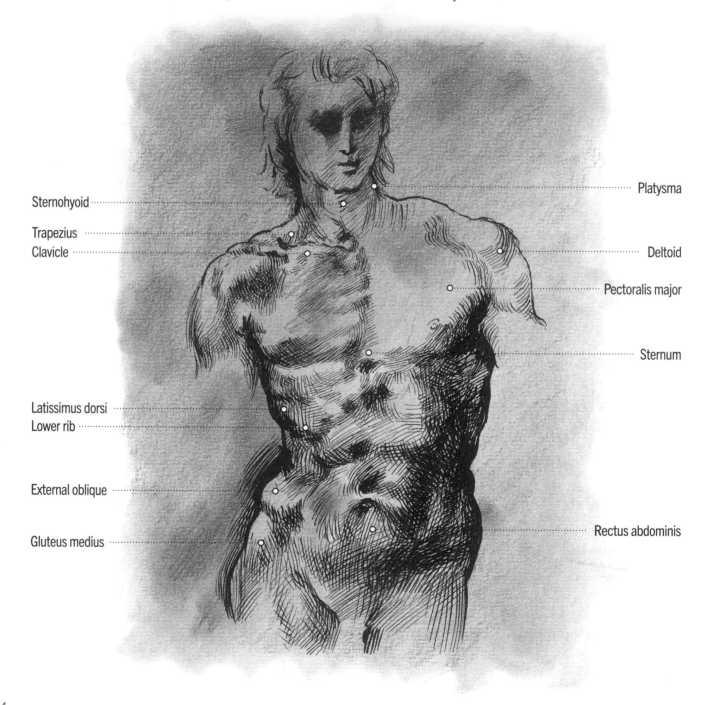

Sternohyoid

Trapezius
Clavicle

Latissimus dorsi
Lower rib

External oblique

Gluteus medius

Platysma

Deltoid

Pectoralis major

Sternum

Rectus abdominis

After Agnolo Bronzino (1503–72)

Bronzino was heavily influenced by Michelangelo, as were most of the artists of this time, but he also responded to the much smoother drawing of Raphael (see page 107), who was as successful as Michelangelo, but had a much shorter life. The carefully modulated forms in this drawing of a goddess have none of the ruggedness of Michelangelo's pen drawing. As painter at the Medici court in Florence, Bronzino knew how to make his models pleasing to the eye, with a seductive modelling style. However, the main muscles of the Bronzino torso are not as obvious as in Michelangelo's dramatic drawings; and the goddess being nicely fleshed out, the divisions between the muscles are much less clearly defined.

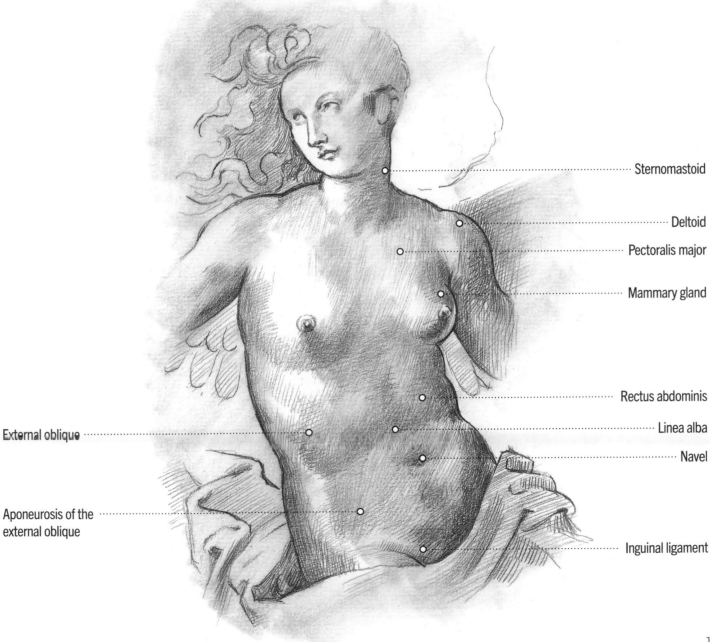

Sternomastoid

Deltoid

Pectoralis major

Mammary gland

Rectus abdominis

External oblique

Linea alba

Navel

Aponeurosis of the
external oblique

Inguinal ligament

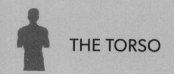

DRAWINGS OF THE TORSO IN MOVEMENT BY MASTER ARTISTS
After Michelangelo

The following drawings of the moving torso demonstrate the flexibility and strength of the section between the ribcage and the pelvis, often called 'the core'. It is worth studying drawings like this to make you aware of the multiplicity of subtle shapes visible on the surface of the human body, indicating the muscle and bone structure beneath. Make your own versions on the practice pages at the end of the chapter.

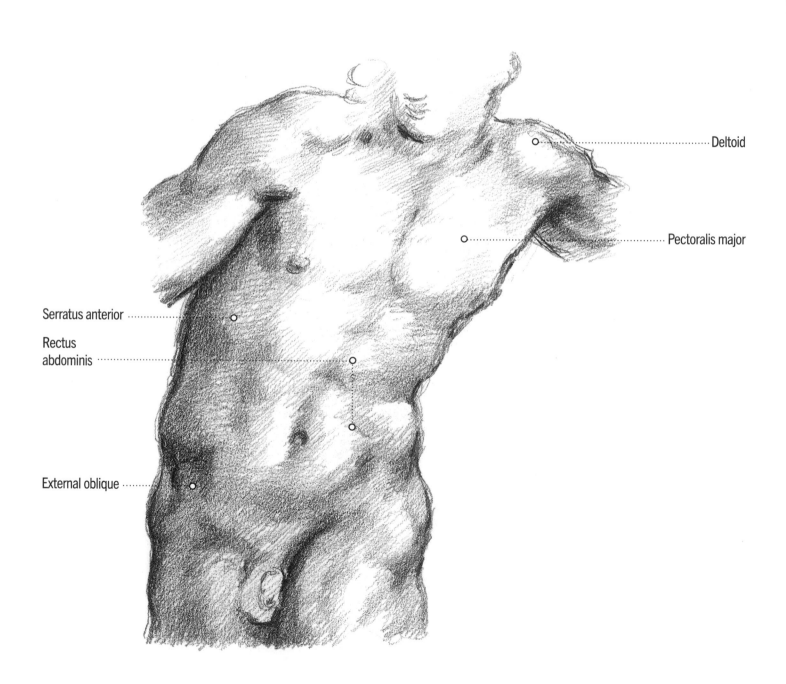

Deltoid

Pectoralis major

Serratus anterior

Rectus abdominis

External oblique

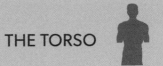

After Raphael (1483–1520)

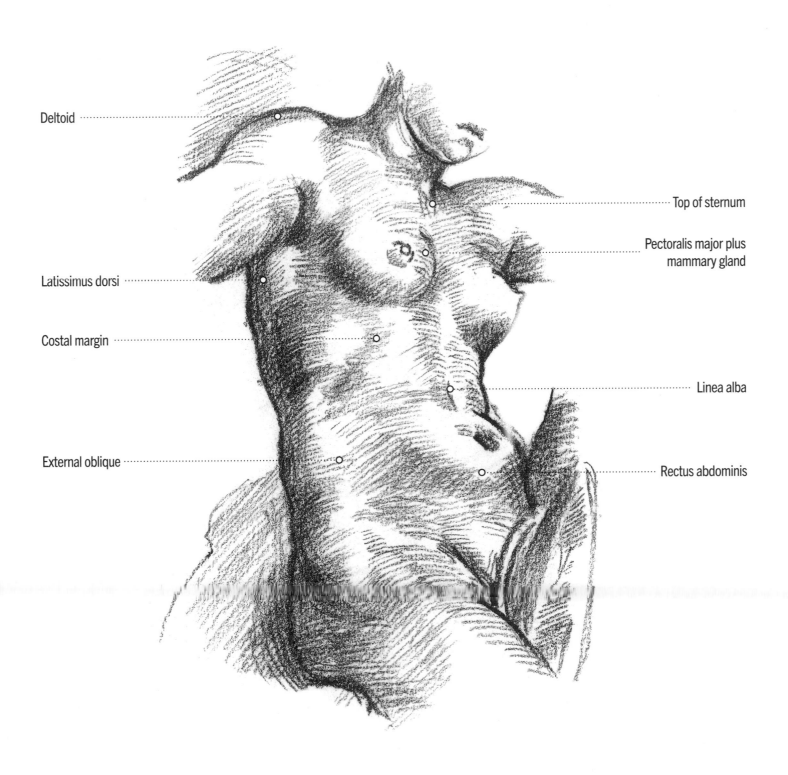

Deltoid

Top of sternum

Pectoralis major plus
mammary gland

Latissimus dorsi

Costal margin

Linea alba

External oblique

Rectus abdominis

After Bartolommeo Passarotti (1529–92)

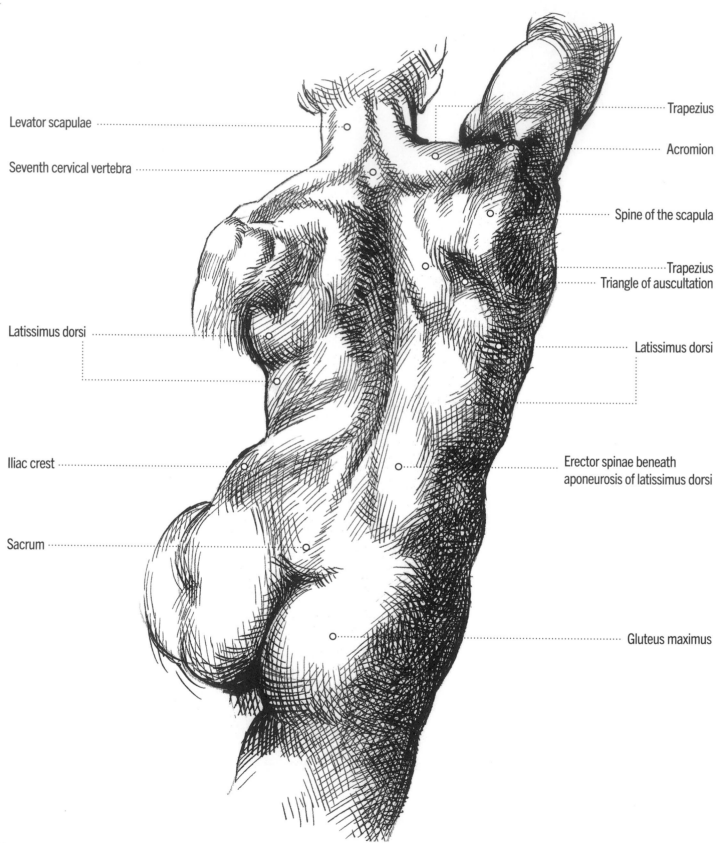

Levator scapulae

Seventh cervical vertebra

Latissimus dorsi

Iliac crest

Sacrum

Trapezius

Acromion

Spine of the scapula

Trapezius
Triangle of auscultation

Latissimus dorsi

Erector spinae beneath
aponeurosis of latissimus dorsi

Gluteus maximus

After Franz von Stuck (1863–1928)

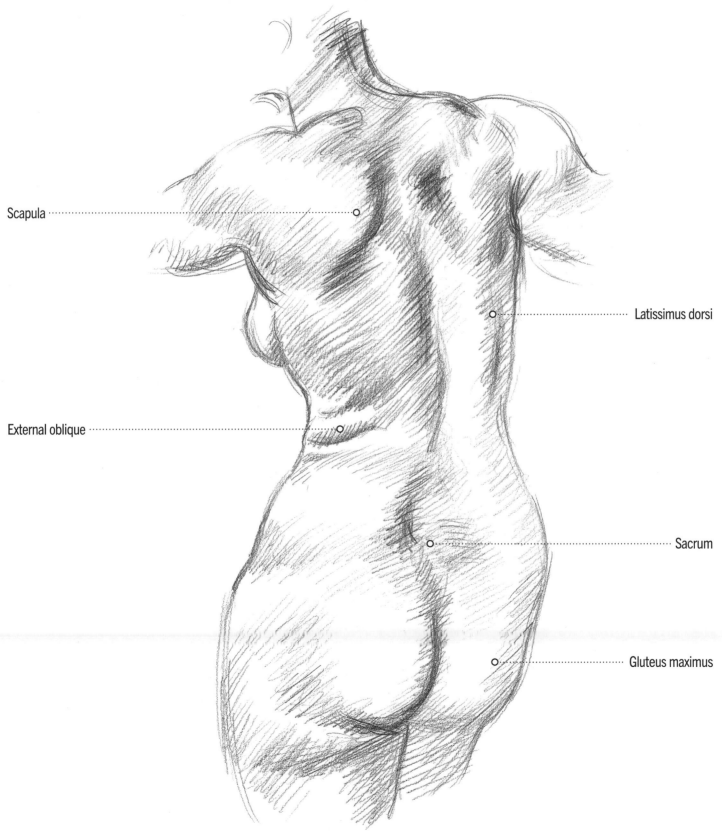

Scapula

Latissimus dorsi

External oblique

Sacrum

Gluteus maximus

THE ARMS AND HANDS

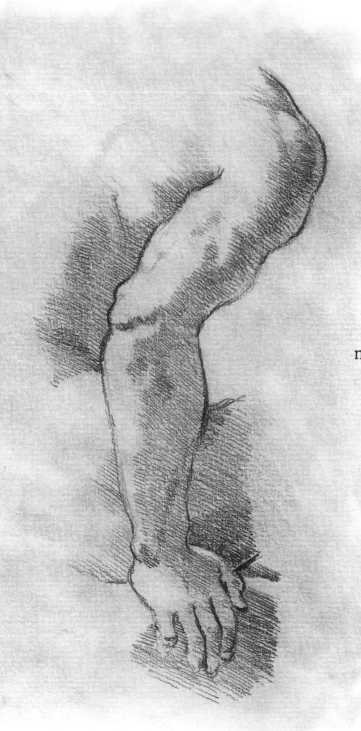

The upper limbs of the body are structured on the basis of the long bones of the humerus, the ulna and the radius, with the additional small bones of the wrist and hand. The design of the arm is very subtle and the hand is so flexible and adaptable that almost any movement in any direction is possible. These are the limbs that allow human beings to handle tools, operate machines and do the things that most other animals cannot manage.

The way that the arms work from the shoulders is quite complex and so too is the musculature of the hand; don't be surprised if you find it difficult to retain all the anatomical information. However, as an artist, your main goal is to gain familiarity with the general structure of the arms and hands, so that when you come to draw them,

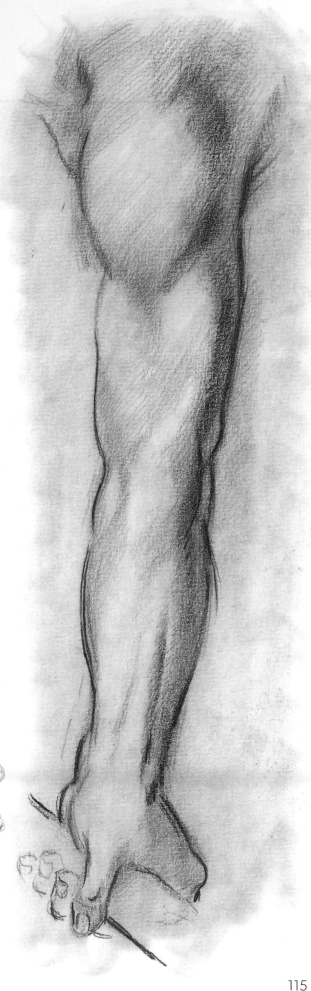

they will be convincing enough to give your drawing some credibility.

As in previous sections of this book, I will first give an outline of the skeleton, then the muscles that surround the bone structure, followed by the surface view of the limb. The complex structure of the hand is examined separately, followed by drawings of the arms and hands engaged in various movements. You can help your understanding by flexing and relaxing the muscles in your own arms, and by studying your own hand.

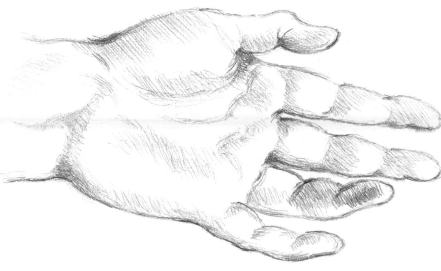

SKELETON OF THE ARM AND HAND
Front view

The bone structure of the arm appears quite straightforward at first glance. However, the areas of the shoulder and the wrist are quite complex and help to allow the many movements of the limb.

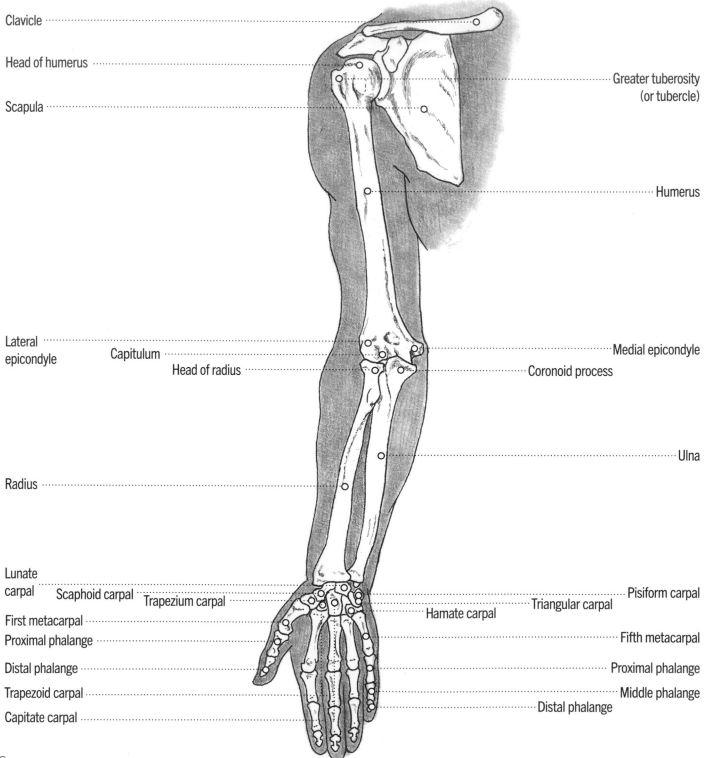

Clavicle

Head of humerus

Scapula

Greater tuberosity (or tubercle)

Humerus

Lateral epicondyle

Capitulum

Head of radius

Medial epicondyle

Coronoid process

Ulna

Radius

Lunate carpal

Scaphoid carpal

Trapezium carpal

Pisiform carpal

Triangular carpal

Hamate carpal

First metacarpal

Proximal phalange

Fifth metacarpal

Distal phalange

Proximal phalange

Trapezoid carpal

Middle phalange

Capitate carpal

Distal phalange

SKELETON OF THE ARM AND HAND
Back view

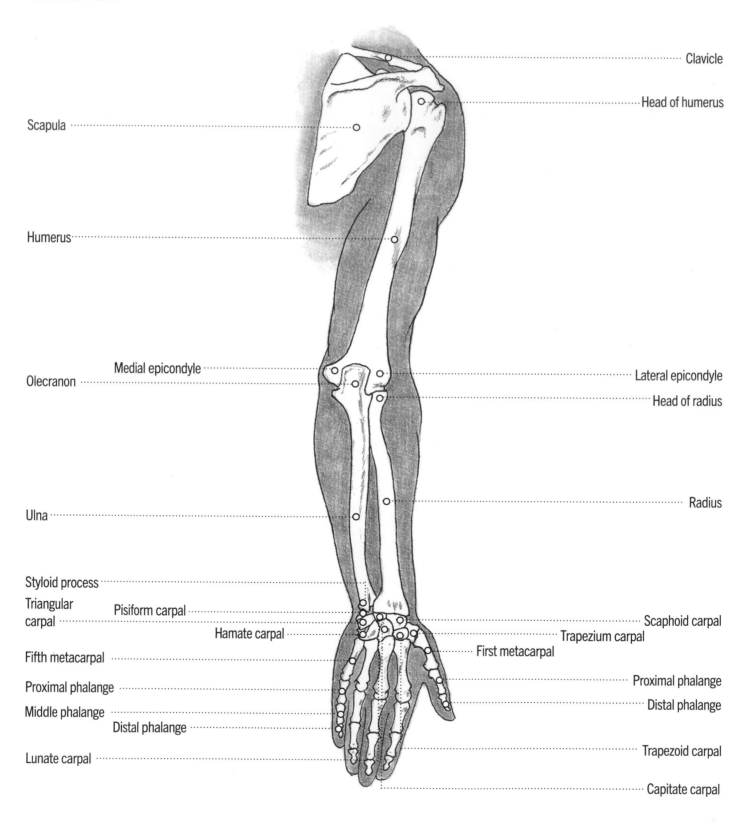

Clavicle

Head of humerus

Scapula

Humerus

Medial epicondyle

Lateral epicondyle

Olecranon

Head of radius

Ulna

Radius

Styloid process

Triangular
carpal

Pisiform carpal

Scaphoid carpal

Hamate carpal

Trapezium carpal

Fifth metacarpal

First metacarpal

Proximal phalange

Proximal phalange

Middle phalange

Distal phalange

Distal phalange

Lunate carpal

Trapezoid carpal

Capitate carpal

MUSCLES OF THE ARM AND HAND
Front view

Notice the complexity of the interleaving muscles around the shoulder and elbow, and the long strands of tendons passing through the wrist. The bone structure only appears at the point of the shoulder, the elbow and the wrist, but of course on the hand, the bones of the fingers are more obvious.

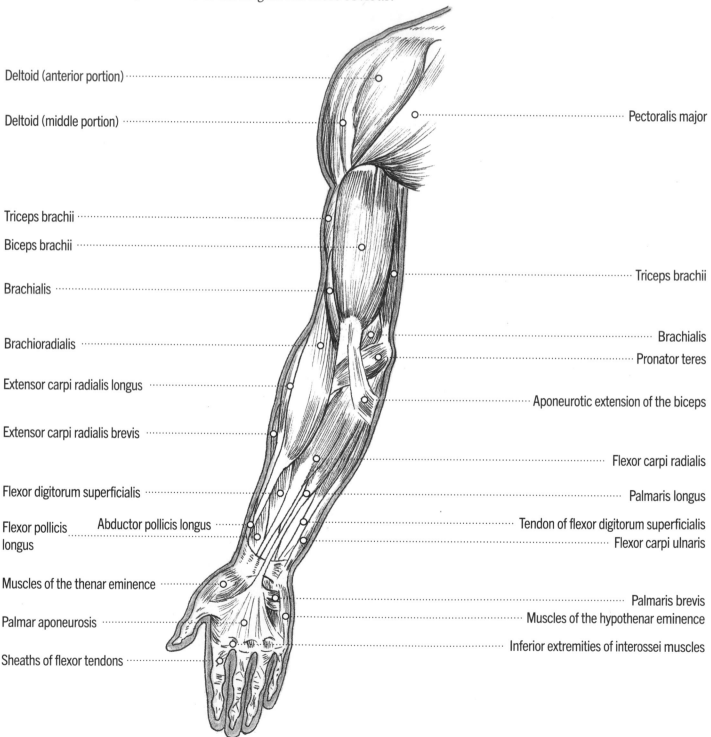

Deltoid (anterior portion)

Deltoid (middle portion)

Triceps brachii

Biceps brachii

Brachialis

Brachioradialis

Extensor carpi radialis longus

Extensor carpi radialis brevis

Flexor digitorum superficialis

Flexor pollicis longus Abductor pollicis longus

Muscles of the thenar eminence

Palmar aponeurosis

Sheaths of flexor tendons

Pectoralis major

Triceps brachii

Brachialis

Pronator teres

Aponeurotic extension of the biceps

Flexor carpi radialis

Palmaris longus

Tendon of flexor digitorum superficialis

Flexor carpi ulnaris

Palmaris brevis

Muscles of the hypothenar eminence

Inferior extremities of interossei muscles

MUSCLES OF THE ARM AND HAND
Back view

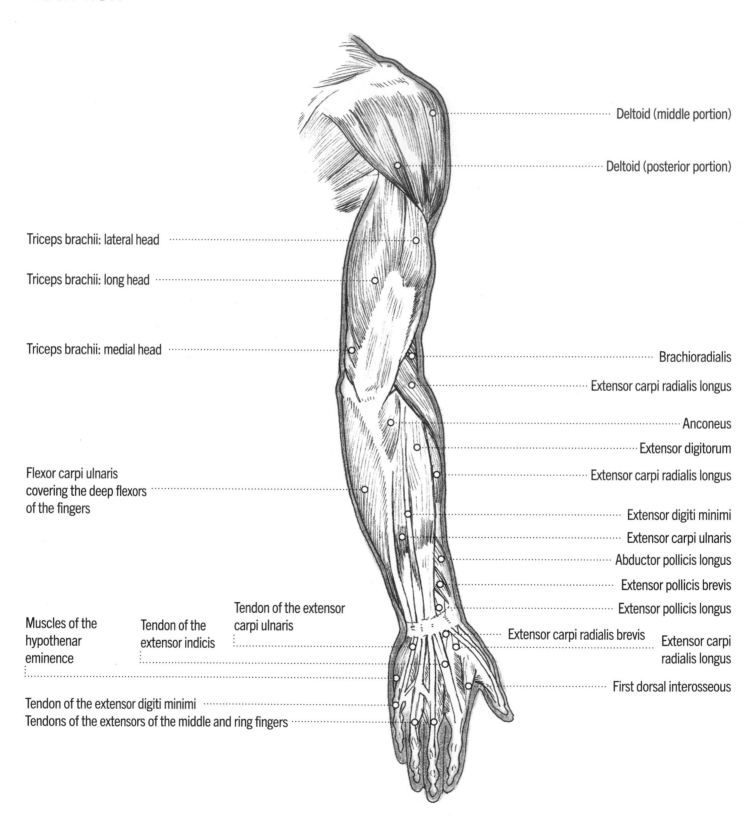

Deltoid (middle portion)

Deltoid (posterior portion)

Triceps brachii: lateral head

Triceps brachii: long head

Triceps brachii: medial head

Brachioradialis

Extensor carpi radialis longus

Anconeus

Extensor digitorum

Extensor carpi radialis longus

Flexor carpi ulnaris covering the deep flexors of the fingers

Extensor digiti minimi

Extensor carpi ulnaris

Abductor pollicis longus

Extensor pollicis brevis

Extensor pollicis longus

Tendon of the extensor carpi ulnaris

Muscles of the hypothenar eminence

Tendon of the extensor indicis

Extensor carpi radialis brevis

Extensor carpi radialis longus

First dorsal interosseous

Tendon of the extensor digiti minimi
Tendons of the extensors of the middle and ring fingers

MUSCLES OF THE ARM AND HAND
Side view, external aspect

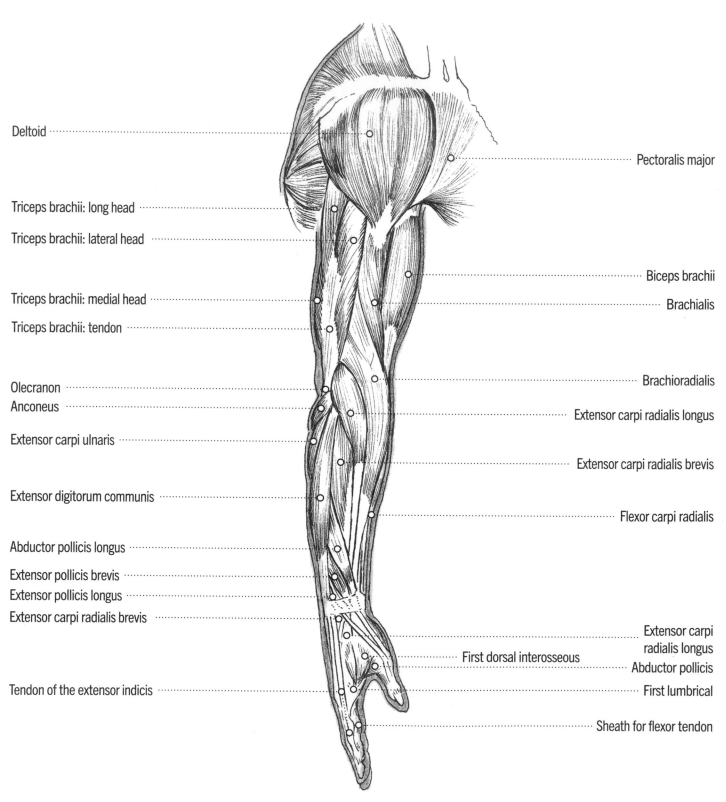

Deltoid

Triceps brachii: long head

Triceps brachii: lateral head

Triceps brachii: medial head

Triceps brachii: tendon

Olecranon

Anconeus

Extensor carpi ulnaris

Extensor digitorum communis

Abductor pollicis longus

Extensor pollicis brevis

Extensor pollicis longus

Extensor carpi radialis brevis

Tendon of the extensor indicis

Pectoralis major

Biceps brachii

Brachialis

Brachioradialis

Extensor carpi radialis longus

Extensor carpi radialis brevis

Flexor carpi radialis

Extensor carpi radialis longus

First dorsal interosseous

Abductor pollicis

First lumbrical

Sheath for flexor tendon

MUSCLES OF THE ARM AND HAND
Side view, internal aspect

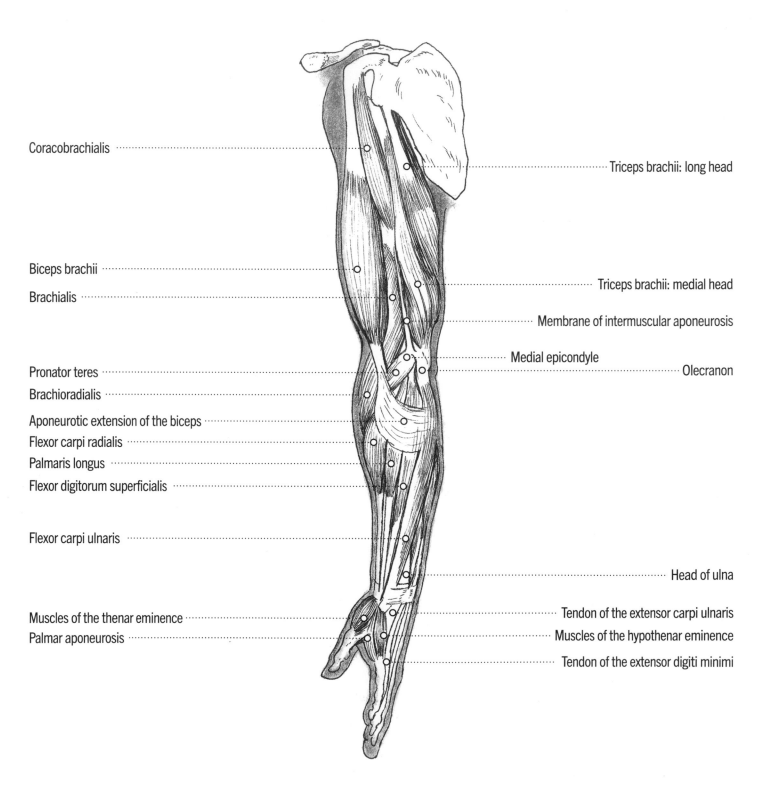

Coracobrachialis

Biceps brachii

Brachialis

Pronator teres

Brachioradialis

Aponeurotic extension of the biceps

Flexor carpi radialis

Palmaris longus

Flexor digitorum superficialis

Flexor carpi ulnaris

Muscles of the thenar eminence

Palmar aponeurosis

Triceps brachii: long head

Triceps brachii: medial head

Membrane of intermuscular aponeurosis

Medial epicondyle

Olecranon

Head of ulna

Tendon of the extensor carpi ulnaris

Muscles of the hypothenar eminence

Tendon of the extensor digiti minimi

SURFACE OF THE MALE ARM AND HAND
Palm-up and palm-down views

When the arm is stretched out horizontally, we can see the shapes of the larger muscles at the surface of the limb. Here we look at the outstretched arm from two angles: with the palm facing up (supine view) and with the palm facing down (prone view).

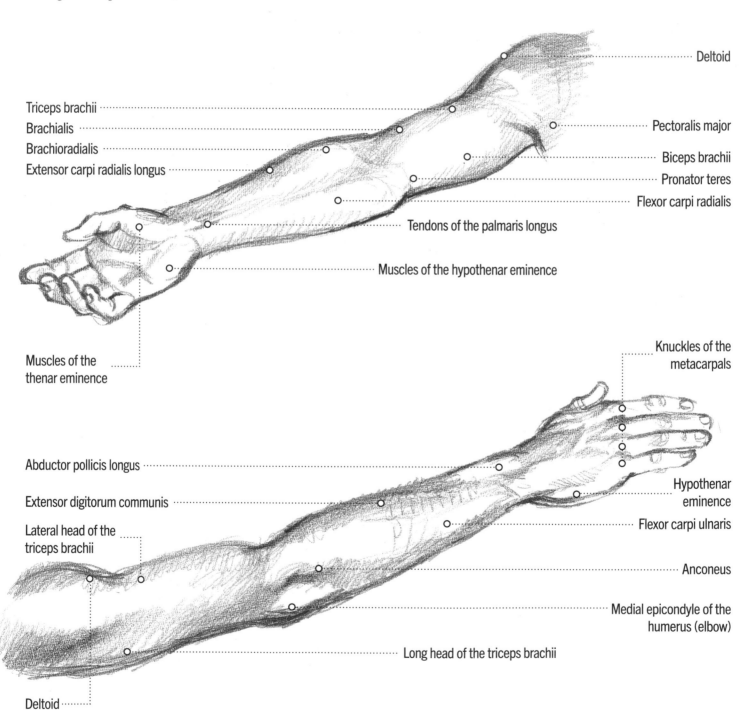

Deltoid

Triceps brachii

Brachialis

Brachioradialis

Extensor carpi radialis longus

Pectoralis major

Biceps brachii

Pronator teres

Flexor carpi radialis

Tendons of the palmaris longus

Muscles of the hypothenar eminence

Muscles of the thenar eminence

Knuckles of the metacarpals

Abductor pollicis longus

Extensor digitorum communis

Lateral head of the triceps brachii

Hypothenar eminence

Flexor carpi ulnaris

Anconeus

Medial epicondyle of the humerus (elbow)

Long head of the triceps brachii

Deltoid

SURFACE OF THE FEMALE ARM AND HAND
Palm-up and palm-down views

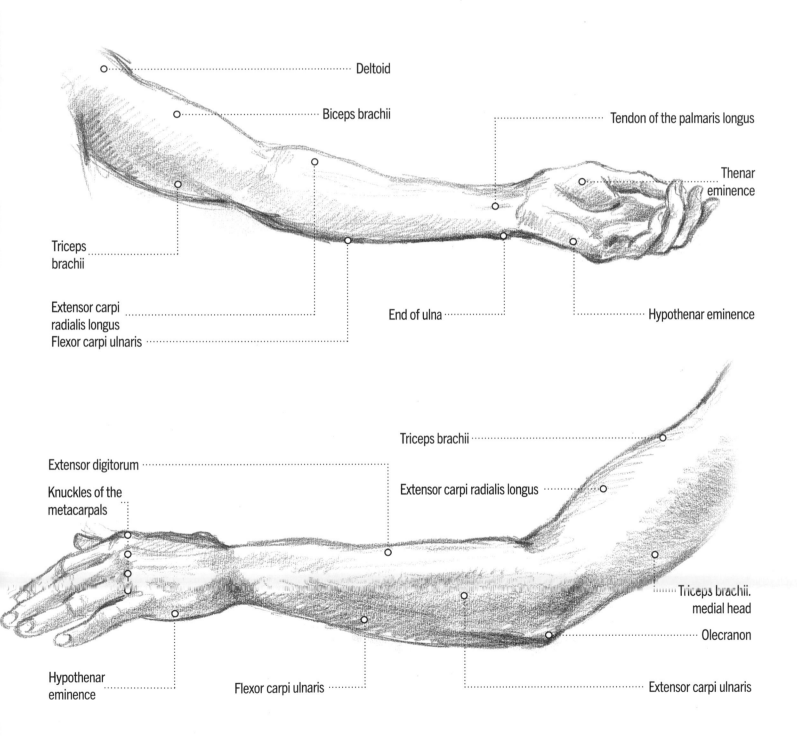

Deltoid

Biceps brachii

Tendon of the palmaris longus

Thenar eminence

Triceps brachii

Extensor carpi radialis longus

Flexor carpi ulnaris

End of ulna

Hypothenar eminence

Triceps brachii

Extensor digitorum

Knuckles of the metacarpals

Extensor carpi radialis longus

Triceps brachii. medial head

Olecranon

Hypothenar eminence

Flexor carpi ulnaris

Extensor carpi ulnaris

THE ARM IN MOVEMENT
Flexing

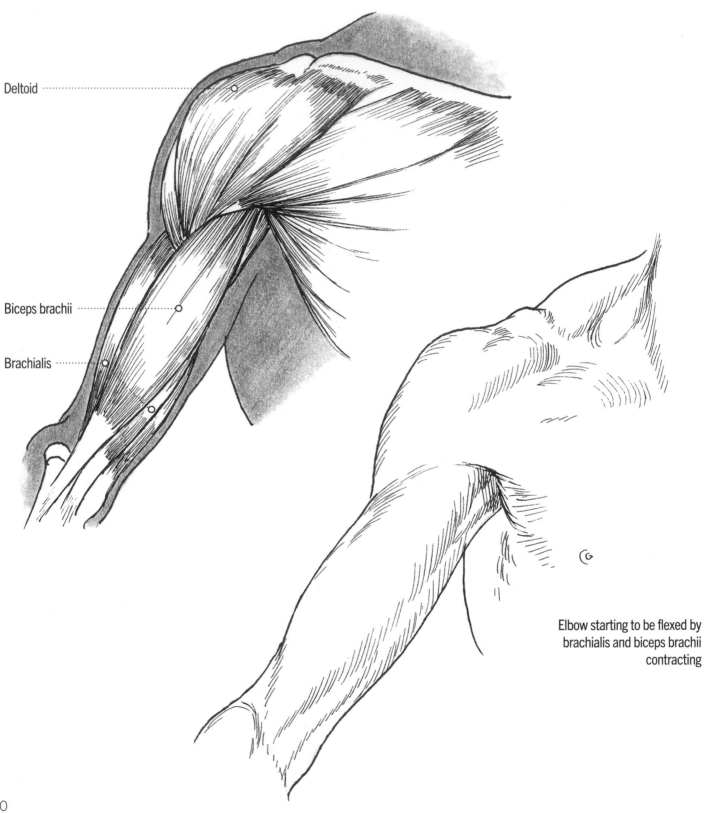

Deltoid

Biceps brachii

Brachialis

Elbow starting to be flexed by
brachialis and biceps brachii
contracting

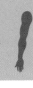

Flexing whole arm

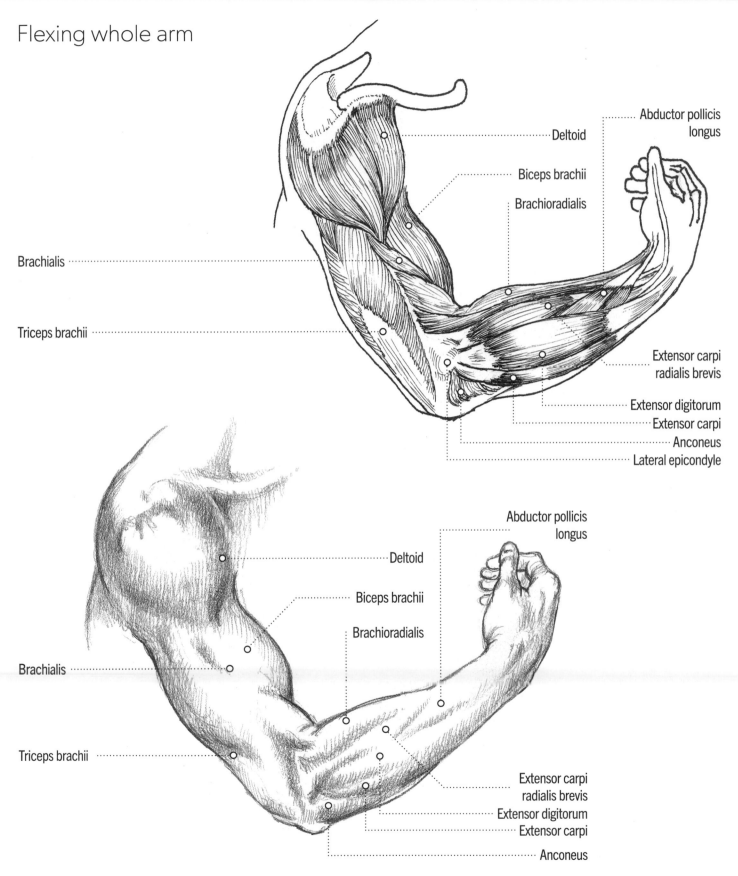

Deltoid

Biceps brachii

Brachioradialis

Abductor pollicis
longus

Brachialis

Triceps brachii

Extensor carpi
radialis brevis

Extensor digitorum

Extensor carpi

Anconeus

Lateral epicondyle

Abductor pollicis
longus

Deltoid

Biceps brachii

Brachioradialis

Brachialis

Triceps brachii

Extensor carpi
radialis brevis

Extensor digitorum

Extensor carpi

Anconeus

SKELETON OF THE HAND
Palm-down view

As well as combined drawings of the arm and hand, I am also dealing with the hand separately because it is such an intricate part of the upper limb. These diagrams of the bones of the hand seen from four different angles are well worth studying, so you will be able to recognize them through the covering of muscle and skin.

**UPPER ROW OF CARPALS
(wrist bones)**

Lunate

Scaphoid

Triquetral (triangular)

Pisiform

Five metacarpals
(palm bones)

First row (proximal) of
5 phalanges (finger bones)

Second row (middle) of 4 phalanges

Third row (distal) of 5 phalanges

• Carpals (wrist bones)
• Metacarpals (palm bones)
• Phalanges (finger bones)

**LOWER ROW OF CARPALS
(wrist bones)**

Capitate

Hamate

Trapezoid

Trapezium
(formed like a saddle
– the thumb sits on it
like a rider on a saddle
and can move back and
forth and to either side)

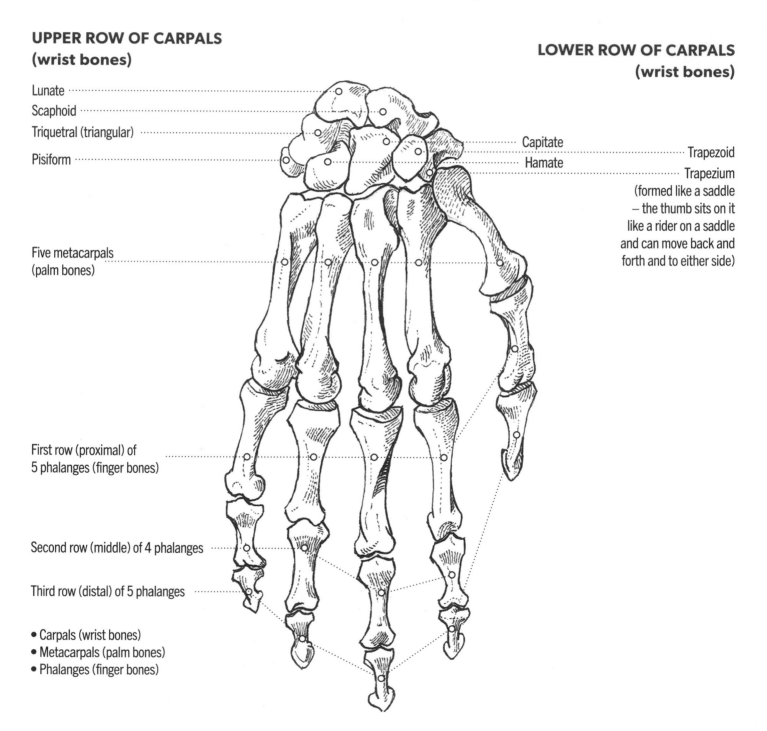

SKELETON OF THE HAND
Palm-up view

**LOWER ROW OF CARPALS
(wrist bones)**

**UPPER ROW OF CARPALS
(wrist bones)**

Trapezium

Capitate

Trapezoid

Hamate

Scaphoid

Lunate

Triquetral (triangular)

Pisiform

Five metacarpals
(palm bones)

First row (proximal) of 5
phalanges (finger bones)

Second row (middle)
of 4 phalanges

Third row (distal)
of 5 phalanges

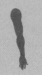

SKELETON OF THE HAND
Little finger (ulnar) side

Note that the thumb is made up of just two phalanges – proximal and distal. Unlike the four fingers, it has no middle phalange.

Pisiform

Triangular

Hamate

Capitate

Five metacarpals (palm bones)

First row (proximal) of 5 phalanges (finger bones)

Second row (middle) of 4 phalanges

Third row (distal) of 5 phalanges

SKELETON OF THE HAND
Thumb (radial) side

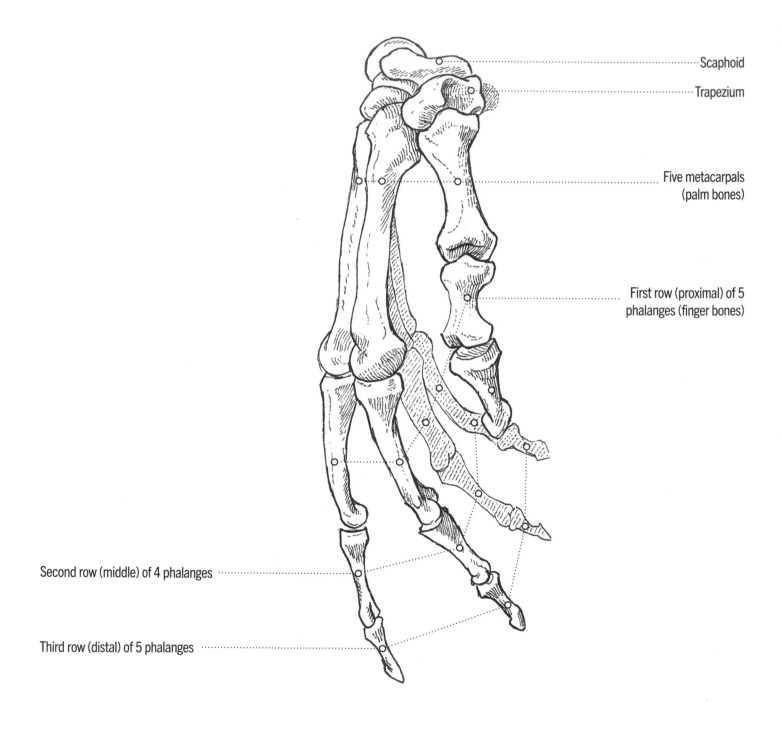

Scaphoid

Trapezium

Five metacarpals
(palm bones)

First row (proximal) of 5
phalanges (finger bones)

Second row (middle) of 4 phalanges

Third row (distal) of 5 phalanges

MUSCLES OF THE HAND
Palm-down view

The hand, being the part of the body which sets human skills apart from all the other animals, is a very complex structure of overlapping muscles and tendons. These allow the fingers and thumb to perform very complicated and subtle motions, enabling humans to construct and handle an enormous number of tools (like the pencil), extending their range of activities far beyond other species.

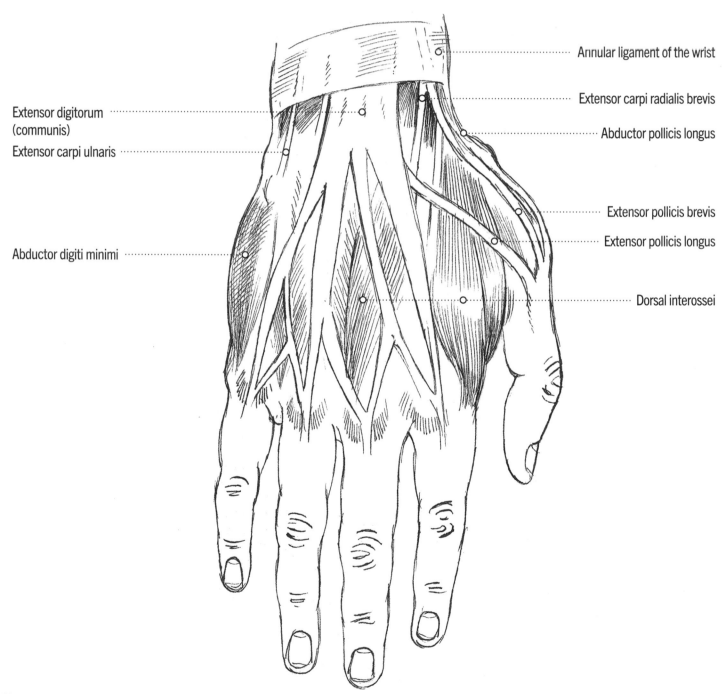

Extensor digitorum (communis)

Extensor carpi ulnaris

Abductor digiti minimi

Annular ligament of the wrist

Extensor carpi radialis brevis

Abductor pollicis longus

Extensor pollicis brevis

Extensor pollicis longus

Dorsal interossei

MUSCLES OF THE HAND
Palm-up view

The main difficulty in drawing the muscles of the hand is that the most significant ones are situated in the arm and are connected to the hand by long tendons. There are some muscles in the hand itself, but they tend to be hidden under the surface pads of the palm and so are not very evident. The most clearly seen muscles are around the base of the thumb and on the opposite edge of the palm.

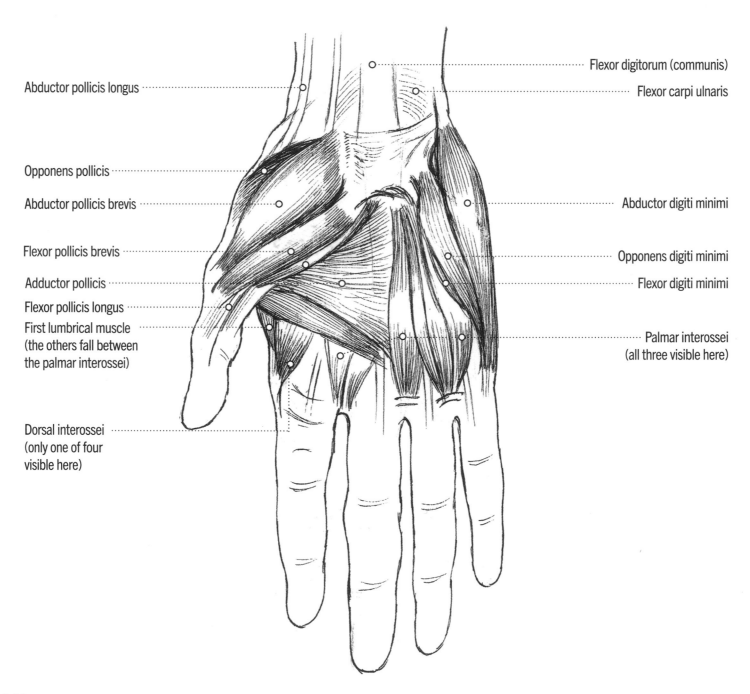

Abductor pollicis longus

Opponens pollicis

Abductor pollicis brevis

Flexor pollicis brevis

Adductor pollicis

Flexor pollicis longus

First lumbrical muscle
(the others fall between
the palmar interossei)

Dorsal interossei
(only one of four
visible here)

Flexor digitorum (communis)

Flexor carpi ulnaris

Abductor digiti minimi

Opponens digiti minimi

Flexor digiti minimi

Palmar interossei
(all three visible here)

SURFACE OF THE MALE HAND
Palm-up view

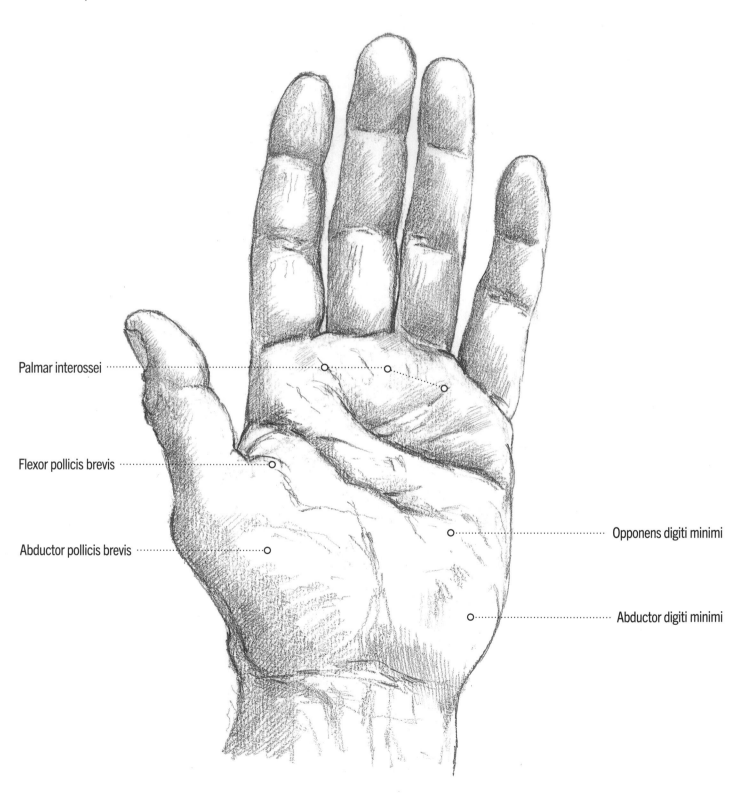

Palmar interossei

Flexor pollicis brevis

Abductor pollicis brevis

Opponens digiti minimi

Abductor digiti minimi

SURFACE OF THE MALE HAND
Palm-down view

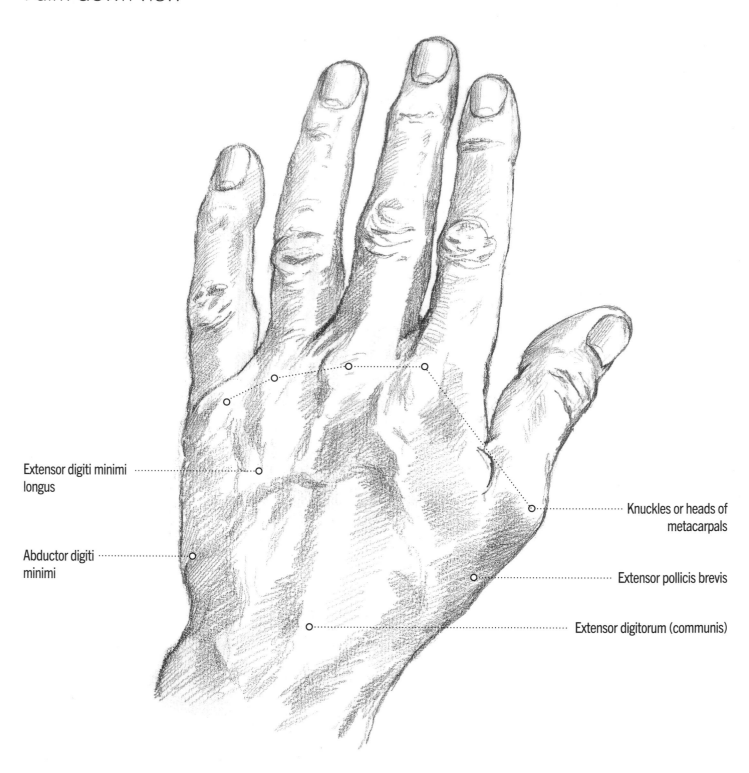

Extensor digiti minimi longus

Abductor digiti minimi

Knuckles or heads of metacarpals

Extensor pollicis brevis

Extensor digitorum (communis)

SURFACE OF THE FEMALE HAND
Palm-down view

The female hand is usually softer-looking and with more tapered fingers than the male. The knuckles of the male hand tend to look more prominent and the fingers are squarer in shape. But don't take this for granted in your drawing: sometimes this typical shape can be reversed.

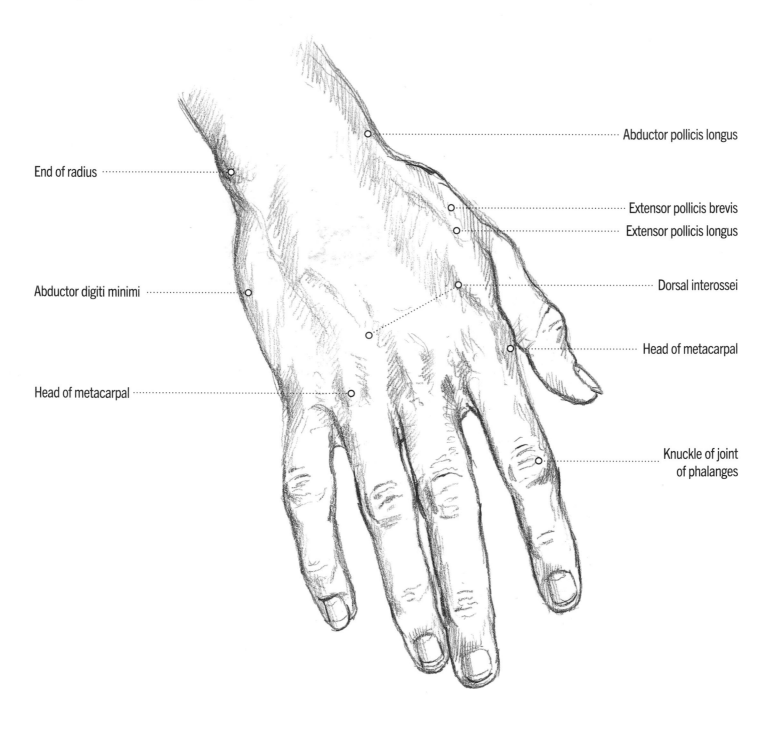

Abductor pollicis longus

End of radius

Extensor pollicis brevis

Extensor pollicis longus

Abductor digiti minimi

Dorsal interossei

Head of metacarpal

Head of metacarpal

Knuckle of joint of phalanges

SURFACE OF THE FEMALE HAND
Palm-up view

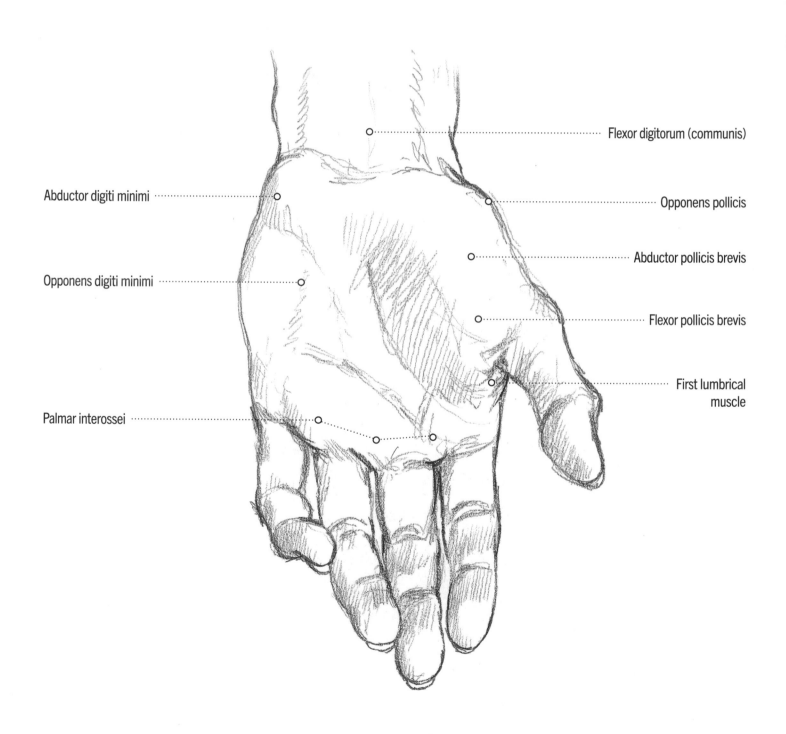

Flexor digitorum (communis)

Abductor digiti minimi

Opponens pollicis

Abductor pollicis brevis

Opponens digiti minimi

Flexor pollicis brevis

First lumbrical muscle

Palmar interossei

RANGE OF HAND MOVEMENT

It is well worth studying the hand in detail, as its movements can be very expressive and capturing them accurately will add a lot to your drawing.

The movements of the hand are mainly produced higher up the arm, the hand itself only having a few muscles. When you move your hand, notice the movements in the muscles of your forearm or upper arm where the action originates. Look out for details, like the pads on the palm of the hand and the front of the fingers which push out when the hand is closed into a fist.

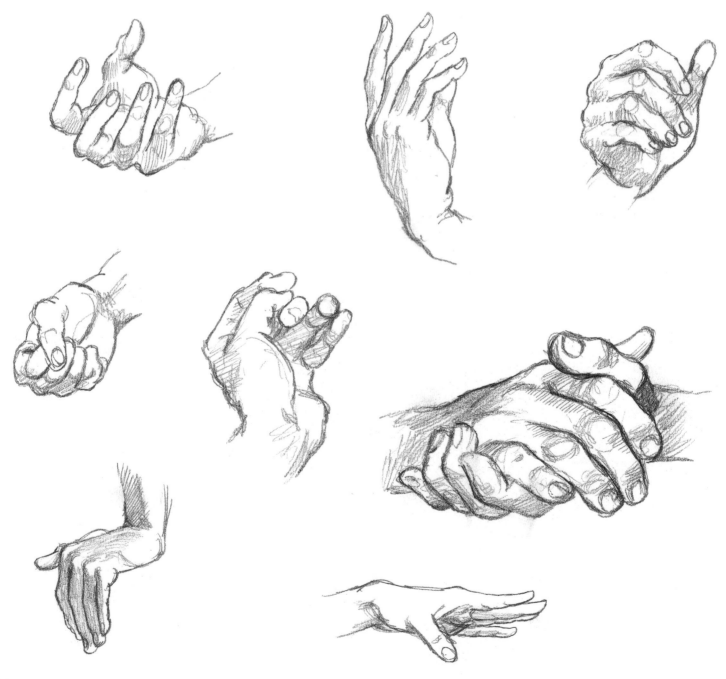

MORE PRECISE HAND MOVEMENTS

Holding a pencil

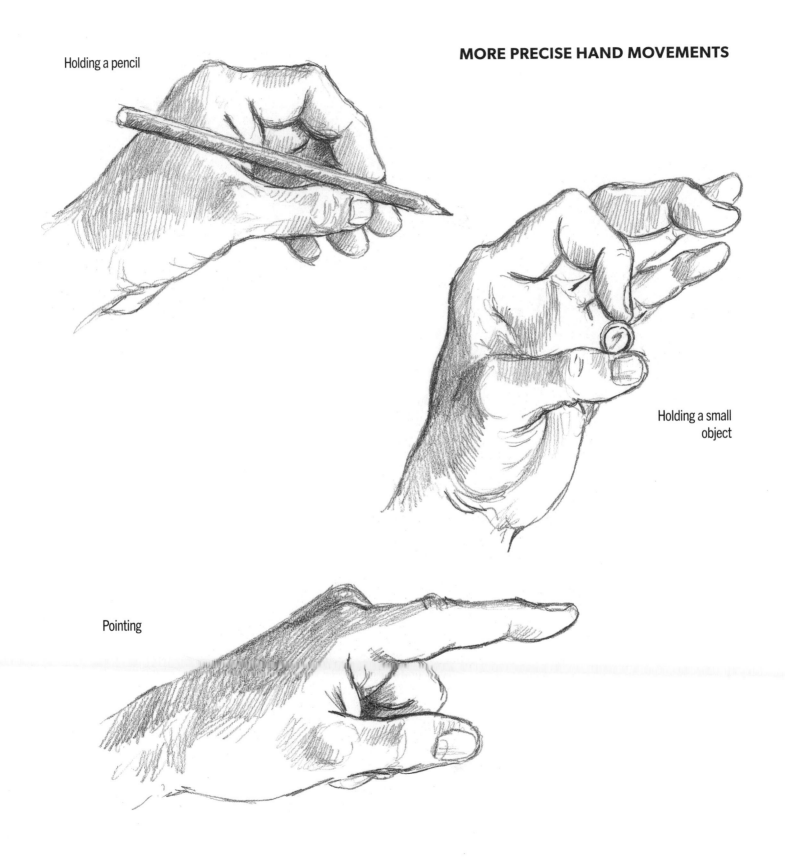

Holding a small object

Pointing

155

What is clear is how flexible and sensitive the hands are, being able to make large, strong movements and detailed, precise ones. The following range of movements are just a few of the hundreds of actions the hand can perform.

Pushing

Holding

Holding

Clenching

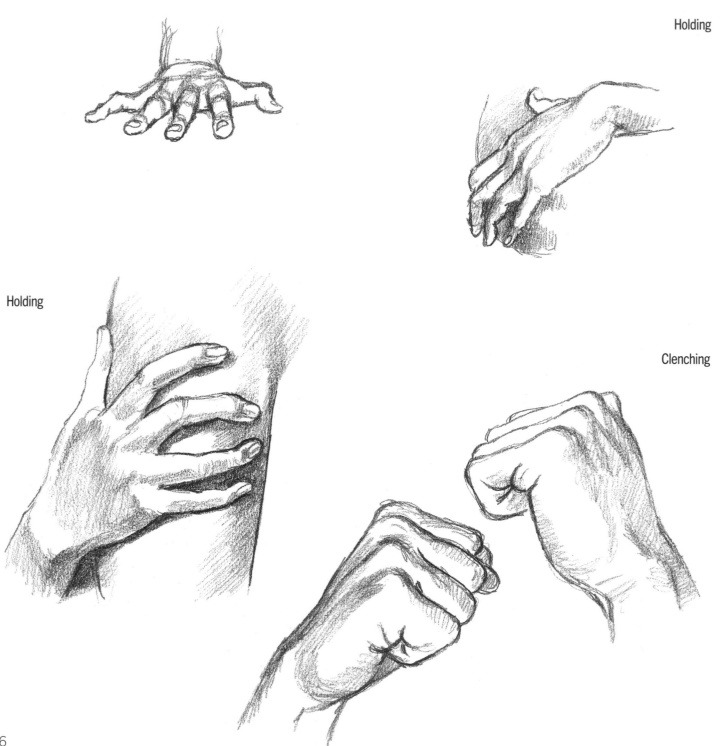

Clutching

Grasping

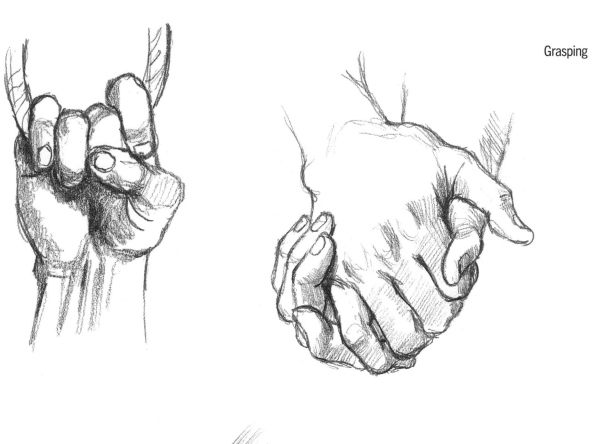

Holding and arranging hair

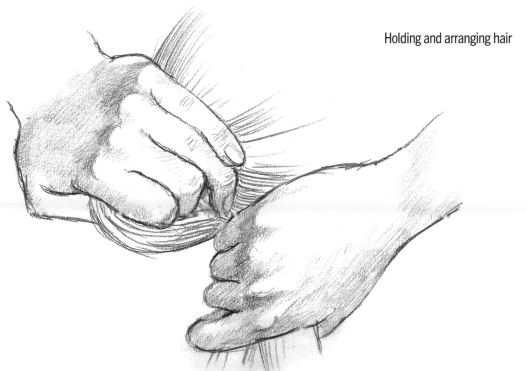

DRAWINGS OF ARMS AND HANDS BY MASTER ARTISTS

Over the following pages I have drawn several images of the arm and hand after a range of master artists. Note the difference in muscularity between portrayals of the male and female arm.

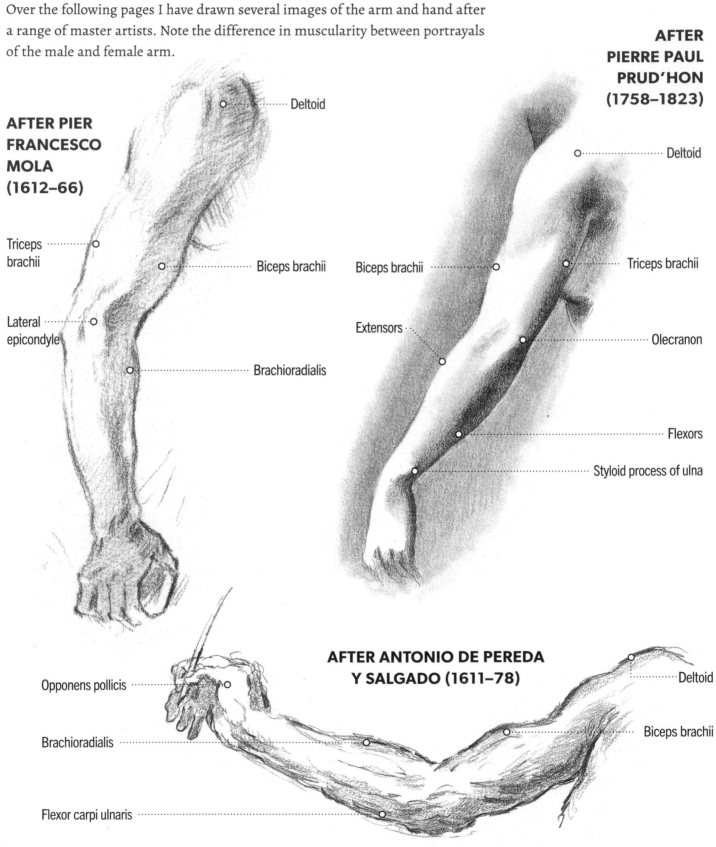

AFTER PIERRE PAUL PRUD'HON (1758–1823)

Deltoid

AFTER PIER FRANCESCO MOLA (1612–66)

Deltoid

Triceps brachii

Biceps brachii

Lateral epicondyle

Brachioradialis

Biceps brachii

Triceps brachii

Extensors

Olecranon

Flexors

Styloid process of ulna

AFTER ANTONIO DE PEREDA Y SALGADO (1611–78)

Deltoid

Opponens pollicis

Biceps brachii

Brachioradialis

Flexor carpi ulnaris

Four drawings after Michelangelo

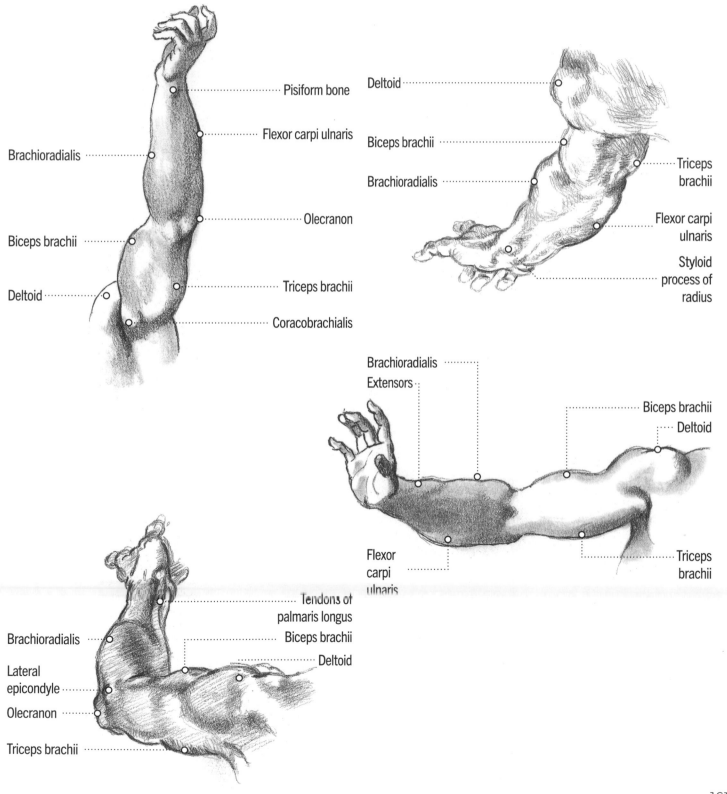

Pisiform bone

Flexor carpi ulnaris

Brachioradialis

Olecranon

Biceps brachii

Triceps brachii

Deltoid

Coracobrachialis

Deltoid

Biceps brachii

Brachioradialis

Triceps brachii

Flexor carpi ulnaris

Styloid process of radius

Brachioradialis
Extensors

Biceps brachii
Deltoid

Flexor carpi ulnaris

Triceps brachii

Tendons of palmaris longus

Biceps brachii

Deltoid

Brachioradialis

Lateral epicondyle

Olecranon

Triceps brachii

AFTER JEAN-ANTOINE WATTEAU (1684–1721)

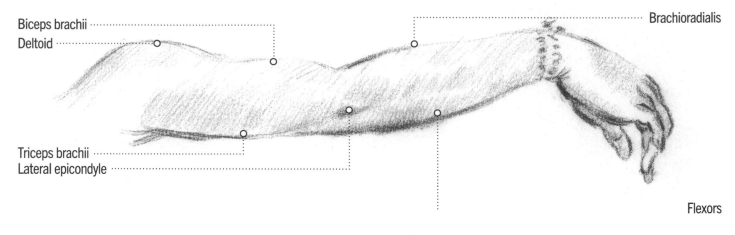

Biceps brachii
Deltoid
Brachioradialis

Triceps brachii
Lateral epicondyle

Flexors

AFTER CHARLES-JOSEPH NATOIRE (1700–77)

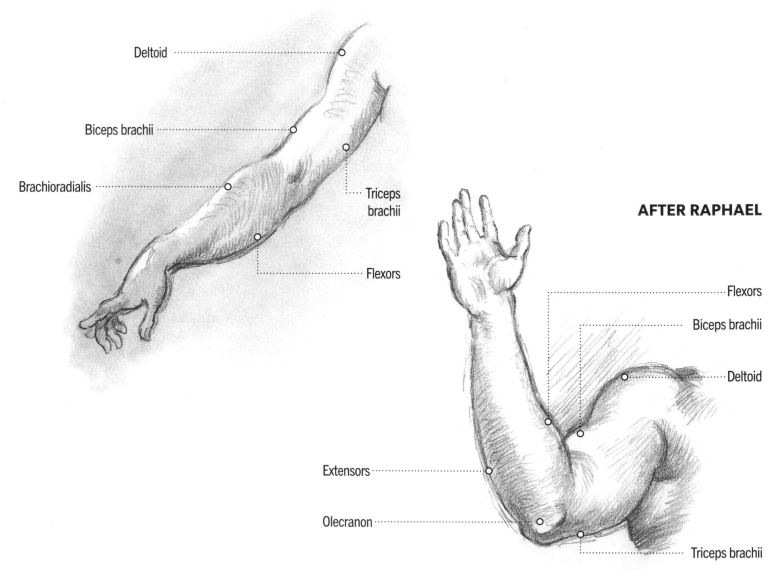

Deltoid

Biceps brachii

Brachioradialis

Triceps brachii

Flexors

AFTER RAPHAEL

Flexors

Biceps brachii

Deltoid

Extensors

Olecranon

Triceps brachii

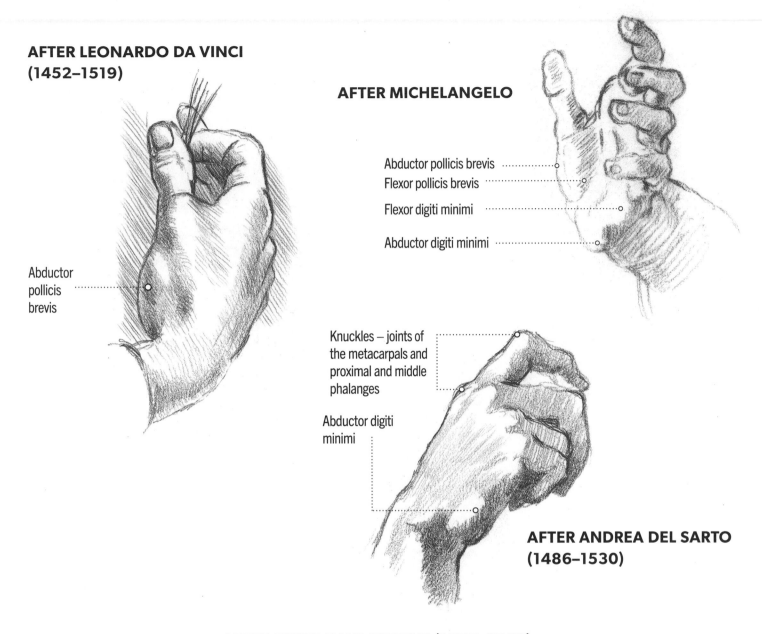

**AFTER LEONARDO DA VINCI
(1452–1519)**

Abductor
pollicis
brevis

AFTER MICHELANGELO

Abductor pollicis brevis

Flexor pollicis brevis

Flexor digiti minimi

Abductor digiti minimi

Knuckles – joints of
the metacarpals and
proximal and middle
phalanges

Abductor digiti
minimi

**AFTER ANDREA DEL SARTO
(1486–1530)**

AFTER PETER PAUL RUBENS (1577–1640)

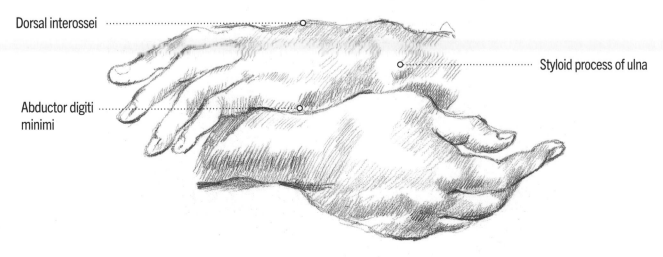

Dorsal interossei

Styloid process of ulna

Abductor digiti
minimi

THE LEGS AND FEET

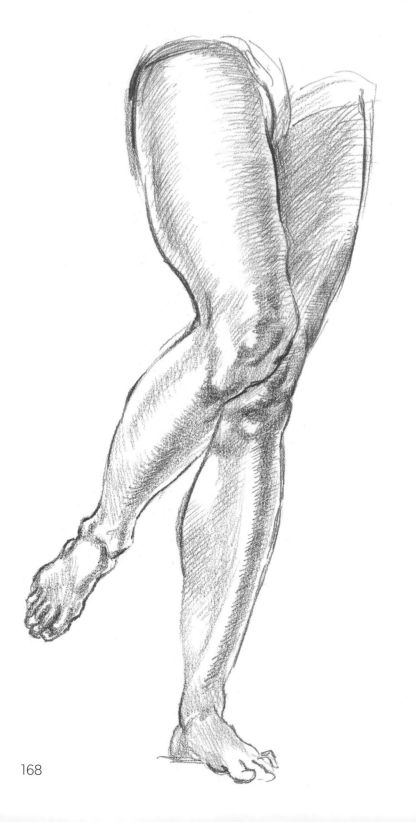

Our lower limbs are probably the most powerful parts of the body, having the largest bones and the strongest muscles. This is no surprise, since the legs not only support the total body weight but also have to propel it along in the world. The legs and feet comprise about half the overall height of the average person.

The knee and ankle joints are just as complex as the elbows and wrists, but because of their weight-bearing facility they are constructed more sturdily. Ankles still have to be quite flexible but the bones of the feet, unlike the hands, form a rather more solid platform. The toes are clearly less dextrous than the fingers, despite being constructed along similar lines.

The lower limbs must combine extreme flexibility with power and their muscles are usually well developed.

The point at which the legs join the torso is immensely important when it comes to the mobility of the body. This means that although the groin and hip area is strongly built and heavily muscled, it is also amazingly supple, as can be seen in the movements of dancers and gymnasts.

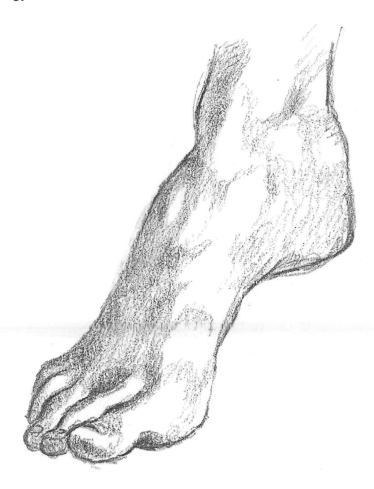

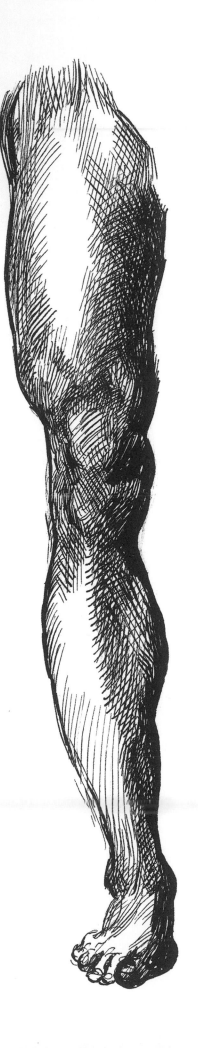

SKELETON OF THE LEG
Front view

The skeleton of the lower limb is composed of noticeably longer, stronger bones than the upper limb. The femur is the longest and largest bone in the human body and is in the classic shape that we think of when we visualize a bone, comprising a powerful straight shaft and bulbous ends which help join it to the bone structures of the hip and knee.

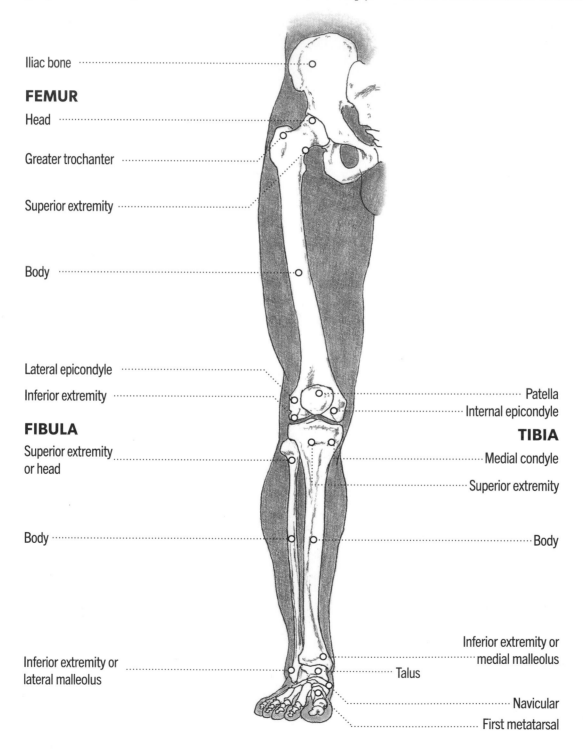

Iliac bone

FEMUR

Head

Greater trochanter

Superior extremity

Body

Lateral epicondyle

Inferior extremity

FIBULA

Superior extremity
or head

Body

Inferior extremity or
lateral malleolus

Patella

Internal epicondyle

TIBIA

Medial condyle

Superior extremity

Body

Inferior extremity or
medial malleolus

Talus

Navicular

First metatarsal

SKELETON OF THE LEG
Back view

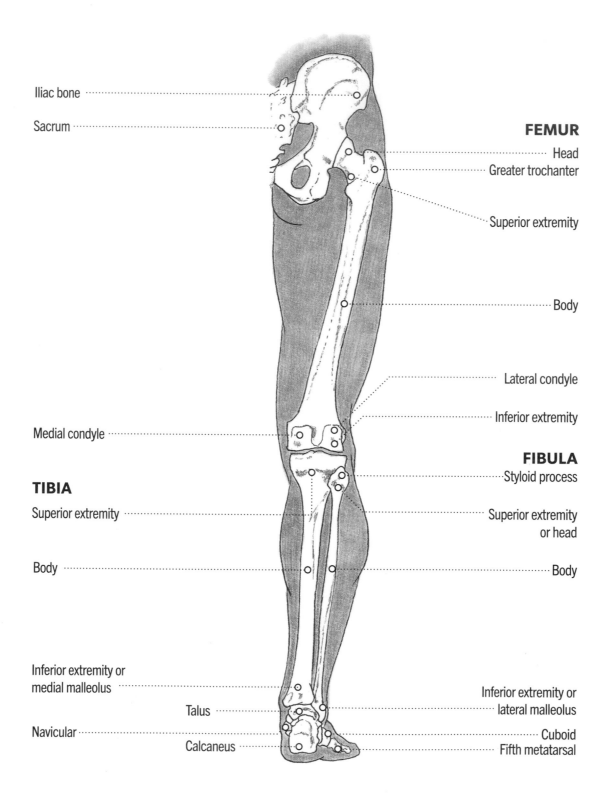

Iliac bone

Sacrum

FEMUR

Head

Greater trochanter

Superior extremity

Body

Lateral condyle

Inferior extremity

Medial condyle

FIBULA

Styloid process

TIBIA

Superior extremity

Superior extremity
or head

Body

Body

Inferior extremity or
medial malleolus

Talus

Inferior extremity or
lateral malleolus

Navicular

Calcaneus

Cuboid

Fifth metatarsal

172

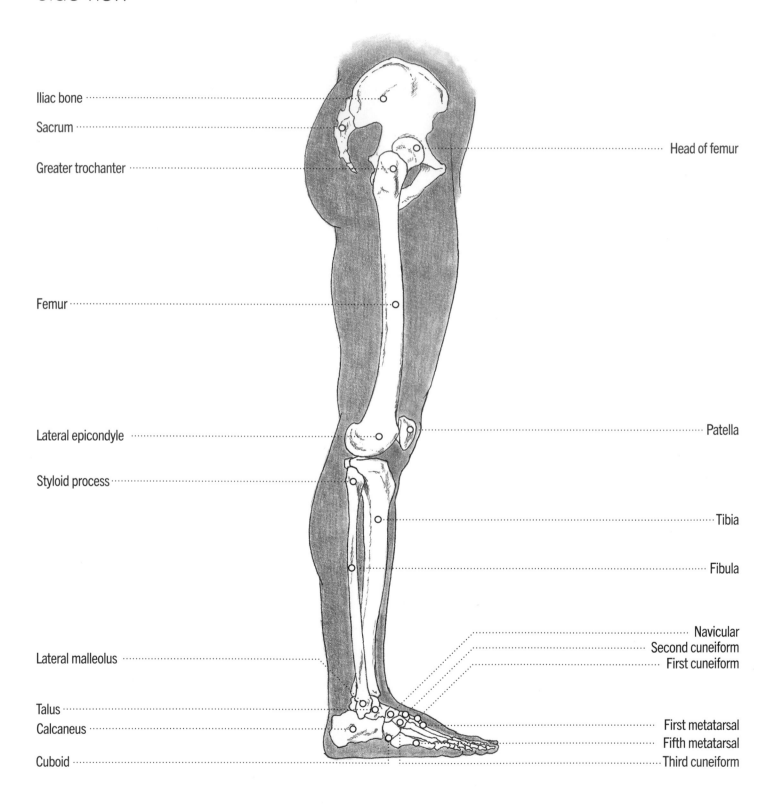

SKELETON OF THE LEG
Side view

Iliac bone

Sacrum

Greater trochanter

Femur

Lateral epicondyle

Styloid process

Lateral malleolus

Talus

Calcaneus

Cuboid

Head of femur

Patella

Tibia

Fibula

Navicular

Second cuneiform

First cuneiform

First metatarsal

Fifth metatarsal

Third cuneiform

MUSCLES OF THE LEG
Front view

Like the upper limbs, the legs are wrapped in long, layered muscles that help to give flexibility. However, because of the increased strength needed to support the rest of the body's weight, the leg muscles tend to be longer and bigger.
 I have included the band of fascia running down the side of the leg over the muscles (the fascia lata and the iliotibial band).

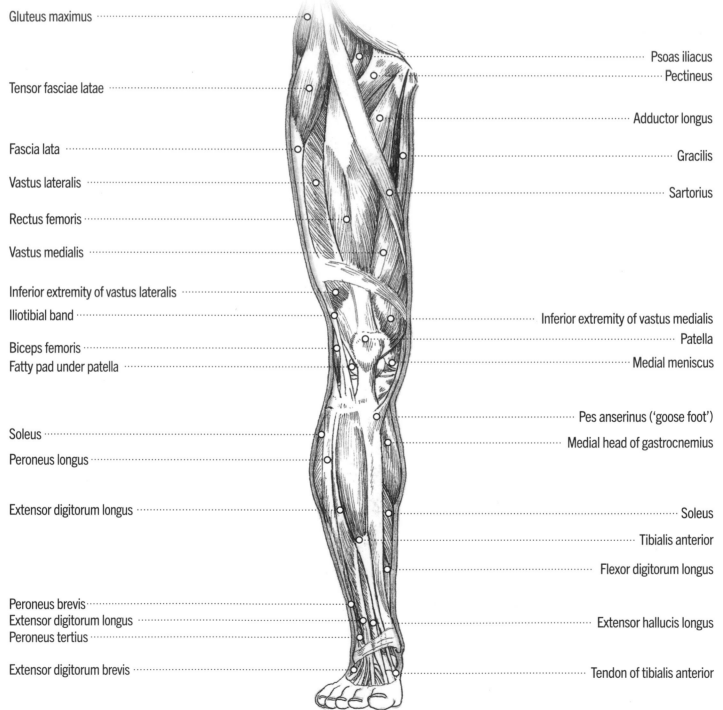

Gluteus maximus

Tensor fasciae latae

Fascia lata

Vastus lateralis

Rectus femoris

Vastus medialis

Inferior extremity of vastus lateralis
Iliotibial band

Biceps femoris
Fatty pad under patella

Soleus
Peroneus longus

Extensor digitorum longus

Peroneus brevis
Extensor digitorum longus
Peroneus tertius

Extensor digitorum brevis

Psoas iliacus
Pectineus

Adductor longus

Gracilis

Sartorius

Inferior extremity of vastus medialis
Patella
Medial meniscus

Pes anserinus ('goose foot')
Medial head of gastrocnemius

Soleus

Tibialis anterior

Flexor digitorum longus

Extensor hallucis longus

Tendon of tibialis anterior

MUSCLES OF THE LEG
Back view

The group of tendons that run down the back of the leg to the knee are collectively known as the hamstrings. These are the tendons of the biceps femoris, the semitendinosus and the semimembranosus.

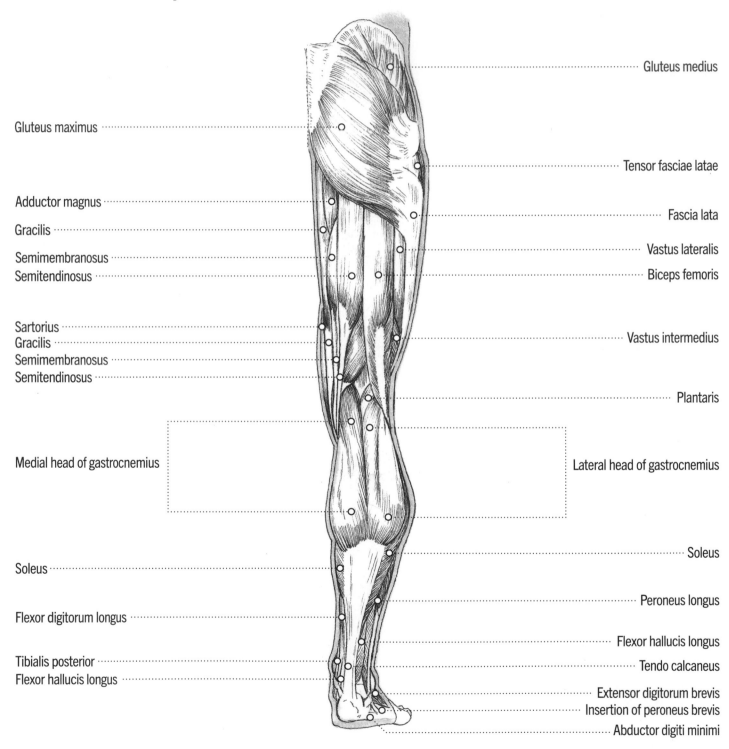

Gluteus medius

Gluteus maximus

Tensor fasciae latae

Adductor magnus

Fascia lata

Gracilis

Vastus lateralis

Semimembranosus

Biceps femoris

Semitendinosus

Sartorius

Vastus intermedius

Gracilis

Semimembranosus

Semitendinosus

Plantaris

Medial head of gastrocnemius

Lateral head of gastrocnemius

Soleus

Soleus

Peroneus longus

Flexor digitorum longus

Flexor hallucis longus

Tibialis posterior

Tendo calcaneus

Flexor hallucis longus

Extensor digitorum brevis

Insertion of peroneus brevis

Abductor digiti minimi

MUSCLES OF THE LEG
Side view, external aspect

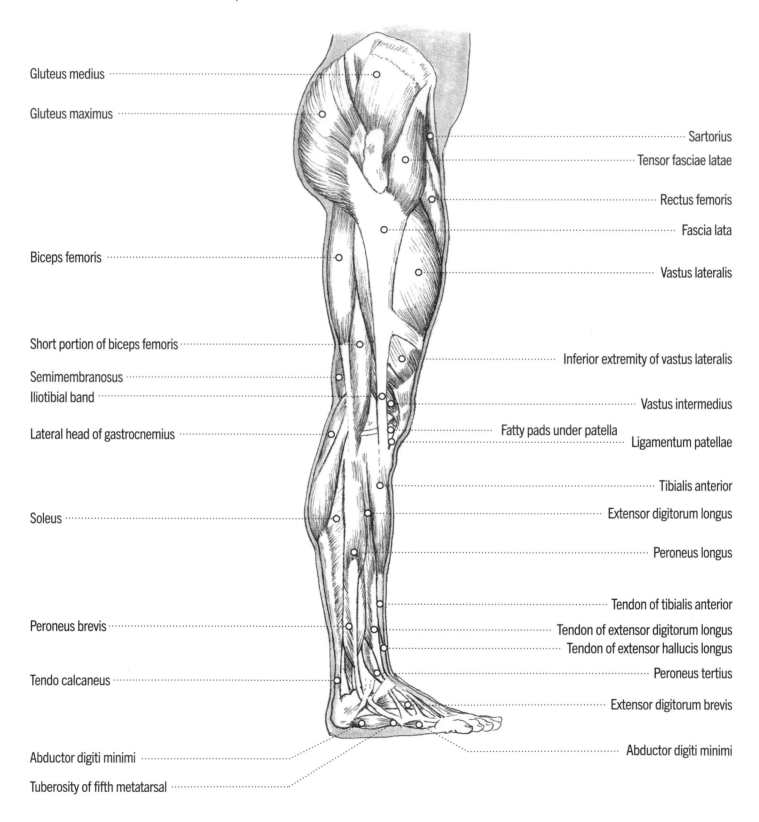

Gluteus medius

Gluteus maximus

Biceps femoris

Short portion of biceps femoris

Semimembranosus

Iliotibial band

Lateral head of gastrocnemius

Soleus

Peroneus brevis

Tendo calcaneus

Abductor digiti minimi

Tuberosity of fifth metatarsal

Sartorius

Tensor fasciae latae

Rectus femoris

Fascia lata

Vastus lateralis

Inferior extremity of vastus lateralis

Vastus intermedius

Fatty pads under patella

Ligamentum patellae

Tibialis anterior

Extensor digitorum longus

Peroneus longus

Tendon of tibialis anterior

Tendon of extensor digitorum longus

Tendon of extensor hallucis longus

Peroneus tertius

Extensor digitorum brevis

Abductor digiti minimi

MUSCLES OF THE LEG
Side view, internal aspect

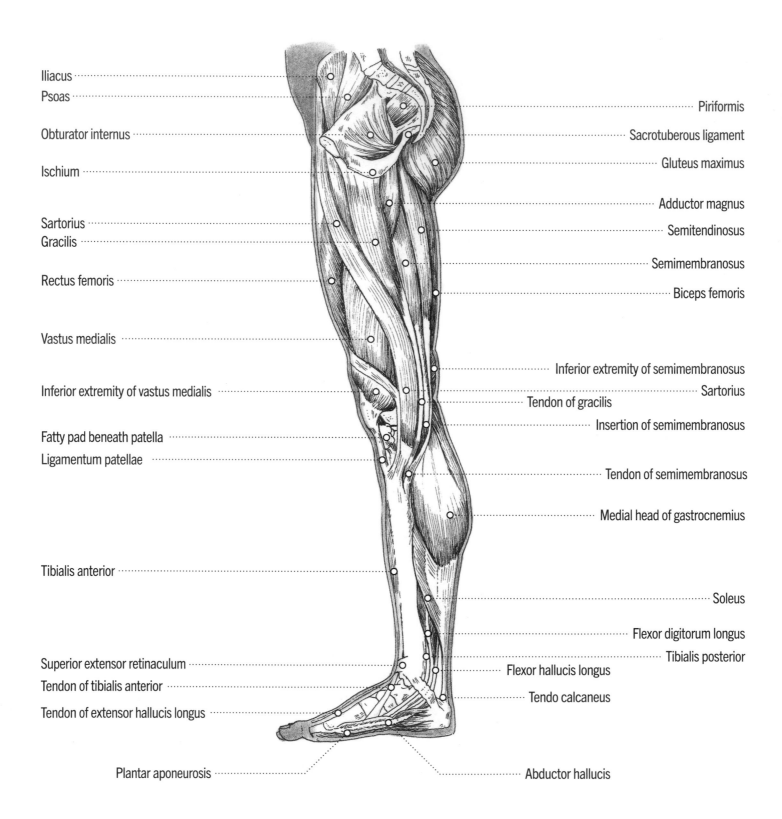

Iliacus

Psoas

Obturator internus

Ischium

Sartorius

Gracilis

Rectus femoris

Vastus medialis

Inferior extremity of vastus medialis

Fatty pad beneath patella

Ligamentum patellae

Tibialis anterior

Superior extensor retinaculum

Tendon of tibialis anterior

Tendon of extensor hallucis longus

Plantar aponeurosis

Piriformis

Sacrotuberous ligament

Gluteus maximus

Adductor magnus

Semitendinosus

Semimembranosus

Biceps femoris

Inferior extremity of semimembranosus

Sartorius

Tendon of gracilis

Insertion of semimembranosus

Tendon of semimembranosus

Medial head of gastrocnemius

Soleus

Flexor digitorum longus

Tibialis posterior

Flexor hallucis longus

Tendo calcaneus

Abductor hallucis

SURFACE OF THE FEMALE LEG
Front and back views

Seeing the leg from the surface gives no real hint of its complexity underneath the skin. On the whole, the larger muscles are the only ones easily seen and the only bone structure visible is at the knee and the ankles. However the tibia (shin bone) creates a long, smooth surface at the front of the lower leg that is clearly noticeable.

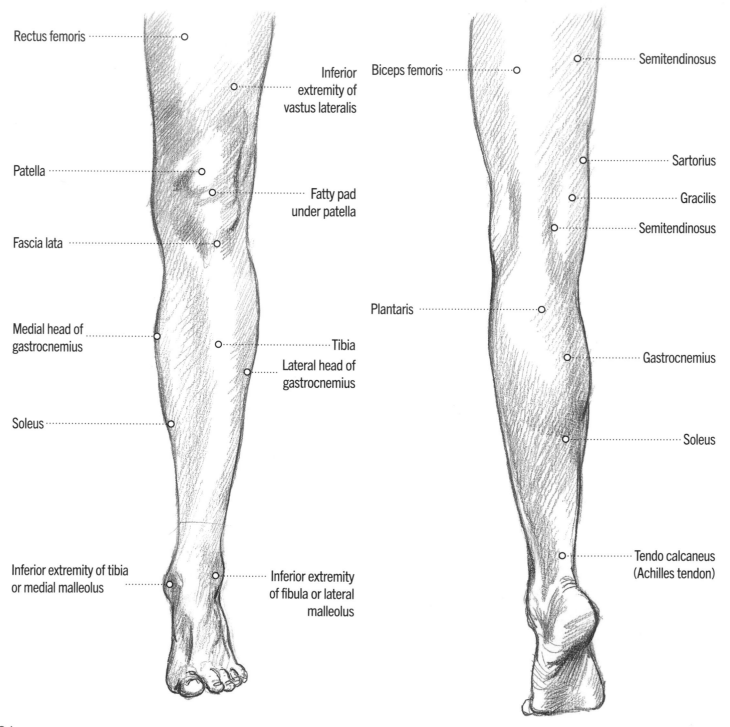

Rectus femoris

Inferior extremity of vastus lateralis

Biceps femoris

Semitendinosus

Patella

Fatty pad under patella

Sartorius

Gracilis

Semitendinosus

Fascia lata

Plantaris

Medial head of gastrocnemius

Tibia

Lateral head of gastrocnemius

Gastrocnemius

Soleus

Soleus

Inferior extremity of tibia or medial malleolus

Inferior extremity of fibula or lateral malleolus

Tendo calcaneus (Achilles tendon)

FEMALE OUTSIDE LEG

FEMALE INSIDE LEG

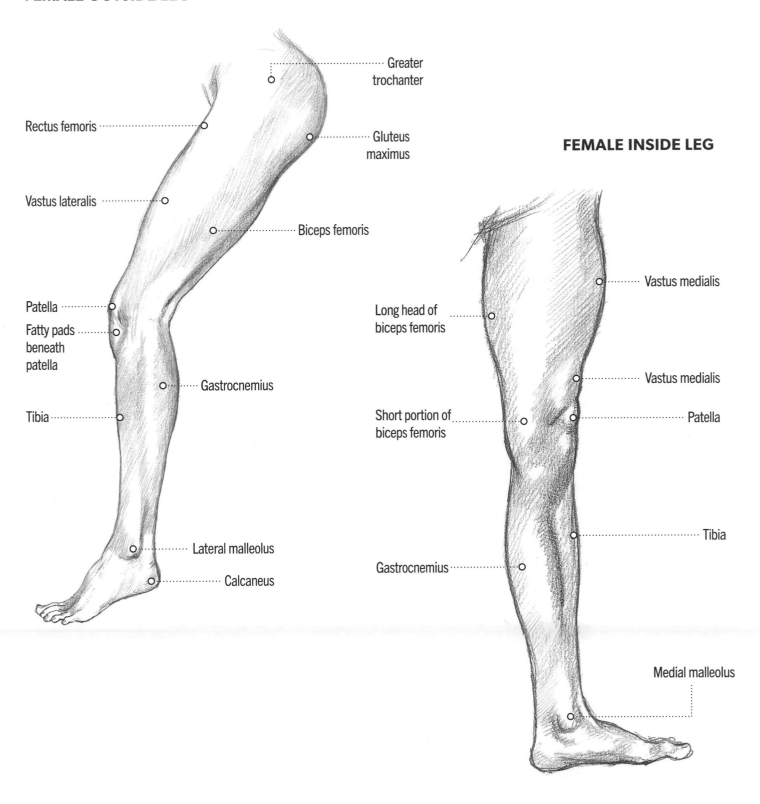

Greater trochanter

Rectus femoris

Gluteus maximus

Vastus lateralis

Biceps femoris

Patella

Fatty pads beneath patella

Gastrocnemius

Tibia

Lateral malleolus

Calcaneus

Vastus medialis

Long head of biceps femoris

Vastus medialis

Short portion of biceps femoris

Patella

Tibia

Gastrocnemius

Medial malleolus

SURFACE OF THE MALE LEG
Front and back views

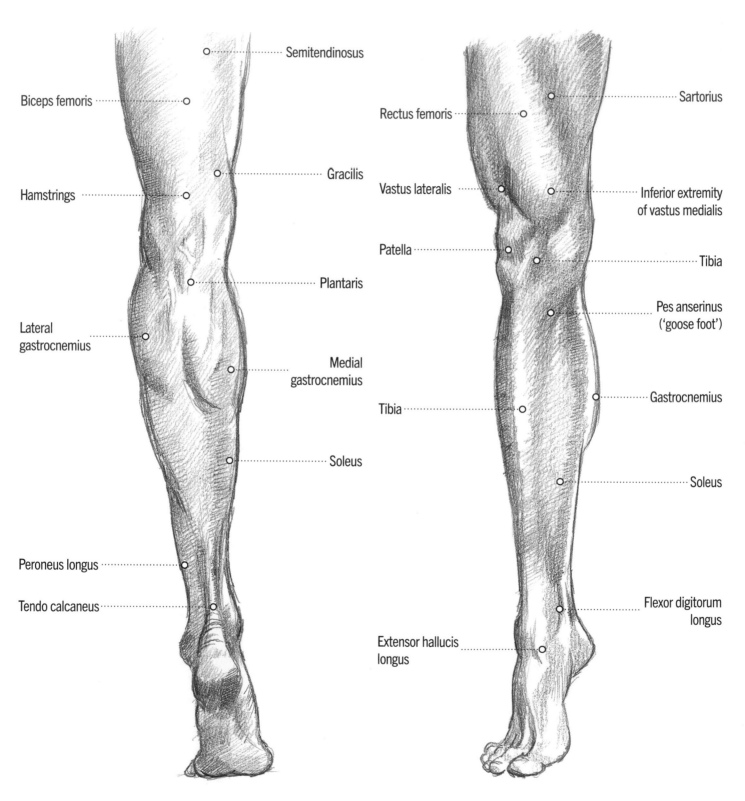

Semitendinosus

Biceps femoris

Gracilis

Hamstrings

Plantaris

Lateral
gastrocnemius

Medial
gastrocnemius

Soleus

Peroneus longus

Tendo calcaneus

Rectus femoris

Sartorius

Vastus lateralis

Inferior extremity
of vastus medialis

Patella

Tibia

Pes anserinus
('goose foot')

Gastrocnemius

Tibia

Soleus

Flexor digitorum
longus

Extensor hallucis
longus

MALE OUTSIDE LEG

MALE INSIDE LEG

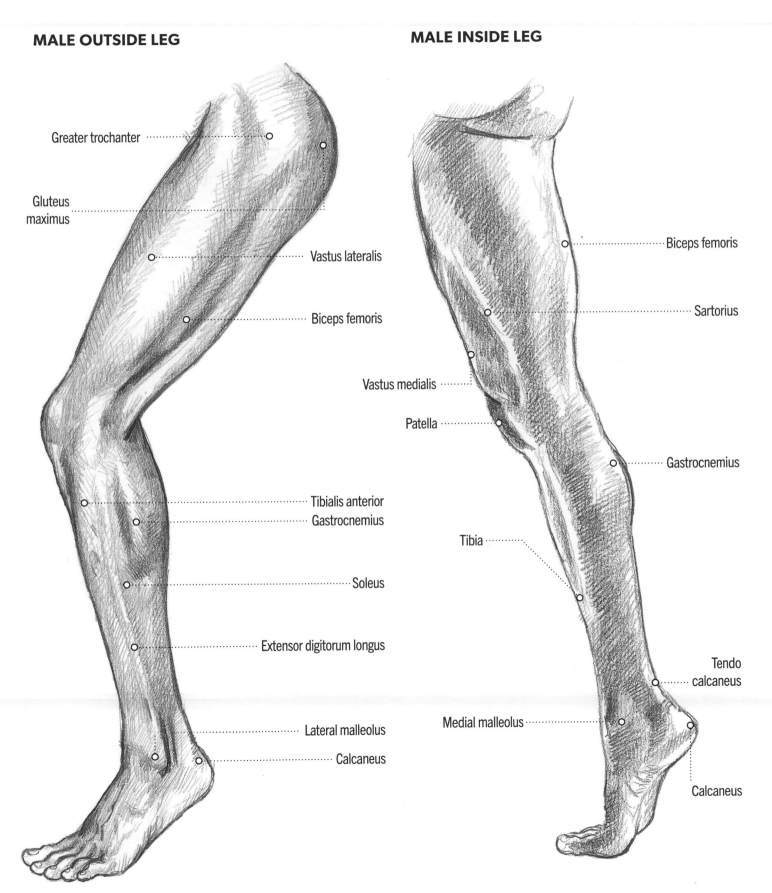

Greater trochanter

Gluteus maximus

Vastus lateralis

Biceps femoris

Tibialis anterior

Gastrocnemius

Soleus

Extensor digitorum longus

Lateral malleolus

Calcaneus

Biceps femoris

Sartorius

Vastus medialis

Patella

Gastrocnemius

Tibia

Tendo calcaneus

Medial malleolus

Calcaneus

SKELETON OF THE FOOT
Top view

As with the hand in the previous chapter, I will deal with the foot separately from the leg, as it is quite a complex feature. It is not such a familiar part of the body either, as people tend to keep their shoes on when walking about in public.

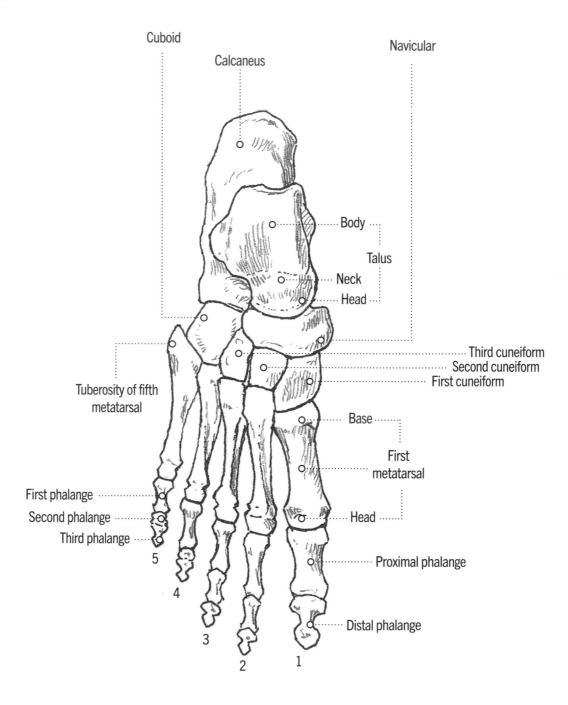

Cuboid

Calcaneus

Navicular

Body

Talus

Neck

Head

Third cuneiform

Second cuneiform

First cuneiform

Tuberosity of fifth metatarsal

Base

First metatarsal

First phalange

Second phalange

Third phalange

Head

5

Proximal phalange

4

Distal phalange

3

2

1

SKELETON OF THE FOOT
Bottom view

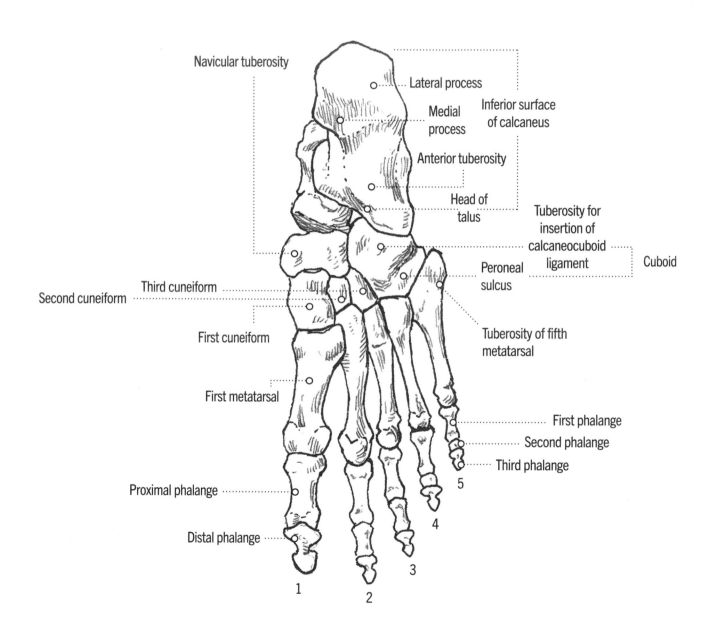

Navicular tuberosity

Lateral process

Medial process

Inferior surface of calcaneus

Anterior tuberosity

Head of talus

Tuberosity for insertion of calcaneocuboid ligament

Cuboid

Peroneal sulcus

Third cuneiform

Second cuneiform

First cuneiform

Tuberosity of fifth metatarsal

First metatarsal

First phalange

Second phalange

Third phalange

Proximal phalange

Distal phalange

5

4

3

1

2

SKELETON OF THE FOOT
Side view

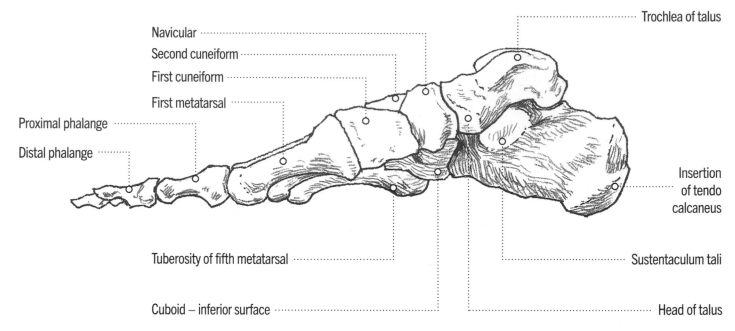

Navicular

Second cuneiform

First cuneiform

First metatarsal

Proximal phalange

Distal phalange

Trochlea of talus

Insertion of tendo calcaneus

Tuberosity of fifth metatarsal

Sustentaculum tali

Cuboid – inferior surface

Head of talus

PRACTICE AREA

MUSCLES OF THE FOOT
Top and bottom views

The muscles of the foot have several complex layers that are not easily seen on the surface, nor do we have much opportunity to examine the sole of the foot, so it is not so familiar to us.

TOP VIEW

Extensor digitorum longus

Peroneus tertius

Extensor hallucis longus

Extensor digitorum brevis

**BOTTOM VIEW
DEEP LAYER**

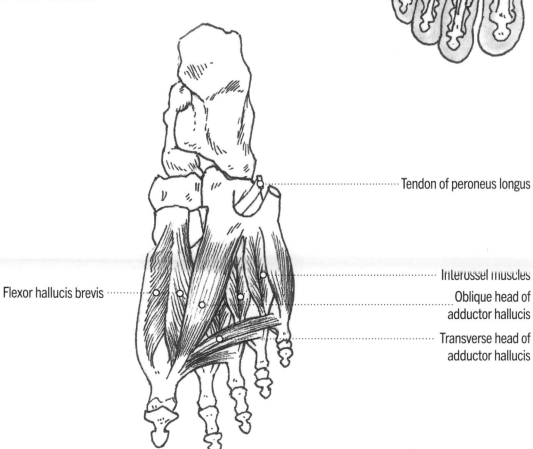

Tendon of peroneus longus

Interossei muscles

Oblique head of adductor hallucis

Transverse head of adductor hallucis

Flexor hallucis brevis

195

MUSCLES OF THE FOOT
Middle and superficial layers

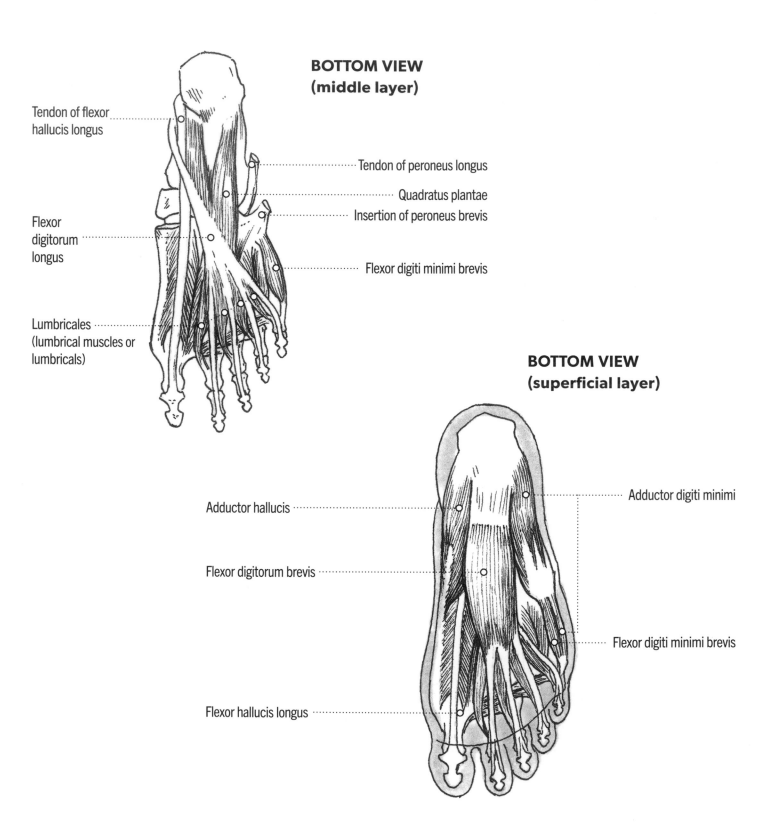

**BOTTOM VIEW
(middle layer)**

Tendon of flexor hallucis longus

Tendon of peroneus longus

Quadratus plantae

Insertion of peroneus brevis

Flexor digitorum longus

Flexor digiti minimi brevis

Lumbricales (lumbrical muscles or lumbricals)

**BOTTOM VIEW
(superficial layer)**

Adductor hallucis

Adductor digiti minimi

Flexor digitorum brevis

Flexor digiti minimi brevis

Flexor hallucis longus

SURFACE OF THE FOOT

FRONT VIEW: MALE

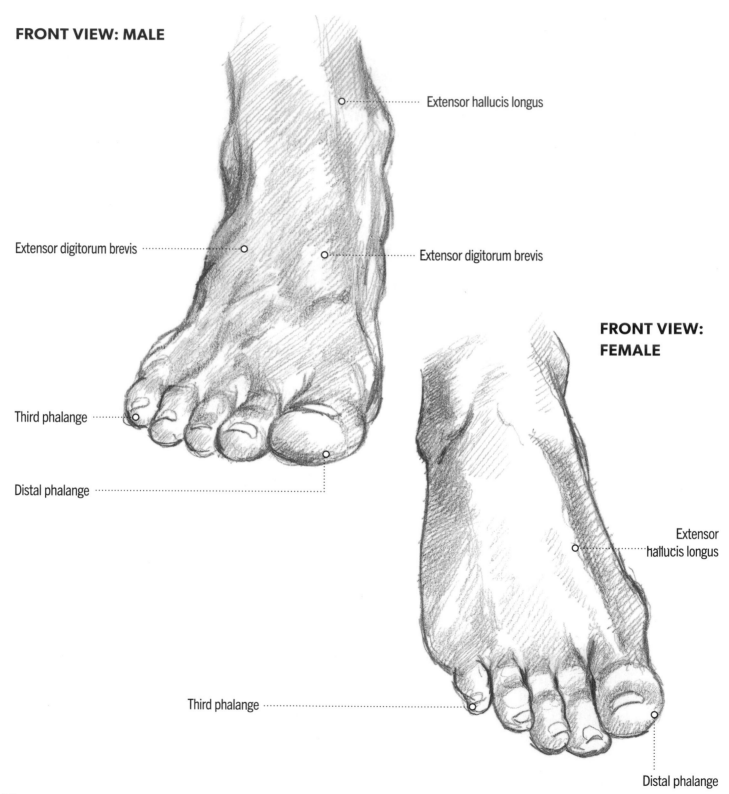

Extensor hallucis longus

Extensor digitorum brevis

Extensor digitorum brevis

FRONT VIEW: FEMALE

Third phalange

Distal phalange

Extensor hallucis longus

Third phalange

Distal phalange

INSIDE VIEW: FEMALE

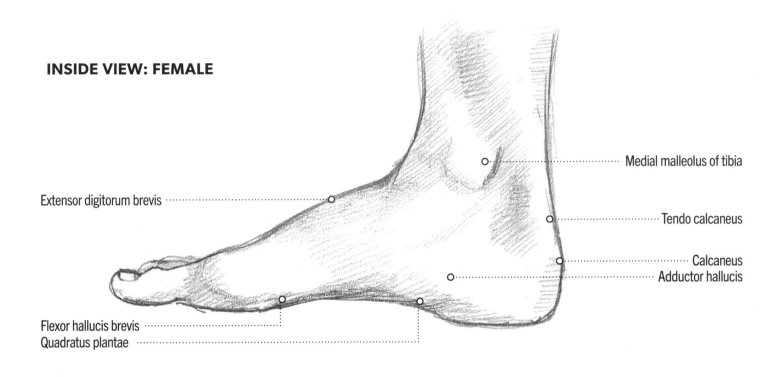

Medial malleolus of tibia

Extensor digitorum brevis

Tendo calcaneus

Calcaneus
Adductor hallucis

Flexor hallucis brevis
Quadratus plantae

INSIDE VIEW: MALE

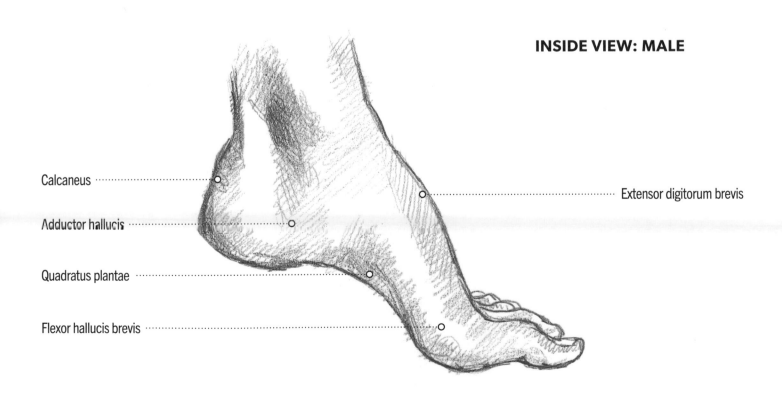

Calcaneus

Extensor digitorum brevis

Adductor hallucis

Quadratus plantae

Flexor hallucis brevis

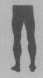

Various views

TOP VIEW: FEMALE

OUTSIDE VIEW: MALE

OUTSIDE VIEW: FEMALE

BOTTOM VIEW: FEMALE

SURFACE VIEWS OF THE FEMALE LEG

The leg in movement is quite flexible but without the more detailed movements of the arm. The emphasis is on strength and powerful movements that carry the whole body. Over the following pages are various views of legs performing simple movements: note the smoother appearance of the female limb and the clearer musculature of the male.

SIDE VIEW: FLEXED

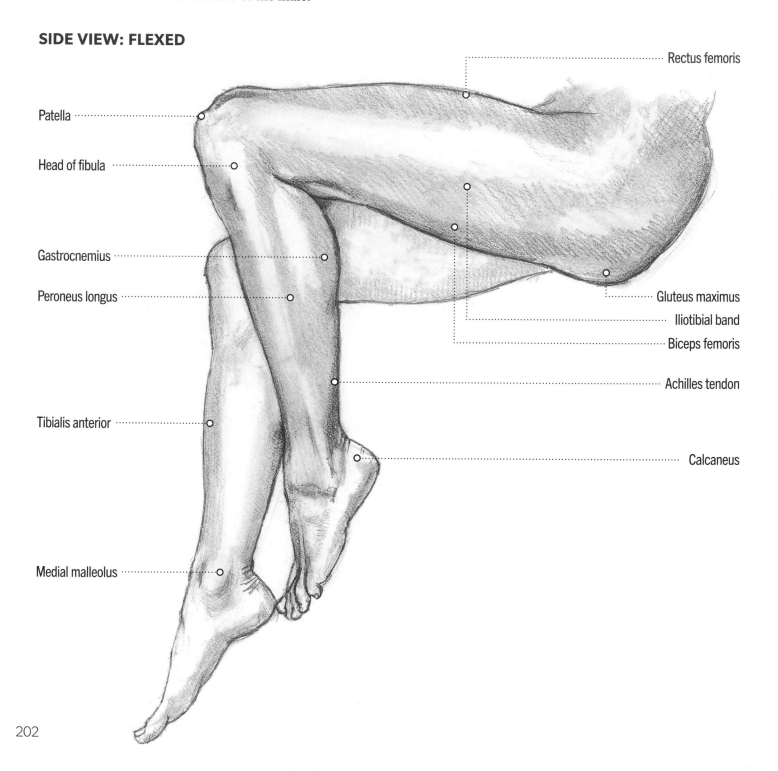

Rectus femoris

Patella

Head of fibula

Gastrocnemius

Peroneus longus

Gluteus maximus

Iliotibial band

Biceps femoris

Achilles tendon

Tibialis anterior

Calcaneus

Medial malleolus

FRONT VIEW: FLEXED

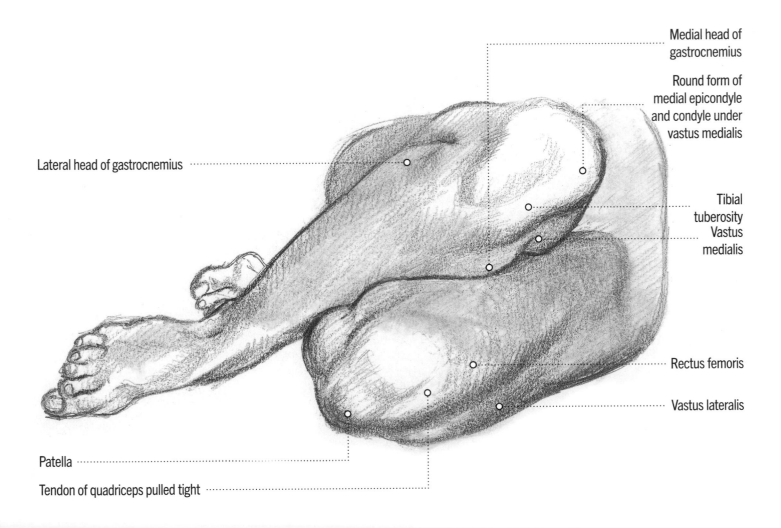

Medial head of gastrocnemius

Round form of medial epicondyle and condyle under vastus medialis

Lateral head of gastrocnemius

Tibial tuberosity
Vastus medialis

Rectus femoris

Vastus lateralis

Patella

Tendon of quadriceps pulled tight

SURFACE VIEWS OF THE MALE LEG

FRONT VIEW: FLEXED

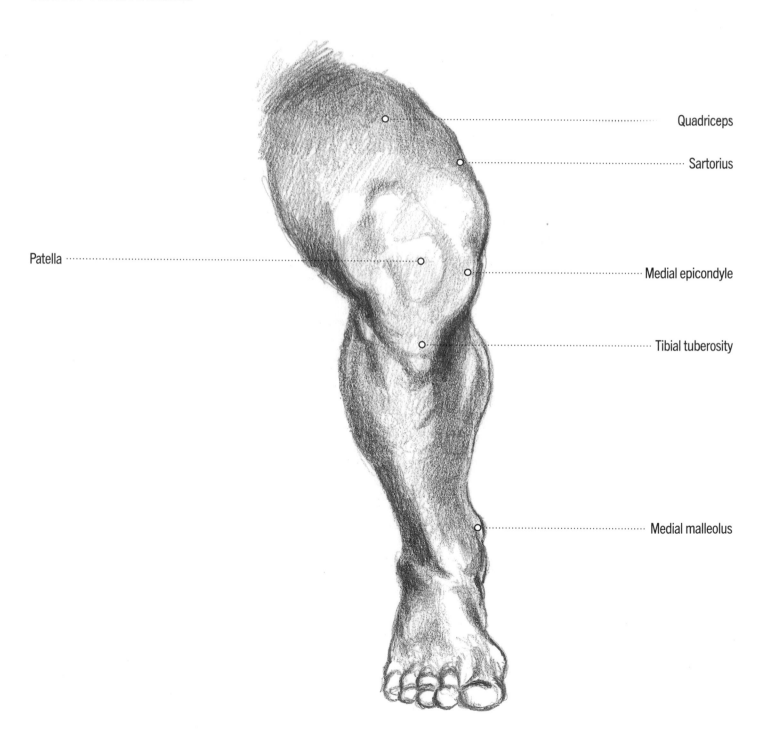

Quadriceps

Sartorius

Patella

Medial epicondyle

Tibial tuberosity

Medial malleolus

SIDE VIEW: FLEXED

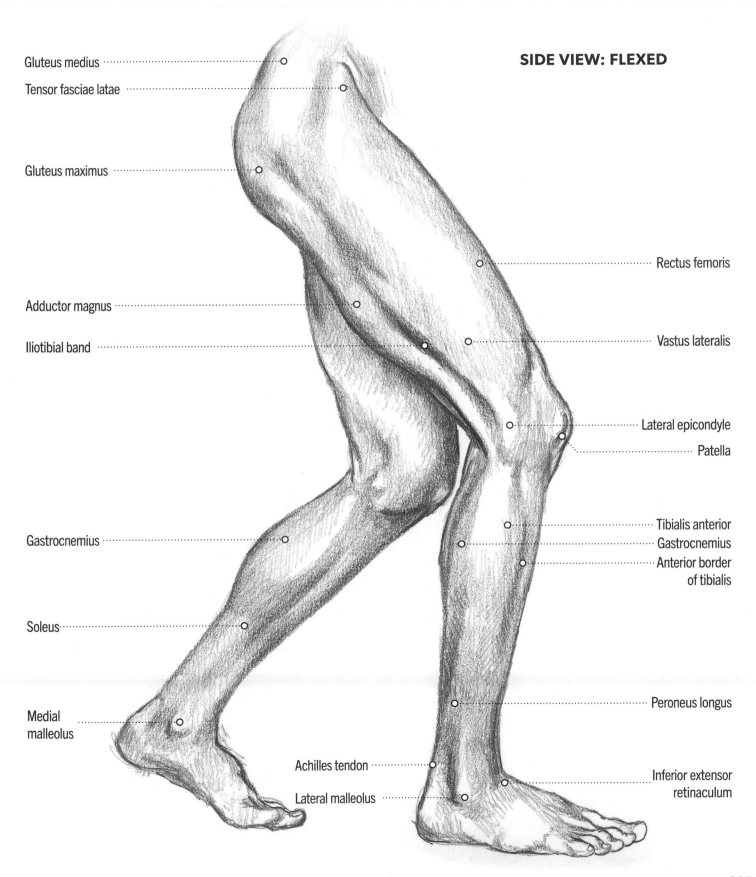

Gluteus medius

Tensor fasciae latae

Gluteus maximus

Adductor magnus

Iliotibial band

Gastrocnemius

Soleus

Medial malleolus

Rectus femoris

Vastus lateralis

Lateral epicondyle

Patella

Tibialis anterior

Gastrocnemius

Anterior border of tibialis

Peroneus longus

Achilles tendon

Lateral malleolus

Inferior extensor retinaculum

205

DRAWINGS OF LEGS AND FEET IN MOVEMENT BY MASTER ARTISTS
After Michelangelo

In these drawings after master artists, I have only given the names of some of the visible muscles and bone structure. It would be a good exercise to see what others you can identify, using the diagrammatic information in the previous pages. This will help you to memorize the terms.

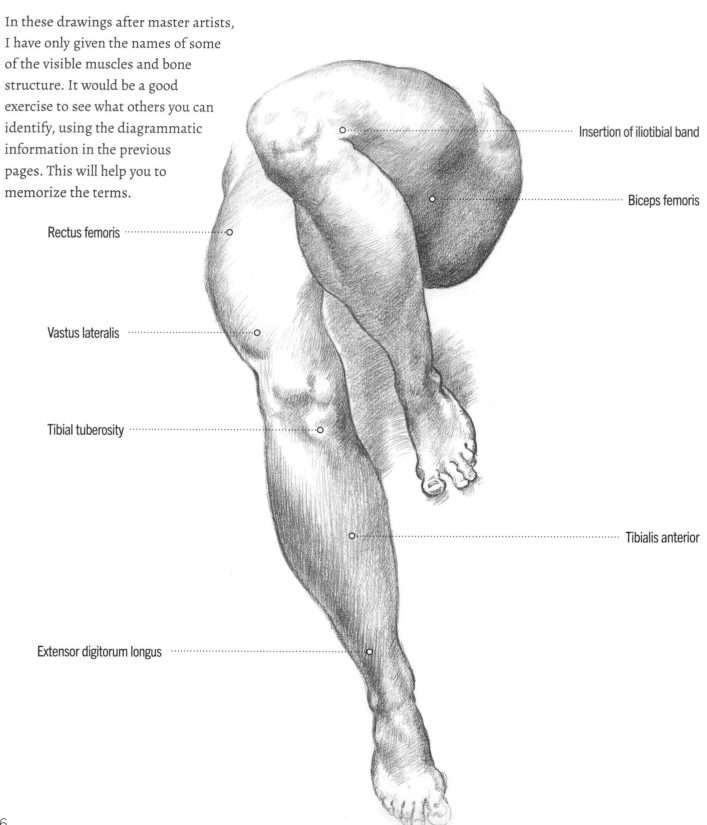

Insertion of iliotibial band

Biceps femoris

Rectus femoris

Vastus lateralis

Tibial tuberosity

Tibialis anterior

Extensor digitorum longus

After Rubens

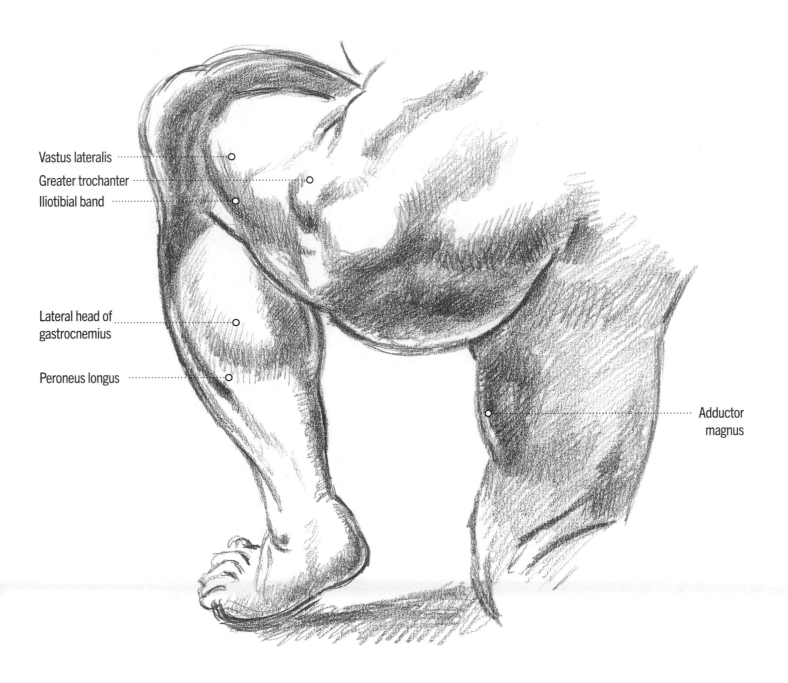

Vastus lateralis

Greater trochanter

Iliotibial band

Lateral head of gastrocnemius

Peroneus longus

Adductor magnus

After Louis de Boulogne (1654–1733)

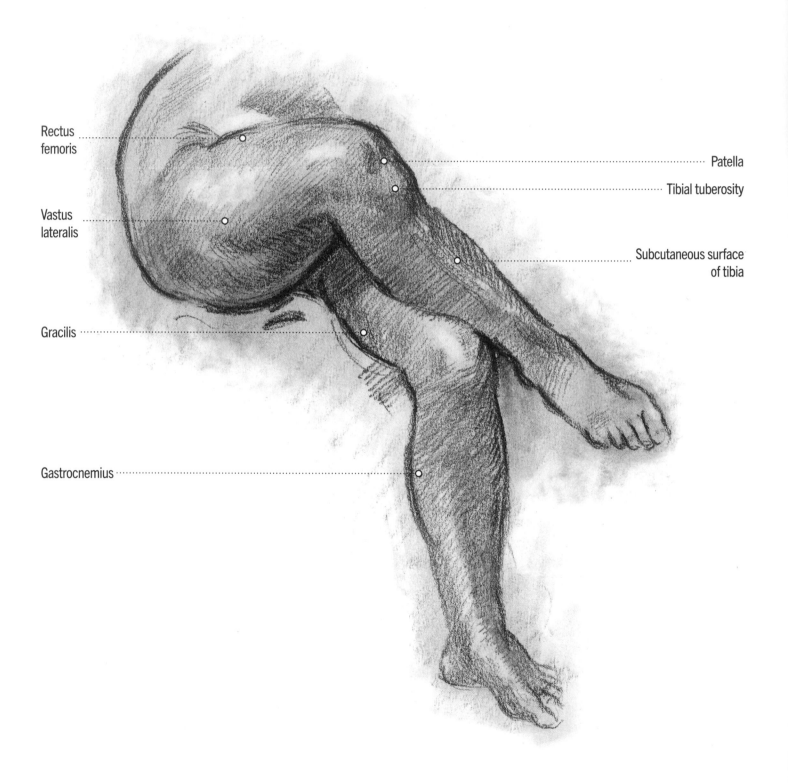

Rectus femoris

Patella

Tibial tuberosity

Vastus lateralis

Subcutaneous surface of tibia

Gracilis

Gastrocnemius

After Michelangelo

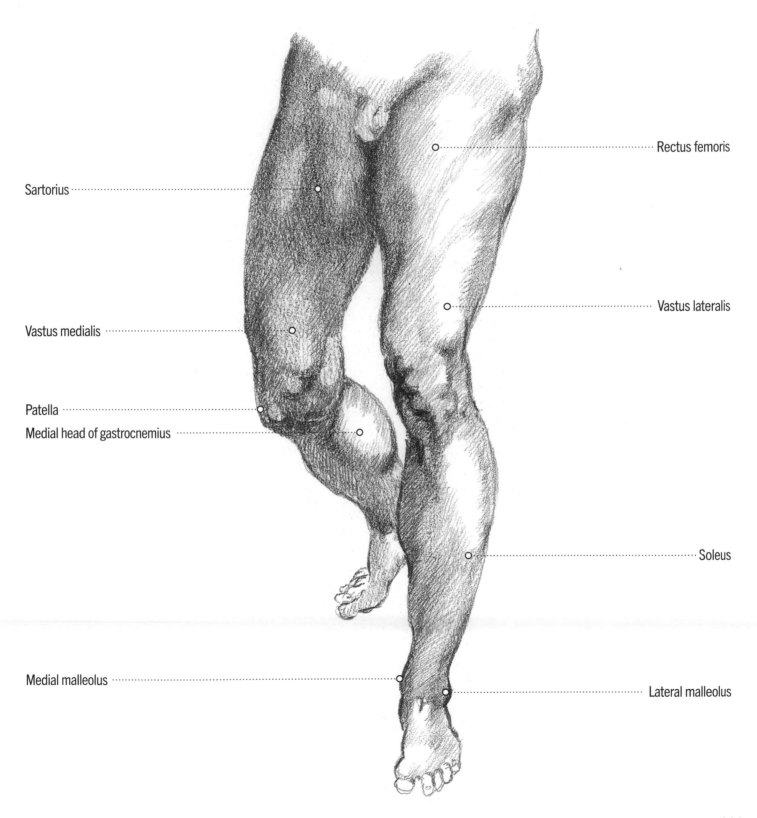

Sartorius

Rectus femoris

Vastus lateralis

Vastus medialis

Patella

Medial head of gastrocnemius

Soleus

Medial malleolus

Lateral malleolus

DRAWING THE WHOLE FIGURE

This final chapter includes exercises and techniques for depicting the complete human figure, and explores the benefits of practising life drawing for artists. Although the diagrams and examples in a book like this will give you a lot of information about the human body, it is essential for really good results to draw from life as often as possible, in order to become familiar with what happens to the muscles and bone structure of the body in different circumstances and in different individuals.

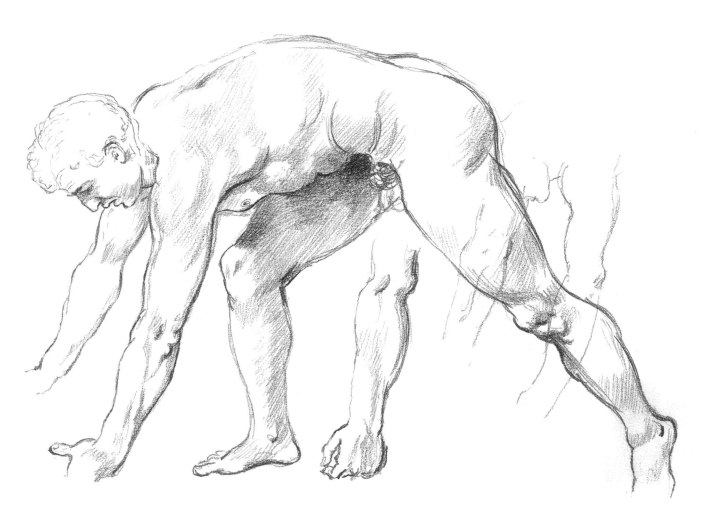

We will look at some basic poses and how you can draw these step by step, as well as how to work at speed when drawing from a live model. The range of poses the human body can adopt is enormous, and showing body language effectively can lend your drawing an expressive power, even in the briefest sketch. When it comes to depicting movement, observation is key, and your knowledge of how the muscles work beneath the skin will aid your drawing. Adapting your style to use a fluid pencil line and a light touch will add to the feeling of movement.

We examine various techniques and media that can be used to portray the figure, from contour lines and stippling to convey volume, to pared-back line drawing where every mark counts.

Finally we look at the possibilities of composition, analysing examples of single figures and more complex arrangements of interlocking forms.

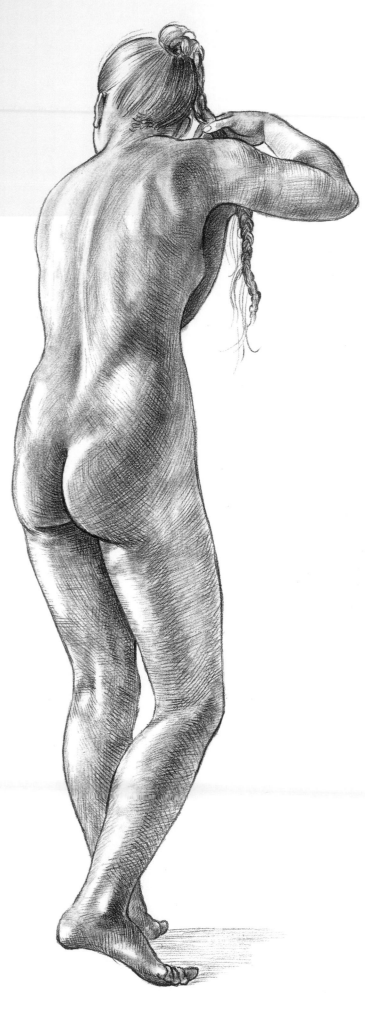

LIFE DRAWING

Drawing from life is often said to be the foundation of all drawing and of course this is particularly so in the case of figure drawing. The human body is the most subtle and difficult thing to draw and you will learn more from a few lessons in front of a model than you ever could drawing from photographs.

In most urban areas, life drawing classes are not too difficult to come by and if there is an adult education college or an art school that offers part-time courses it is an excellent way to improve your skills.

One of the great advantages of life classes is that there is usually a highly qualified artist teaching the course. The dedication and helpfulness of most of these teachers of drawing will enable you to gradually improve your drawing step by step, and the additional advantage of having other students from beginners to quite skilful practitioners, will encourage your work by emulation and competition.

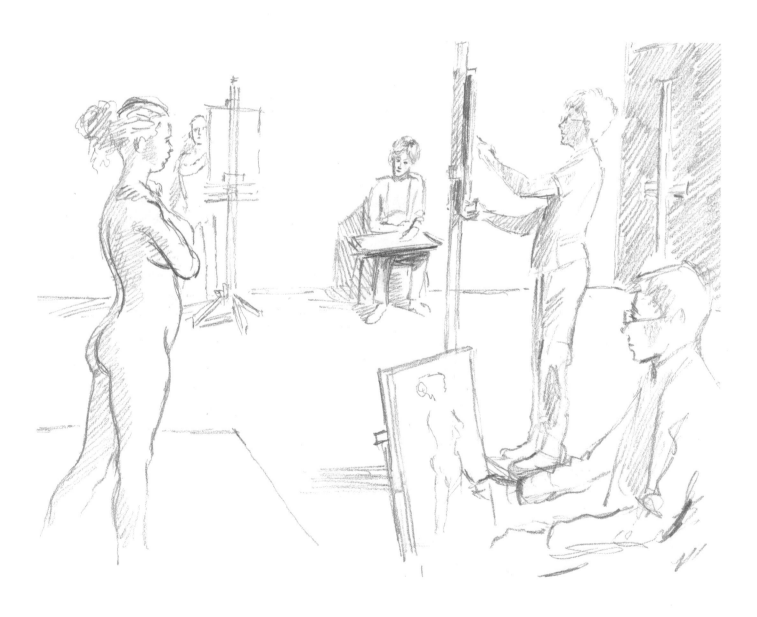

Lighting the model

In order to make your drawing work more effectively it is necessary to take the way the light falls onto the figure in to consideration. Natural light is the norm in life drawing, except in winter when it may not be available for sufficient hours in the day. Most artists' studios have north-facing windows because they give light, without the harsh shadows caused by sunshine. With north light the shadows tend to be even and soft, showing very clearly quite small graduations in tone so that the changes of surface direction can be quite easily seen.

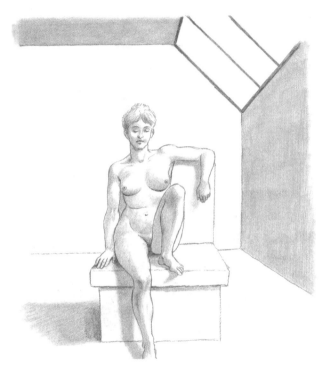

In this drawing of a model in a north-lit studio, a typical even light is spread across the space, giving wide gradations in the tonal quality of the shadows on the form. Note how the angle of the light causes the shadows to fall on the left side of her body and beneath her chin and breasts.

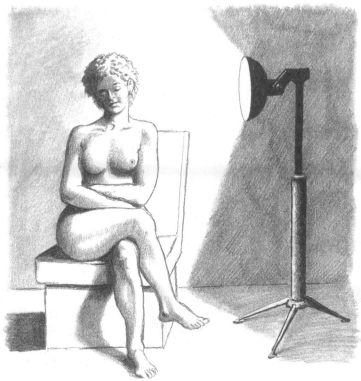

This picture gives a clear indication of how strong directional light produces harsh shadows and very brightly lit areas. This can produce very dramatic pictures: the Italian artist Caravaggio, for example, was known to have had massive arrays of candlepower to light his models in order to produce his very dramatic contrasts in light and shade, known as chiaroscuro.

217

FOUR BASIC STAGES OF DRAWING A FIGURE

For a beginner first embarking on drawing the whole figure, the tendency is to become rather tense about the enormity of the task. The presence of a real live model, as opposed to a still-life object, can make you feel not only that your work may be judged and found wanting by your subject, but also the life class you are in and that you also perhaps cannot work at your leisure.

To begin with, just think in terms of simple shapes rather than visualizing a finished drawing that you feel you are not capable of achieving. Starting very simply, for example with a seated male figure, there are some easy ways to work your way into the task of drawing it.

The first stage is to see the very basic shape that the disposition of the body and limbs make in the simplest geometric way. This figure is sitting with one knee up, leaning on the lower knee with the elbow of one arm. This produces a triangular shape between the torso and head and the arm and lower leg. Set against that is the additional triangle of the bent leg, which creates another triangular shape cutting into the first shape. With very simple lines, sketch in the position and proportion of the shapes.

The next stage is to make the shape more like the actual volume of the figure by drawing curved outlines around each limb and the head and torso. I have left out the original lines of the above drawing so that you can see how much there is to draw in this stage. This drawing needs to be done quite carefully as it sets the whole shape for the finished piece of work.

The next step is to block in the changes in the planes of the surface as shown by the light and shade on the body. This process needs only to be a series of outlines of areas of shadow and light. At the same time, begin to carefully define the shapes of the muscles and bone structure by refining your second outline shape – this is where your knowledge of anatomy will help you to add detail. At this stage you will want to do quite a bit of correcting to make your shapes resemble your model. Take your time and work as as accurately as you can, until you see a very similar arrangement of shapes when you look from your drawing to the model.

Lastly comes the addition of shading so that the three-dimensional aspect of the figure begins to make itself evident. Notice how there are large areas of tone with darker tones within them where the body is more curved. Again you can keep on correcting until you are satisfied. All this takes time, so don't forget to give your model some time to rest and stretch in between your long periods of drawing.

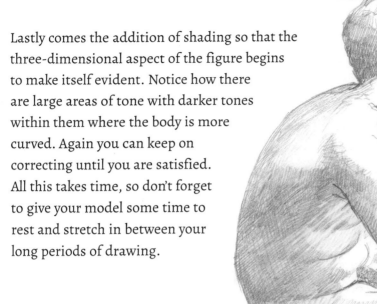

PRACTICE AREA

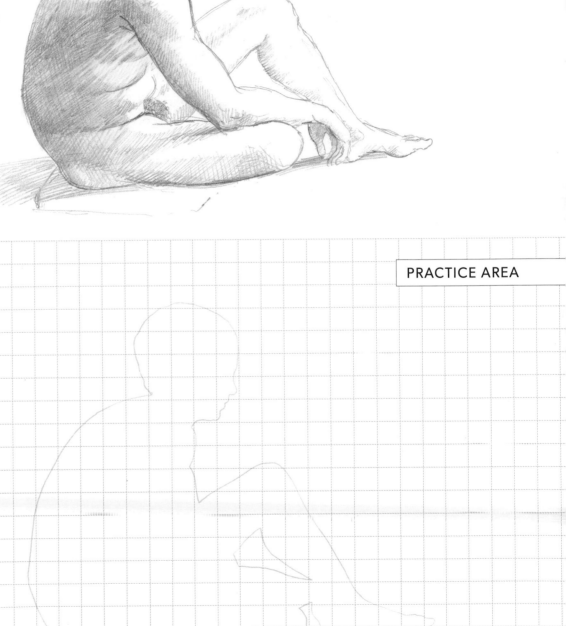

A MORE DIFFICULT POSE

Once you have drawn a simple figure successfully, it is time to move on to something a little more challenging that will expand your skills further and build your confidence. This time, you will work through a similar set of stages with a female model – but the pose is more difficult both for the model to hold and for you to draw. Go carefully, allowing yourself time for accuracy and the model adequate resting periods.

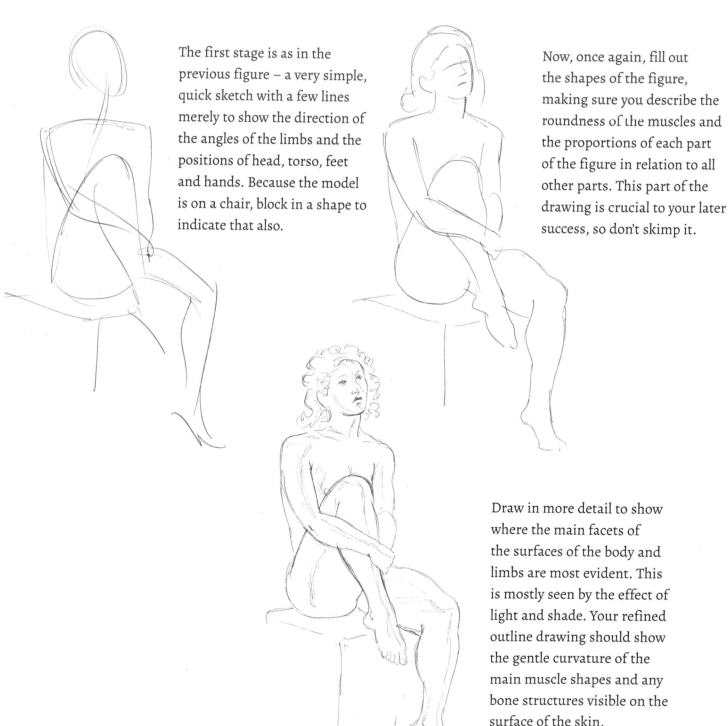

The first stage is as in the previous figure – a very simple, quick sketch with a few lines merely to show the direction of the angles of the limbs and the positions of head, torso, feet and hands. Because the model is on a chair, block in a shape to indicate that also.

Now, once again, fill out the shapes of the figure, making sure you describe the roundness of the muscles and the proportions of each part of the figure in relation to all other parts. This part of the drawing is crucial to your later success, so don't skimp it.

Draw in more detail to show where the main facets of the surfaces of the body and limbs are most evident. This is mostly seen by the effect of light and shade. Your refined outline drawing should show the gentle curvature of the main muscle shapes and any bone structures visible on the surface of the skin.

PRACTICE AREA

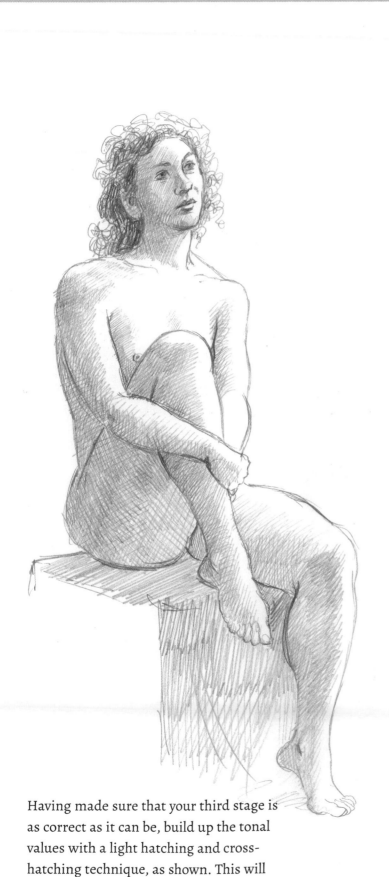

Having made sure that your third stage is as correct as it can be, build up the tonal values with a light hatching and cross-hatching technique, as shown. This will give the figure weight and volume.

221

WORKING AT SPEED

Another practice always useful for life drawing is to draw extremely
quickly with just a few fluid lines to see how fast the whole figure
can be sketched in. This is encouraged by many life-class tutors as it
teaches students to look for the absolutely essential lines of the pose.
Practise a dozen or so drawings like these of the model, taking various
one- or two-minute poses and putting in the absolute minimum. You
should be working so quickly you have no time to correct errors.

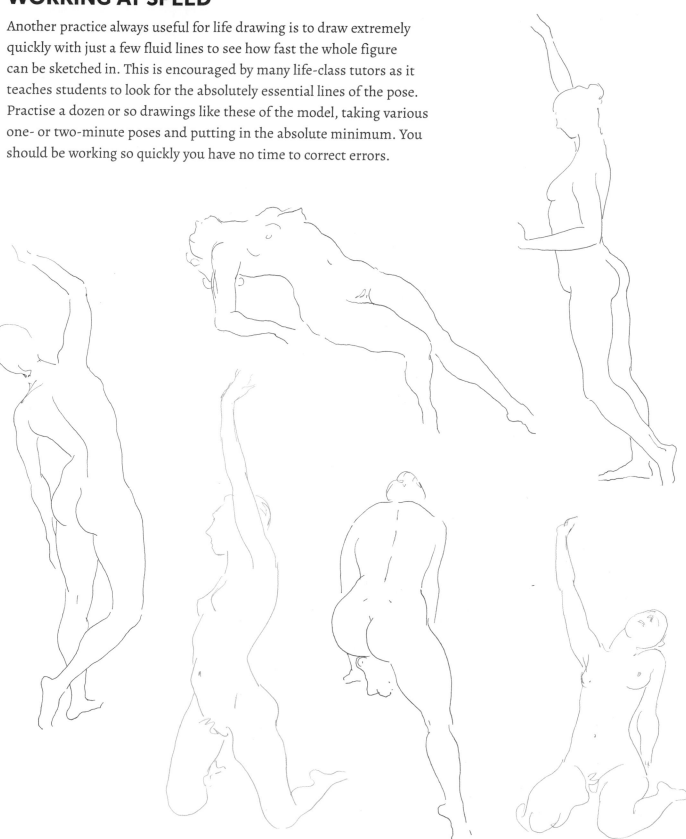

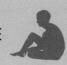

Seated and reclining figures

There are, of course, as many poses or actions as there are movements in the human body. These are all posed models who are reclining or sitting in a pose that can be held for a while. The drawing needs to show that the body is at rest, which is fairly obvious by the positions shown.

These are slightly more tightly organized
poses than those on the last two pages.
This often gives a more sculptural quality
to the arrangement and produces a more
contained effect in a drawing. The poses
also present some different challenges to
the artist: foreshortening and form are two
areas that will need more attention when
drawing these models.

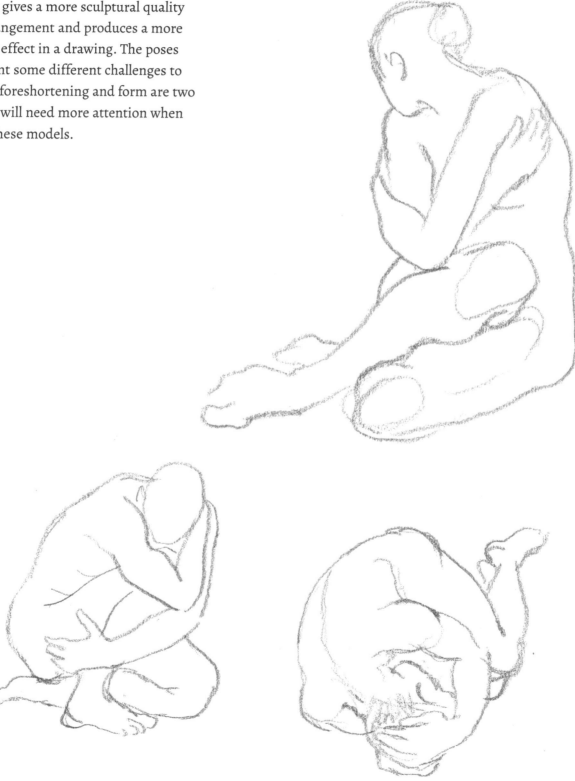

BODY LANGUAGE

As we have seen in many of the master drawings in this book, the human figure will often bring some emotional context to a picture. This is mostly shown by the way the figure is depicted moving and can also require the juxtaposition of two figures – for example, a figure waving its fists in the air and confronting a cowering figure would obviously suggest some disagreement or aggression going on. However, the moods indicated are usually more subtle than this and, particularly when there is only one figure present, the artist has to understand and master the conventions of body-language before the picture will tell the desired story. Here you can see some examples of the moods that different poses evoke.

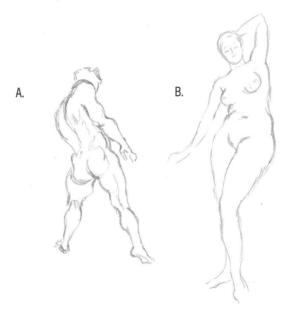
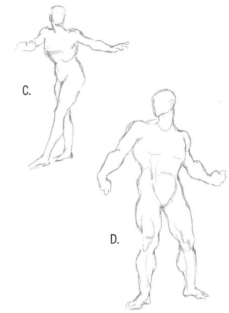

A. The pose of this masculine figure suggests some effort possibly related to pulling or pushing, shown by the braced legs, straight arm and twisted spine.

B. The female figure seems to stretch out in dreamy languor, emphasized by the sinuous quality of her arms and legs.

C. Another female figure, this time one who looks startled by something behind her, with a slightly theatrical gesture.

D. This male figure is obviously aggressive, with his pulled-back fist and fighting stance, reinforced by his heavily muscled form.

E. A female figure with arms aloft appears to be crowing with delight or jubilation, as though she has just won a prize.

F. Turning to look at something behind and at her feet, this figure shows her surprise in a rather dramatic gesture.

G. In a crouching position with head down, this man appears to be moving hastily away from something causing fear or a similar emotion.

H. The kneeling figure shows mental strain of some sort which, with his hand to his head, suggests the conventional pose for agonized thought.

I. This female figure seems to be protecting herself with a pose suggesting the foetal position.

J. A male character sitting back as though on the beach enjoying the sunshine evokes a feeling of simple relaxation.

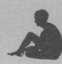

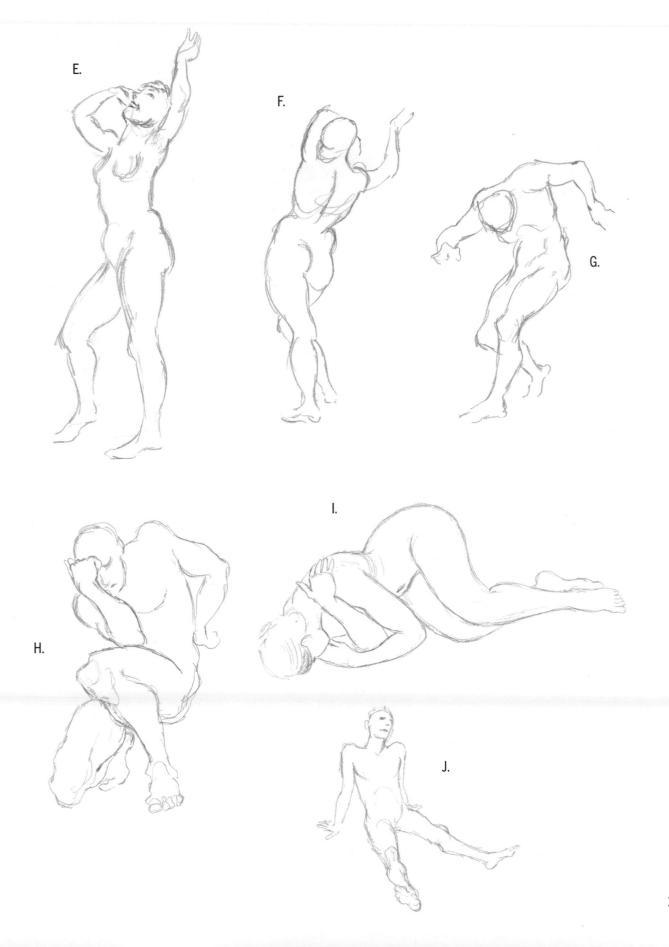

E.

F.

G.

I.

H.

J.

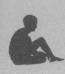

WALKING AND RUNNING FIGURES

Photographs are a great boon to the artist wanting to discover just how the parts of the body relate to each other as the model moves, but they should be used with caution as copying from a photograph can produce sterile results. An artist should be looking not just to make an accurate drawing of lines and shapes but also to express the feeling of the movement in a way that can be understood by the viewer: look particularly at the styles of depiction chosen here. Study photographs, but stamp your own mark as an artist on your drawings.

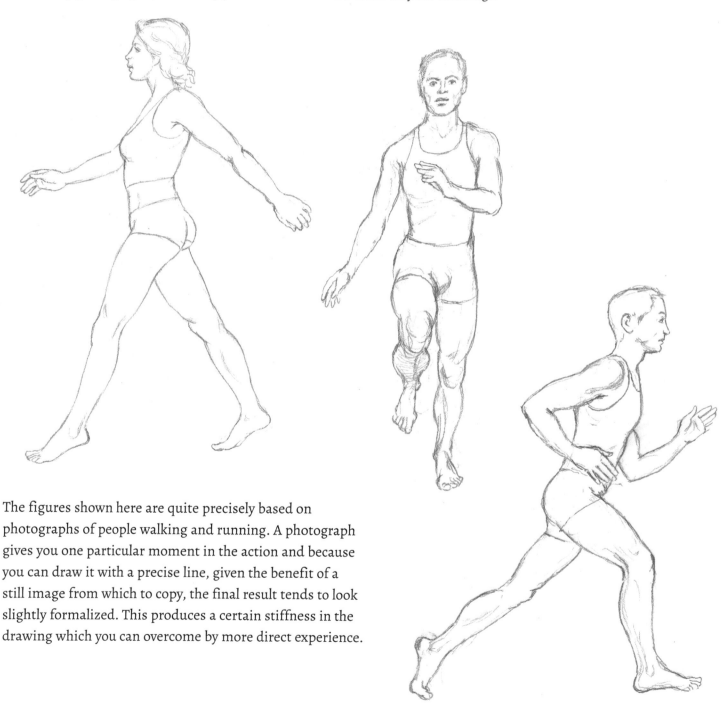

The figures shown here are quite precisely based on photographs of people walking and running. A photograph gives you one particular moment in the action and because you can draw it with a precise line, given the benefit of a still image from which to copy, the final result tends to look slightly formalized. This produces a certain stiffness in the drawing which you can overcome by more direct experience.

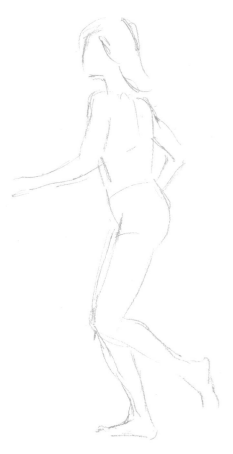

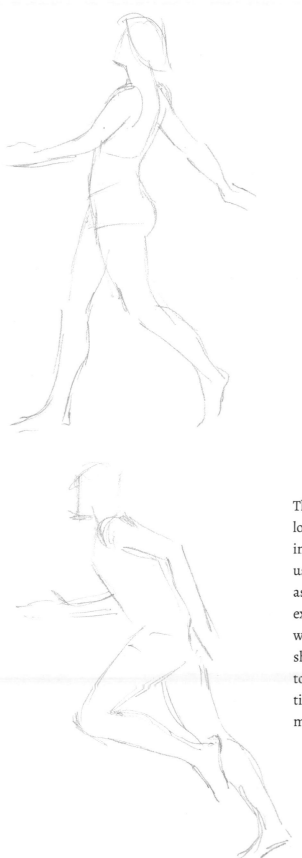

The next three figures, drawn much more loosely without the aid of photographs, give an impression of the movement. The type of line used helps to produce an image which looks as though it is in motion; none of the lines are exact and in some cases there are several lines, which create a blurred effect. Notice how the shoulders and hips work in opposition; the torso is sometimes vertical but is quite often tilted forward or back at different parts of the movement.

DANCING FIGURES

Here we can see some of the most mobile joints in the body stretched to their maximum capacity as figures are projected off the ground with necessary vigour.

This drawing of a leaping man shows how the left leg is bent as much as possible while the right leg is extended. The torso is leaning forward, as is the head, and the arms are lifted above the shoulders to help increase his elevation.

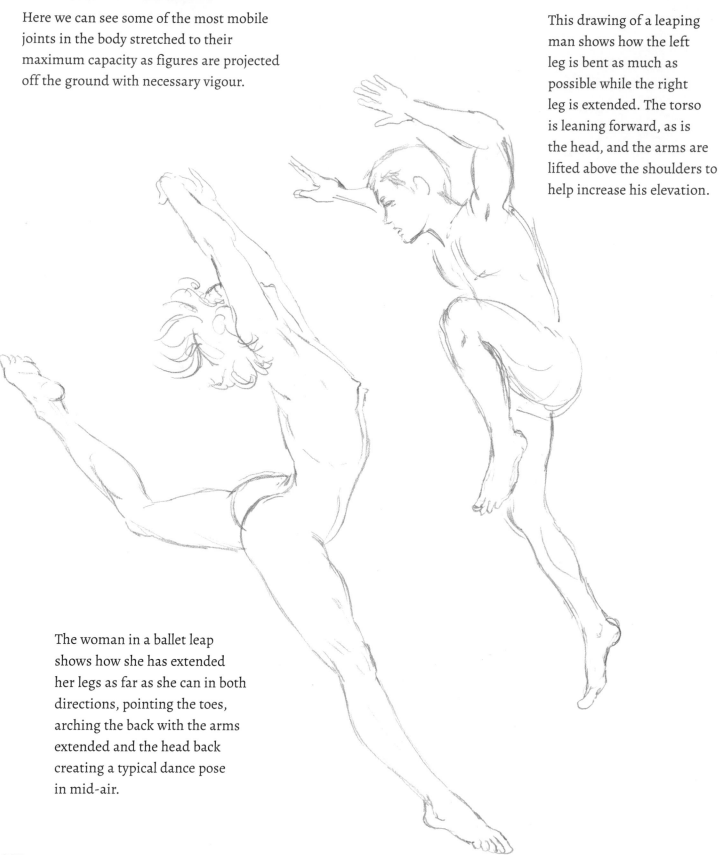

The woman in a ballet leap shows how she has extended her legs as far as she can in both directions, pointing the toes, arching the back with the arms extended and the head back creating a typical dance pose in mid-air.

230

The next two figures of a woman leaping in dance mode show extreme extension of the legs and arms in order to create a balanced figure in mid-air. Notice how the muscles, particularly in the thighs, are very evident because of the effort involved in the action.

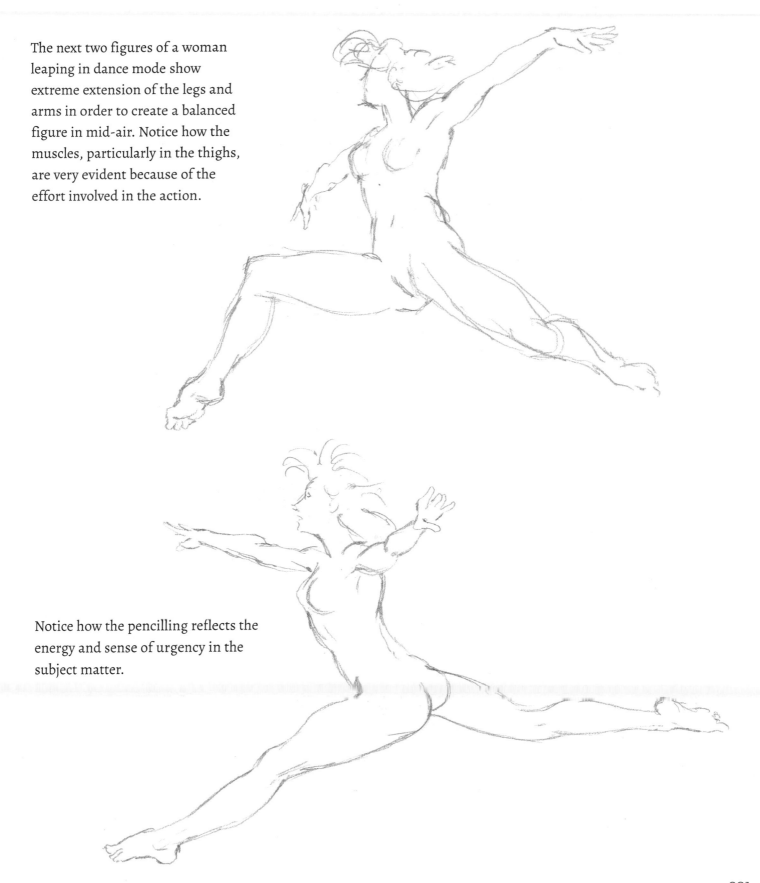

Notice how the pencilling reflects the energy and sense of urgency in the subject matter.

FIGURES IN MOVEMENT AFTER A MASTER ARTIST
After Jean-Auguste Dominique Ingres (1780–1867)

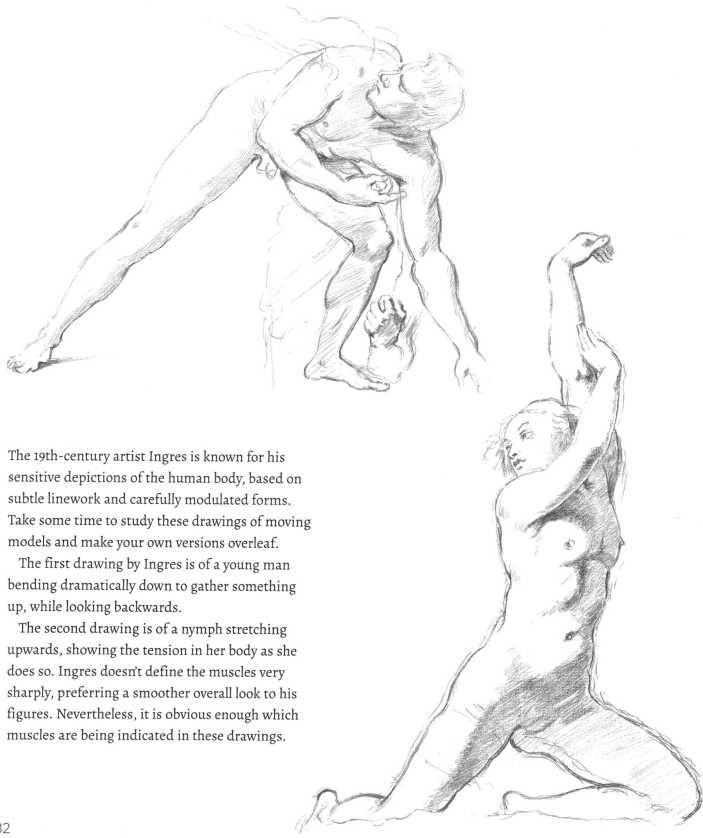

The 19th-century artist Ingres is known for his sensitive depictions of the human body, based on subtle linework and carefully modulated forms. Take some time to study these drawings of moving models and make your own versions overleaf.

The first drawing by Ingres is of a young man bending dramatically down to gather something up, while looking backwards.

The second drawing is of a nymph stretching upwards, showing the tension in her body as she does so. Ingres doesn't define the muscles very sharply, preferring a smoother overall look to his figures. Nevertheless, it is obvious enough which muscles are being indicated in these drawings.

The next drawing shows a man lifting
a chair above his shoulder as he walks
forward. The arm muscles are particularly
obvious.

The final Ingres life study shows a man
reaching down to lift something from the
ground. The stretching of the legs and arms
brings into play all the muscles of the limbs.

As happens in many life drawings by
accomplished artists, Ingres has drawn
extra definitions of the feet in the standing
pose and the stretched arm in the drawing
below. These workings help to clarify what
is actually happening in a complex part of
the pose.

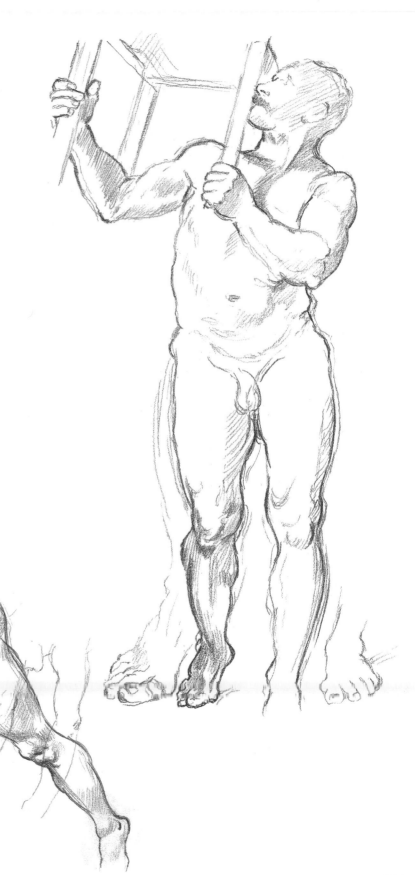

DIFFERENT STYLES

On the following pages we will look at varying techniques for portraying the human form, starting with two different approaches to showing the volume and solidity of the figure. You can make a small figure appear weighty by blocking in areas of tone, a technique used by artists when the drawing is to be painted as it clarifies how the area of tone and colour should be painted. Contour lines also give the impression of the roundness of the head and body.

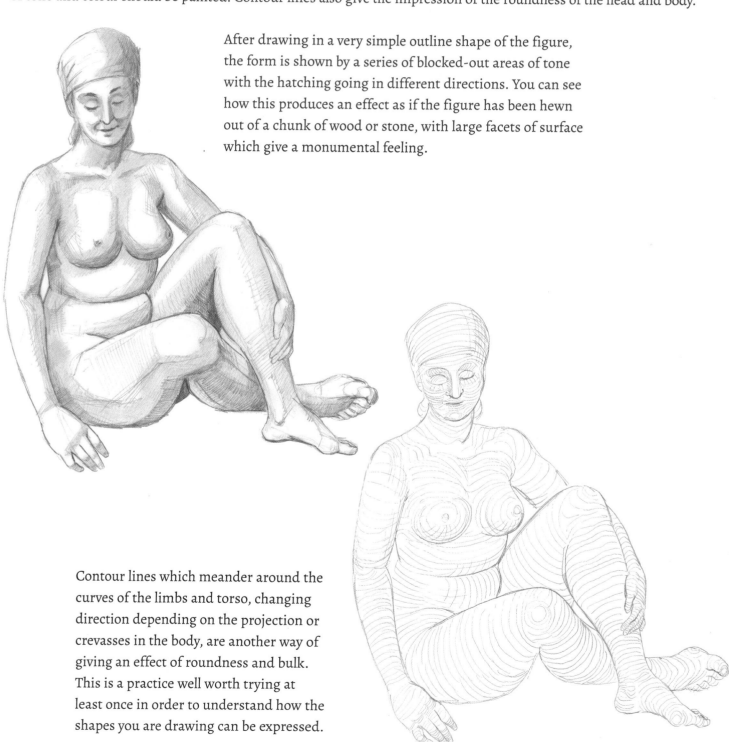

After drawing in a very simple outline shape of the figure, the form is shown by a series of blocked-out areas of tone with the hatching going in different directions. You can see how this produces an effect as if the figure has been hewn out of a chunk of wood or stone, with large facets of surface which give a monumental feeling.

Contour lines which meander around the curves of the limbs and torso, changing direction depending on the projection or crevasses in the body, are another way of giving an effect of roundness and bulk. This is a practice well worth trying at least once in order to understand how the shapes you are drawing can be expressed.

Hard and soft lines

Even in a line drawing with no attempt at tone you can influence the way the viewer will see and understand your figure. Producing a hard, definite line requires a steadier nerve on the part of the artist than a softer, more tentative line, but both are an equally valid way of describing the human form and lending feeling to the image.

A harder and very confident way of producing the form of the body is to go for absolute minimum line. You will have to make up your mind about a whole passage of the figure and then, as simply and accurately as you can, draw a strong, clear line without any corrections to produce a vigorous, clearly defined outline shape. Only the very least detail should be shown, just enough to give the effect of the human figure you see in front of you. This requires a bold approach and either works first go or not, but of course you can have as many shots at it as you have time for. It really teaches economy of both line and effect and also makes you look very carefully at the figure.

Allowing your pencil or pen to loosely follow the model's form in such a way that you produce a mass of weaving lines around the main shapes helps to express the softness and fluidity of the figure. This allows you to gradually discover the shape by a series of loosely felt lines that don't pin you down too tightly. What it loses in sharpness it gains in movement and flow of form.

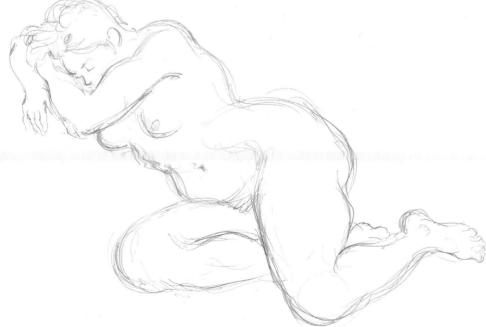

Blocking in mass

When beginners start life drawing, they often take the slow and painstaking approach of very detailed working, which a professional would not do. It is useful to learn how to block in large chunks of the figure, ignoring the detail, in order to get a better idea of the whole solid mass more quickly.

The first example also shows how you may ignore the curves of the body to produce a rather sculptural interpretation of the masses of form. This helps you to produce a much stronger-looking drawing and is easier to measure from point to point.

The second example is not so chunky and some curves are visible, but nevertheless the main point is that it produces an impression of the bulk of the form, using very little in the way of detail.

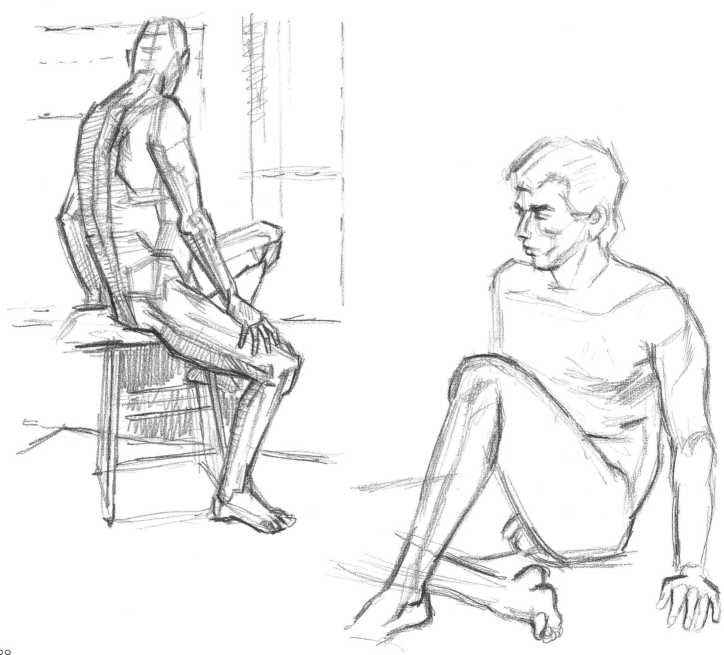

Stippling

The next study is quite different in technique, executed with a graphic pen fine-liner. This is a daring thing to do if you are a beginner, because every mark you make is obvious, and it is not possible to erase in the normal way. But if you persevere with your studies, it is in fact a very good way to draw, as it makes you more aware of your imperfections and also, as you improve, it gives you the confidence to make mistakes without cringing when others see them. A word of warning, however: it is extremely time-consuming, so you will need a good long pose.

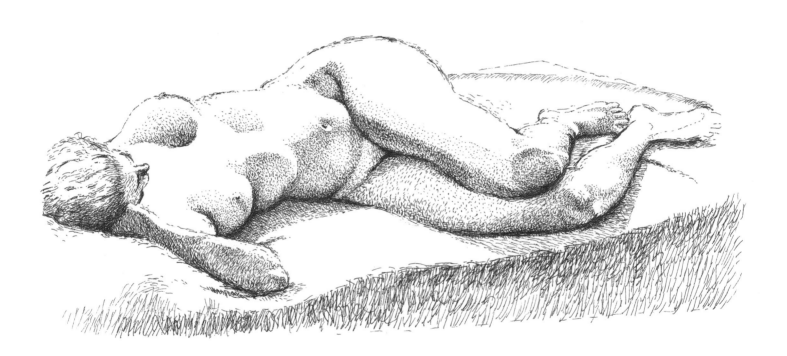

VARYING STYLES OF MASTER DRAUGHTSMEN

Here I look at a series of drawings in different mediums by great artists showing how they used their chosen medium to great effect.

In this drawing the great Renaissance artist Raphael Sanzio used a very particular technique of the time which was probably influenced by Michelangelo's drawings. The use of ink in clearly defined lines, some heavier than others, gives a very precise result in which there is no doubt about the shape and bulk of the figure. It is a good, albeit rather difficult, method for a beginner that is worth practising and persisting with.

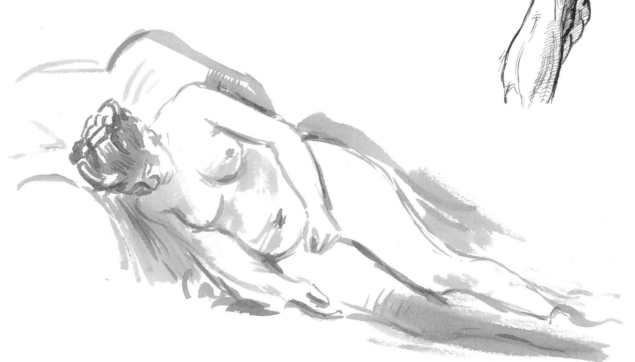

This drawing of a reclining nude woman by Rembrandt van Rijn (1606–69) shows how brilliant he was with the use of a brush. The economy of the line and the handling of the very light tonal areas give maximum effect with very little drawing.

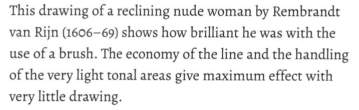

This beautiful line drawing of a crouching woman by the great French sculptor Aristide Maillol (1861–1944), drawn at the beginning of the 20th century, shows how the soft smoky texture of the chalk line gives a feeling of the roundness of the limbs and the soft quality of the flesh. A line drawing like this is quite difficult to achieve with any degree of quality because you need to get it more or less right first time. However, it is worth trying because of the discipline which it imposes on the artist not to make too many mistakes.

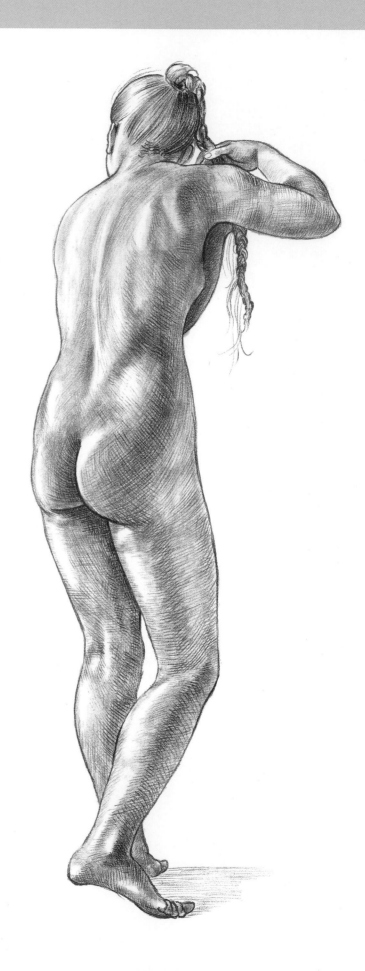

In this example after the German artist Julius Schnorr von Carolsfeld (1794–1872), the pencil is used almost scientifically with the line taking pre-eminence. It is one of the most perfect drawings I've ever seen in this meticulous pencil style. The result is quite stupendous, even though this is just a copy and probably doesn't have the precision of the original. Every line is visible. The tonal shading which follows the contours of the limbs is exquisitely observed. This is not at all easy to do and getting the repeated marks to line up correctly requires great discipline. It is worth practising this kind of drawing because it will increase your skill at manipulating the pencil and test your ability to concentrate.

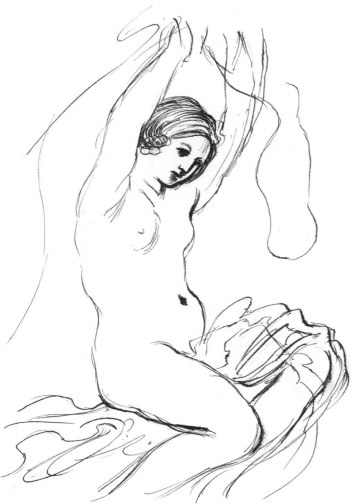

Rarely have I seen such brilliant line drawings in ink of the human figure as those of the painter Guercino (1591–1666). In this example the line is extremely economical and looks as though it has been drawn from life very rapidly. The flowing lines seem to produce the effect of a solid body in space, but they also have a marvellous lyrical quality of their own. Try drawing like this, quickly without worrying about anything except the most significant details, but getting the feel of the subject in as few lines as possible. You will have to draw a figure from life in order to get an understanding of how this technique works.

In his masterly original of this ink drawing, Tintoretto (c.1518–94) was careful to get the whole outline of the figure. The curvy interior lines suggest the muscularity of the form. There is not too much detail but just enough to convince the eye of the powerful body; every muscle here appears to ripple under the skin. The barest of shading suggests the form.

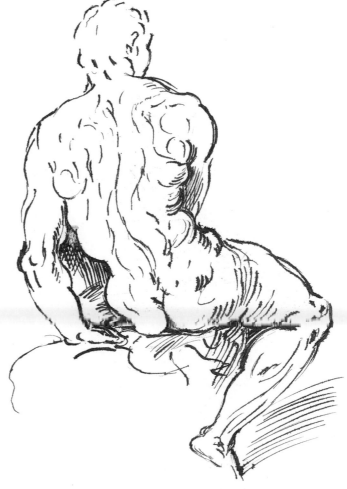

COMPOSITION

As you gain confidence in your figure drawing, you will want to give more thought to the composition of your work and how it appears as a completed picture. You will have to consider how the shape of the figure (or figures) you are drawing (at a life class, for example) will be placed on the surface of the paper – whether it will take up all or some of the paper, and how to position it.

 A very useful tool to help you to achieve interesting compositions is a framing device as shown below. It can be made cheaply by cutting it out of card to any size and format that you wish to work on. By looking through it and moving it slightly up and down and from left to right you can examine the relationship between the figure and the boundaries of the paper and visualize your composition before you actually begin to draw. It will also help you to see the perspective of a figure at an angle to you, as the foreshortening becomes more evident.

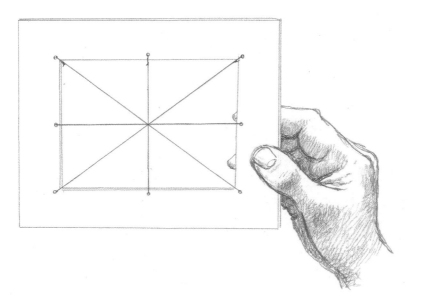

Dividing your framing device into a grid will assist you in placing the figure accurately within the format when you draw it.

 To make a grid, attach four threads to the card: one from centre top to bottom, one from centre left to centre right and two diagonally from corner to corner. Make sure they are pulled tight so that they all meet in the centre of this space.

In this example the edges of the frame are placed so that the figure appears to stretch from the upper right-hand corner to the lower left-hand corner. The centre of the picture is taken up by the torso and hips and the figure is just about balanced between the upper and lower parts of the diagonal line. This would give you a picture that covered the whole area of your surface but left interesting spaces at either side. You will find that it is quite often the spaces left by the figures that help to define the dynamics of your picture and create drama and interest.

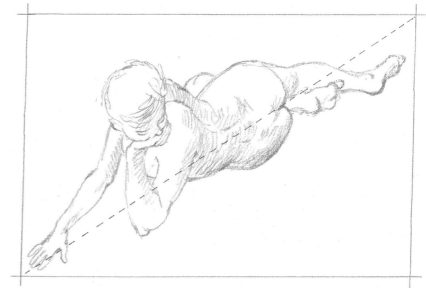

Looking for simple geometric shapes such as triangles and squares will help you to see the overall form of the figure and achieve a cohesive composition within your format.

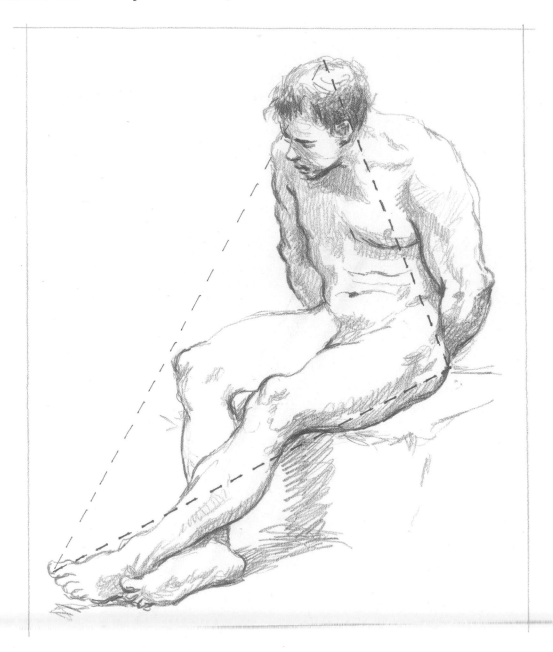

This seated man with his hands behind his back, based on a drawing by Natoire in the Louvre, fits into an elongated triangle with the corners at the top of his head, the back of his hip and the end of his toes. The bulk of his body is between the sides of the triangle, and because the emphasis is on the stretch of his legs to the bottom left-hand corner of the picture there is a strong dynamic that suggests he under some duress – perhaps a prisoner. This simple device produces an emotional effect in the drawing.

Think about the areas of paper around your figures; space in your composition can suggest as much about the mood of the piece as the pose of the figure itself.

This standing figure of a woman turning away from the viewer is a gentle dynamic pose with a strong, upright shape. You might choose to fit the edge of the picture closely around her, as shown by the unbroken line. This is the simplest possible composition, making the figure fit in as in a box. Alternatively, you could use a space as shown by the rectangle with the lighter broken line, which encloses a large amount of space over to her right. Here she is on one side of the composition and the space suggests airiness and the light that is falling on her from the right.

A third choice of composition, shown with the heavier broken line, places her in a space which gives her room on both sides, making a dynamic out of the larger space to the right and the smaller space to the left. It also seems to set her back into the square more effectively, lending distance to the view that didn't occur with the first two compositions.

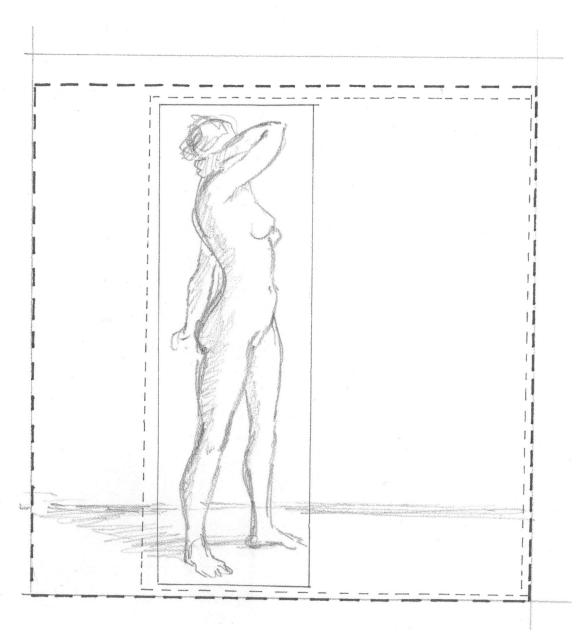

COMPOSITIONS AFTER MASTER ARTISTS

Composition becomes more complex when there is more than one figure to place in the picture, as you have to consider their relationship to each other and how they fit in the designated space. This example shows *The Three Graces* by Rubens, the great master painter of Flanders. His models are three well-built Flemish women, posed in the traditional dance of the graces, hands intertwined. Their stances create a definite depth of space, with a rhythm across the picture helped by the flimsy piece of drapery used as a connecting device. The flow of their arms as they embrace each other also acts as a lateral movement across the picture, so although these are three upright figures, the movement across the picture is very evident. The spaces between the women seem well articulated, partly due to their sturdy limbs.

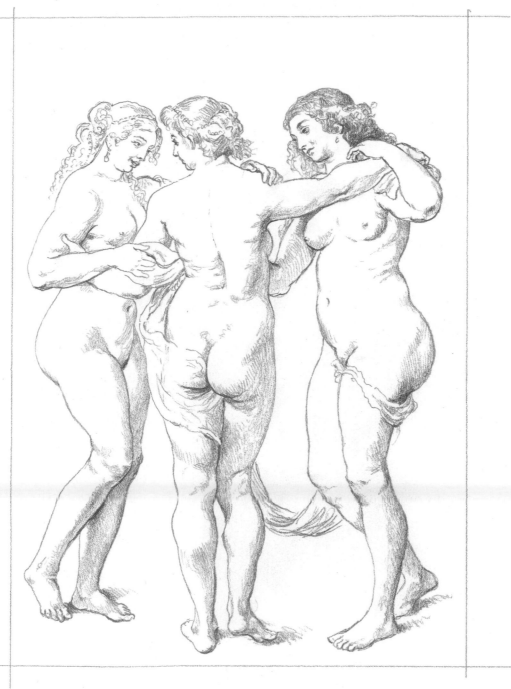

I based this drawing on the picture *Venus and Mars* by Sandro Botticelli (1445–1510), which can be seen in London's National Gallery, in which the reclining figure of Mars is totally surrendered to sleep. As a reclining figure it is one of the most relaxed-looking examples of a human figure.

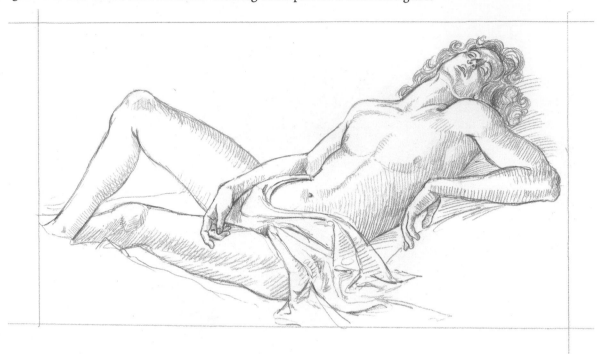

In this drawing, based on a work by the French 18th-century painter François Boucher (1703–70), a nude woman is reclining on a couch, posing for the artist. Although her head is erect, supported by her hands, and her back is hollowed, she is in a pose that doesn't suggest action on her part at all. The side view of a reclining pose is always the most calm and peaceful in effect.

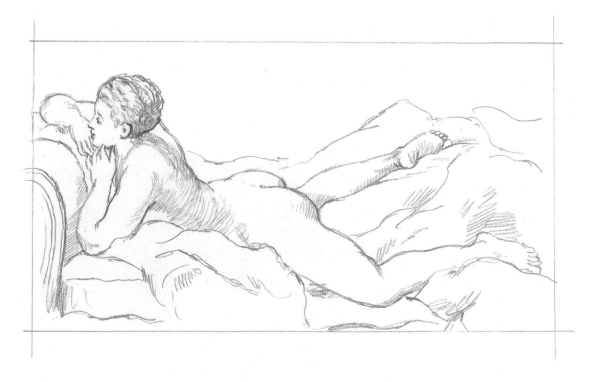

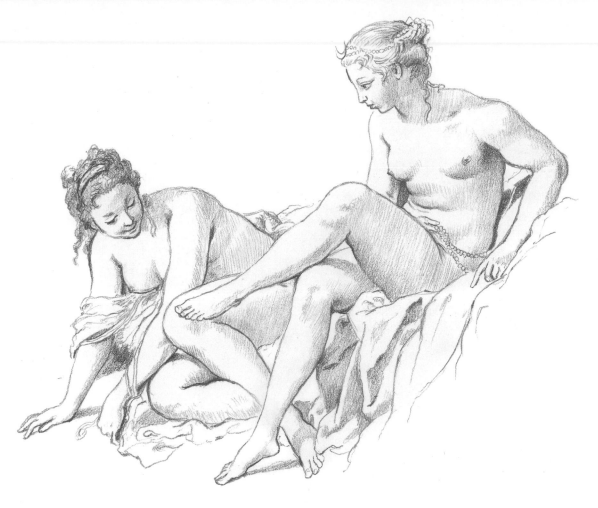

When it is analysed, this composition by Boucher of
two goddesses or nymphs at their toilet becomes a
complex series of interlinking triangular shapes. The
main thrust through the picture goes from the lowest
hand on the left up through the knee and leg of the
seated figure and on to her upper shoulder. From her
head to elbow is an obvious side of a triangle from
which two longer sides converge on her lowest foot. The
line from the seated figure's upper leg along the back
of the kneeling figure produces another possible set of
triangles that go through the feet and hand of the lower
figure. These interlinking triangles produce a neat,
tightly formed composition that still looks natural.

 Now that you have seen some of the possibilities
of figure composition, try making your own versions
on the practice pages provided. Start with a single
figure arrangement before attempting a more complex
composition like the example on this page.

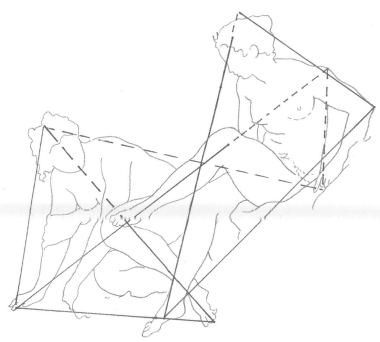